DRAWING
A CREATIVE PROCESS

DRAWING
A CREATIVE PROCESS

◆

FRANCIS D.K. CHING

VAN NOSTRAND REINHOLD
New York

I(T)P Van Nostrand Reinhold is an International Thomson Publishing company.
 ITP logo is a trademark under license.

Printed in the United States of America

Van Nostrand Reinhold International Thomson Publishing GmbH
115 Fifth Avenue Königswinterer Str. 418
New York, NY 10003 53227 Bonn
 Germany

International Thomson Publishing International Thomson Publishing Asia
Berkshire House,168-173 221 Henderson Bldg. #05-10
High Holborn, London WC1V 7AA Singapore 0315
England

Thomas Nelson Australia International Thomson Publishing Japan
102 Dodds Street Kyowa Building, 3F
South Melbourne 3205 2-2-1 Hirakawacho
Victoria, Australia Chiyoda-Ku, Tokyo 102
 Japan

Nelson Canada
1120 Birchmount Road
Scarborough, Ontario
M1K 5G4, Canada

JDL 16 15 14 13 12 11 10 9 8 7 6

Library of Congress Cataloging-in-Publication Data
Ching, Francis D.K., 1943-
 Drawing, a creative process.
 p. cm.
 Bibliography: p. 201
 Includes index.
 ISBN 0-442-31818-9
 1. Drawing. I. Title.
NC710.C66 1989
741.2—dc20

PREFACE

Drawing has a long established role in the visual arts, the recording of events through history, and the development of ideas in our civilization. While usually thought of as an activity requiring the skill of the talented few, drawing is a natural, often spontaneous, human response. People of all ages instinctively doodle while engaged in some other activity. Even young children who scribble with crayons and markers on paper or walls draw intuitively in an effort to describe what they see, to represent what they know, and to express how they feel. The intent of this book is to describe this vital process of drawing as an accessible, enjoyable, productive activity which, at its heart, is a creative process.

Drawing is typically defined as producing a likeness or representation of something by making lines on a surface. The inference is that delineation is different from painting and the coloring of surfaces. While drawing is generally linear in nature, it can include other pictorial elements such as dots and brush strokes which can also be seen as lines. Whatever form a drawing takes, it is fundamentally a means of vision and expression.

Drawing relies on a clear vision. It also requires thought which, in turn, builds understanding. Drawing cannot be detached from seeing and thinking about the fundamental nature of the subject matter being represented. The knowledge and understanding gained through drawing from life directly enhances our ability to draw from the imagination. Just as thought can be put into words, ideas can be made visible in a drawing to promote visual thinking and further stimulate the imagination. Once what is seen or imagined is made visible in a drawing, the image takes on a life of its own and communicates graphically. However eloquently or crudely, all drawings speak to the eye.

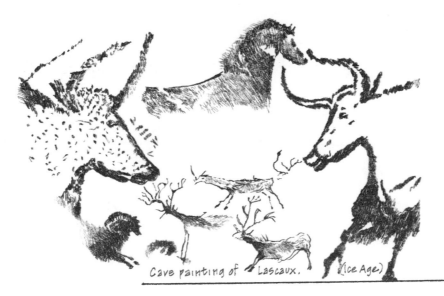

Cave painting of Lascaux. (Ice Age)

With words and images, this book attempts to illuminate the interplay of seeing, visualizing, and expressing through drawing. The work is organized in a sequence which begins with understanding the process of DRAWING and the purposes for which it can be used. The LINE is the drawing element which plays a critical role in the formation of our perceptions as well as the construction of drawings. Lines describe SHAPES, the pictorial forms which establish themselves as images in our visual field, and by which we organize and identify what we see. To convey the three dimensions we experience in reality, we must understand the techniques which effectively create the illusion of DEPTH on a two-dimensional surface. In drawing out the ideas or concepts we ENVISION, we can more effectively design and plan for what does not yet exist except in the mind's eye. Finally, the act of drawing itself is seen as SPECULATION, a true design process which has distinguishing characteristics common to any creative endeavor.

The goal is to provide an illustrated guide for anyone interested in using drawing as a tool for thought and communication. In its purest form, drawing is accomplished freehand, without the aid of mechanical devices. The emphasis is therefore on freehand drawing with simple tools as the most direct and intuitive way to express our visual thoughts and perceptions. Just as we learned to write, freehand drawing skills are acquired and developed by doing. This requires not innate talent nor the fanciest of tools, but rather time, patience, and the willingness to practice and persevere. Most important is understanding the way perceptive seeing and visual thinking are brought together in the creative process of drawing.

CONTENTS

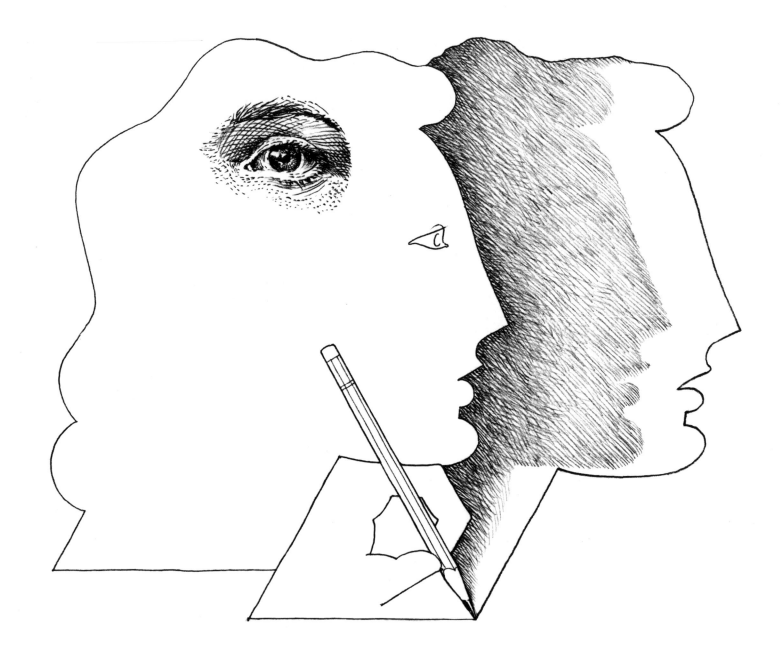

8

DRAWING
PROCESS AND PRODUCT

To draw is to make marks on a surface which graphically represent the likeness of something. This process of transcribing images is a simple, yet powerful human act of visual expression. While it is firmly rooted in our ability to see, drawing can never recreate the reality we see; it can only make visible our perceptions of that outer reality and the inner visions of the mind's eye. In the process of drawing, we create a separate reality which parallels our experiences. Such graphic representations are a vital means of recording our observations, giving form to what we visualize, and communicating our thoughts and conceptions.

THE DRAWING PROCESS

At the heart of all drawing is an interactive process of seeing, visualizing, and expressing images. The images we see give rise to our discovery of the world; the images we visualize enable us to think in visual terms and to understand what we see; the images we draw allow us to express and communicate our thoughts and perceptions.

SEEING

Vision is the primary sensory channel through which we make contact with our external world. It is our best-developed sense, the furthest reaching, and the one we rely on the most for our day-to-day activities. Further, our ability to see provides us with the raw material for our perceptions and ultimately for what we draw.

VISUALIZING

The visual data received by the eye is processed, manipulated, and filtered by the mind in its active search for structure and meaning. The mind's eye creates the images we see, and these are the images we attempt to draw. Drawing is therefore more than a manual skill; it is a visual thought process which depends on our ability not only to see but also to visualize.

EXPRESSING

In drawing, we make marks on a surface in an attempt to graphically represent our perception and understanding of the outer reality we see and the inner imagery of the mind's eye. Drawing thus is a vital means of expression and a natural response to what we see and visualize. It creates a separate world of images which speak to the eye.

A drawn image becomes part of our visual world, and any power it has to express and to communicate relies on our ability to see its graphic resemblance to what we know and understand. The clarity of its message and the significance of its meaning depends on our ability to look into the image, read its strokes, and discern the pattern and relationships they establish.

SEEING

The act of seeing is a dynamic and creative process. It is capable of delivering a stable, thee-dimensional perception of the moving, changing images which make up our visual world. This swift and sophisticated processing of images begins when our eyes receive energy input in the form of visible light — either its source or its reflection from illuminated surfaces.

VISUAL PERCEPTION

The optics of the eye form an upside-down image of incoming light rays on the retina, a collection of nerve cells which are an extension of the brain. These photosensitive cells provide a point-by-point assessment of the intensity of light received. This input is further processed by other nerve cells in the retina and moves down the optic nerve to the visual cortex of the brain, where cells extract specific features of the visual input: the location and orientation of edges, movement, size, and color.

Only a very small area of the retina is capable of distinguishing fine detail. Our eyes must therefore continually scan an object and its environment to see it in its entirety. When we look at something, what we see is actually constructed from a rapid succession of interconnected retinal images. Our visual system thus does more than passively and mechanically record the physical features of a visual stimulus. It actively transforms basic sense impressions of light into meaningful forms. It creates visual perception.

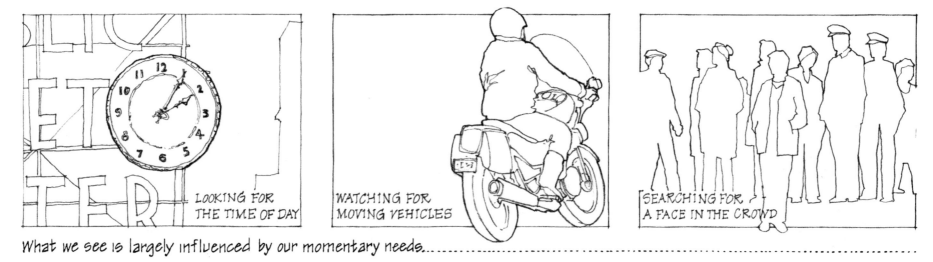

LOOKING FOR THE TIME OF DAY

WATCHING FOR MOVING VEHICLES

SEARCHING FOR A FACE IN THE CROWD

What we see is largely influenced by our momentary needs.

SEEING IS SELECTIVE

We do not see all that we are capable of seeing. We usually perceive our world according to preconceived notions of what we expect or believe to be out there. These perceptual prejudices make our life simpler and safer. We do not have to pay full attention to each and every visual stimulus as if seeing it for the first time each day. Instead, we can select out only those which provide information pertinent to our momentary needs. This expeditious kind of seeing leads, however, to our common use of labels, stereotypical images, and visual cliches.

SEEING FROM DIFFERENT VIEWPOINTS

We all do not necessarily see the same thing. The picture in our head is limited by our interests and what we know. There may well be different ways of perceiving the same visual stimuli according to the kind of information each of us brings to the act of seeing. Our cultural environment and the visual experiences of our lifetime also modify our perceptions and teach us how to interpret what we see.

• A botanist, a painter, and a florist will each see a bouquet of flowers in a different light.

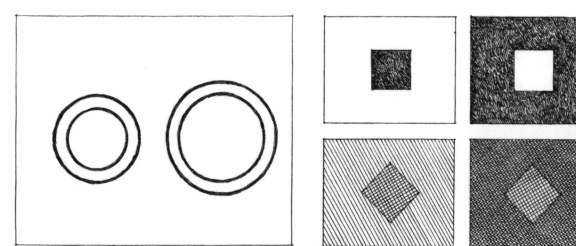

- Certain configurations of lines and shapes can lead to an ambiguous interpretation of form, as in the case of equivocal figures.

- At times, what we perceive does not match what actually exists, as when adjacent shapes, hues, or tonal values affect each other's perceived qualities.

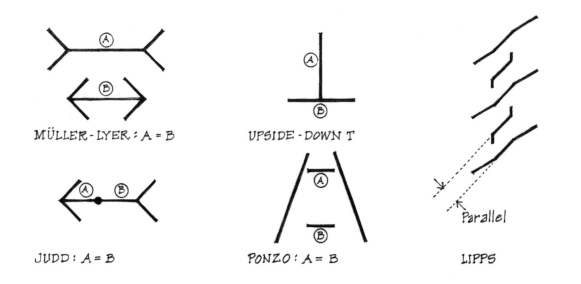

MÜLLER-LYER: A = B

JUDD: A = B

UPSIDE-DOWN T

PONZO: A = B

Parallel

LIPPS

SEEING IN CONTEXT

There is not always a strict correspondence between what we see and what we believe we see. The local environment of an object, as well as its relationship to other objects in space, can influence how we perceive its visual characteristics of size, shape, color, and texture.

- In the case of optical illusions, certain configurations of lines can fool the mind's eye into misperceptions of length, curvature, and direction.

VISUALIZING

Despite its imperfections, sight is still the most important sense for gathering information about our world. In looking at an object, our vision allows us to reach out through space and trace its contours, scan its surface, feel its texture, and explore its environment. More importantly, vision engenders the visual thought that enables us to transform mere discovery into understanding.

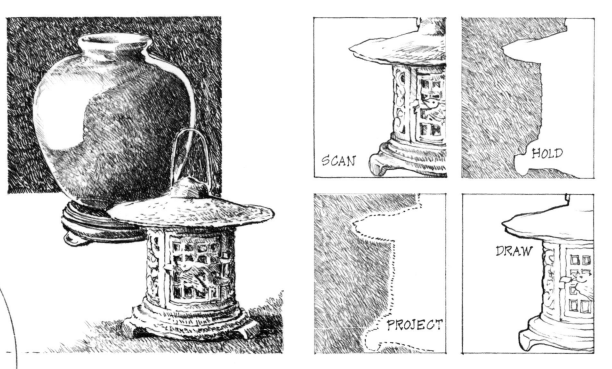

SCAN HOLD

PROJECT DRAW

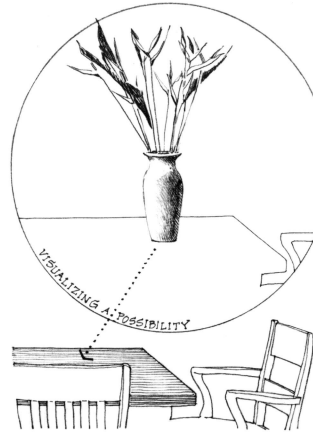

VISUALIZING A POSSIBILITY

SEEING WITH THE MIND'S EYE

Visual thought allows us to abstract, analyze, and synthesize the images we see. It is an essential part of our everyday life. We think in images when we drive down a street looking for an address, search for a missing piece of paper on a crowded desktop, or set the table for a dinner party. In each of these activities, we attempt to match the images we see with the images we hold in the mind's eye. We also think in visual terms when we draw.

We do not simply draw what we see. We draw our perceptions of what we have seen. In drawing what is before us, we scan contours, shapes, and surfaces. In turning our gaze from this image to the drawing surface, we must hold that image in memory before making marks which represent that image. As we continue to draw, we cycle through a process of scanning the subject, holding its image in the mind, and drawing. The images we see in reality and the ones we create on paper are brought together in the images we hold in the mind's eye.

SHAPE

PROPORTION

DRAWING HELPS SHARPEN OUR PERCEPTION OF:

STRUCTURE

DETAILS

The quality of a drawing, therefore, has as much to do with the accuracy of our visual perceptions and memory as the skill of the hand in transcribing an image onto a surface. If we see clearly, we are better able to retain and implant the image we are seeking firmly in our mind, and we are thus able to draw more convincingly. As a drawing emerges on paper, it reveals what we have seen and how we have perceived it. The drawn image becomes a separate reality with a life of its own which feeds back into the mind and becomes part of our visual memory.

So while drawing benefits from skill in visual perception and thought, the converse is also true. In attempting to represent the images we see, the process of drawing stimulates our seeing, exercises our visual perception, and helps us overcome the unseeing glances which we are accustomed to using in our everyday lives. Just as significantly, drawing enhances our ability to retain visual images in memory.

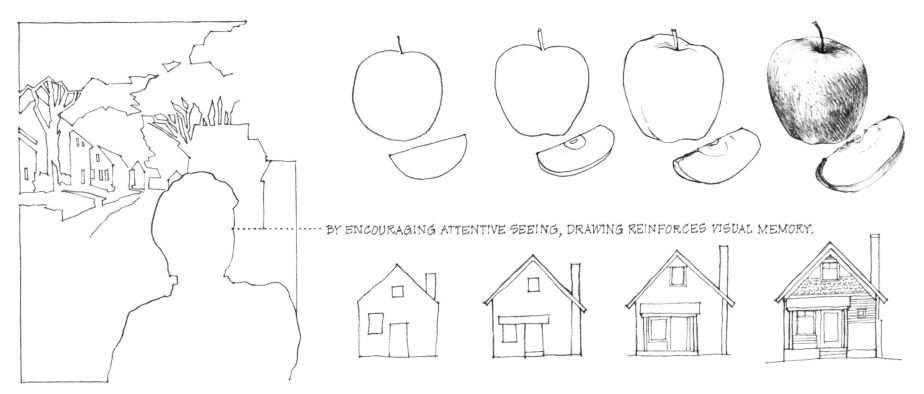

BY ENCOURAGING ATTENTIVE SEEING, DRAWING REINFORCES VISUAL MEMORY.

DRAWING FROM MEMORY

We use short-term memory when drawing what we see before us. The images in our head, however, are not limited to what we see in the present. The mind's eye has the unique ability to transcend time and space. It can transport us to other places and present to us images from the past which were once seen and are now held only in memory. If we can recall and project these visual memories onto a drawing surface, we can draw from reflection on our past experiences.

When we draw from memory, we are not guided by the optical reality we see before us, but rather by the quality of the images we hold in memory. Long-term memory tends to strip from the remembered image what is unnecessary for our present needs. Drawing from long-term memory therefore tends to emphasize the essence of things and what we know about them rather than what was once seen. To improve our visual memory and enhance our ability to retain images for later recall, we must learn to see attentively and practice drawing what we see.

DRAWING BEYOND THE PRESENT

The mind's eye can also present to us images of an inner reality and enable us to draw projections of an imagined future. If we can recall visual memories, we can abstract and analyze them, see them in a new light, combine them in new ways, apply them to new situations, and transform them into new ideas. Thus we can draw what cannot yet be seen except in the mind's eye, and we can use these drawings to simulate and communicate design possibilities for the future.

When drawing what we envision, we are not limited to the perspective views of optical reality. We often draw from an understanding of what we envision, which can be expressed in other ways. In drawing these visualizations, we project the image in our head onto the drawing surface. As this image drives our search on paper, the emerging drawing simultaneously tempers the image in our head. Further thoughts come to mind and are integrated into the process of visualization and drawing.

DRAWING STUDIES BY LEONARDO DA VINCI

EXPRESSING

Drawing is the simplest and most direct way of expressing our visual thoughts and perceptions. In drawing, we pull or drag a tool across a receptive surface. The moving point of the tool leaves traces of lines which correspond in shape and structure to the forms we perceive in reality or see in the mind's eye. There lies beneath the visible lines of a drawing implied patterns of movement. In the normal act of visual perception, we can read these patterns and what they represent.

SHAPE AND FORM

FORM AND SPACE

Once a line is drawn, it exists as a static element, fixed in space, but the kinetic nature of its creation continues to reveal itself to the eye. A line not only describes shape and structure, but also expresses the pace, rhythm, and cadence with which it was drawn. It can be bold or delicate; it can swell or taper as it rises and falls; it can be dense or lightly textured as it skips across a textured surface. We can read into these qualities the skill of the hand and the intent of the maker.

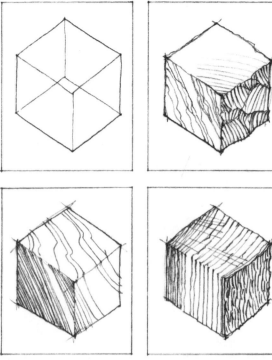

DENSITY AND TEXTURE

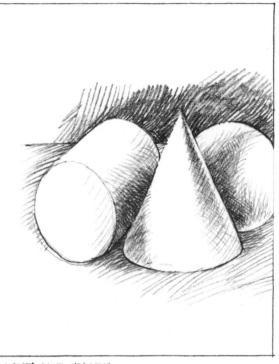

LIGHT AND SHADE

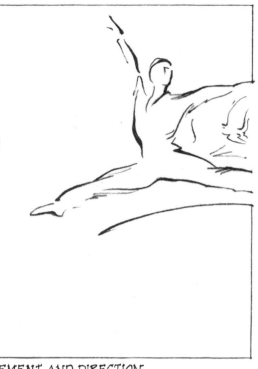

MOVEMENT AND DIRECTION

THE EXPRESSIVE QUALITIES OF LINES

The visual characteristics of a drawn line also have the power of suggestion. They afford a drawing the unique ability to express certain qualities without having a true similarity to the subject it describes. In describing form, a drawn line can also express qualities of weight, density, and surface; in describing space, a line can reveal definition and scale; in describing light, a line can reflect intensity and dispersion; in describing movement, a line can depict pace and rhythm.

This is the special charm of a freehand drawing which distinguishes it from mechanical drafting and computer-generated images. It expresses and reveals to the seeing eye, in the quality of its lines and the underlying pattern of movement used to create it, a visual-tactile experience. The point of the tool is merely an extension of the hand that guides it, and the mind's eye that directs it, in moving across a surface and delineating a unique and personal vision.

PENCIL

Pen and Ink

MARKER

Charcoal

Crayon

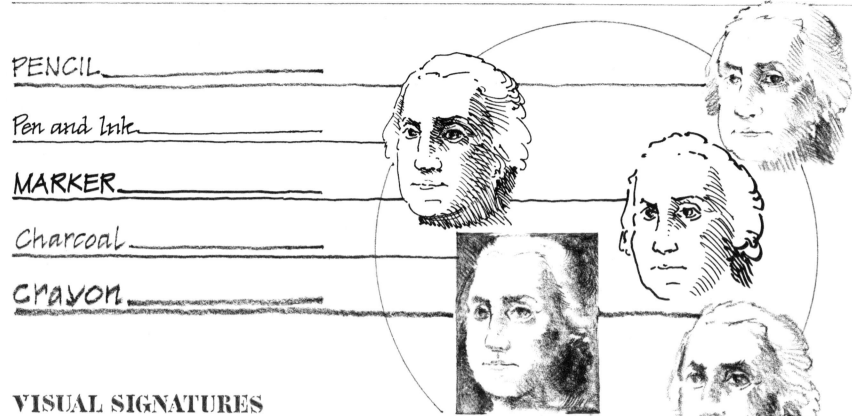

VISUAL SIGNATURES

Drawing requires the simplest of materials — a tool for making marks and a surface for receiving the marks. One can easily draw by dragging a stick through the sand, or by running a finger across a frosted window pane. For a more durable image, there is a wide variety of drawing instruments available. Each has a characteristic feel in the hand, and when drawn across a particular surface, each is capable of making marks with certain visual signatures.

There are two broad categories of drawing media — dry and wet. Dry media, such as graphite and charcoal, are responsive to pressure and the texture of the drawing surface, and capable of a variable line tone and width. Wet media, such as pen and ink or markers, are capable of a more free and fluid line, of constant opacity and varying primarily in width. The following discussion will focus on representative tools of each type — the pencil and the pen. Both are familiar, versatile, and responsive to the demands of a variety of drawing techniques and activities.

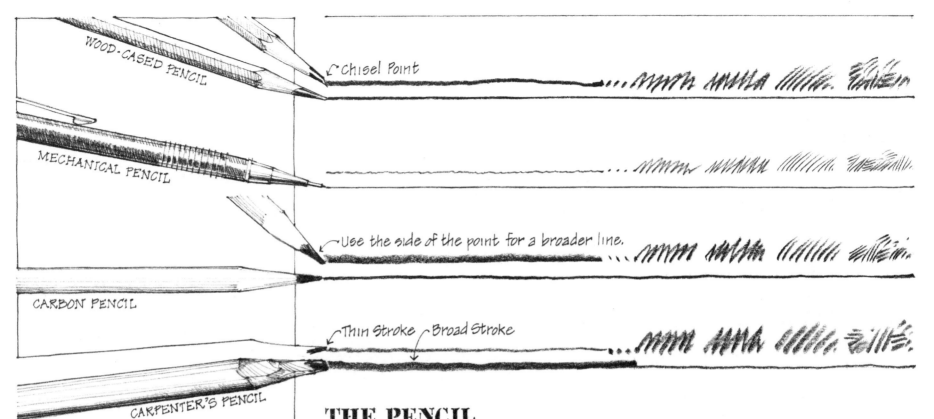

WOOD-CASED PENCIL

↳Chisel Point

MECHANICAL PENCIL

↳Use the side of the point for a broader line.

CARBON PENCIL

↳Thin Stroke ↳Broad Stroke

CARPENTER'S PENCIL

THE PENCIL

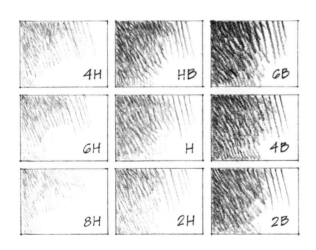

4H	HB	6B
6H	H	4B
8H	2H	2B

Wood-cased pencils are inexpensive, capable of a variety of strokes, and can be used to blend and shade as well. While a common № 2 pencil is certainly suitable. for drawing, the graphite in drawing pencils is of better quality and available in a wider range of grades, from 9H (very hard) through F and HB (medium) to 6B (very soft). The harder grades of lead can produce fine, light lines, while the softer leads can render dense, dark lines and tones. For most freehand drawing, HB, B, and 2B are useful grades.

Mechanical leadholders are designed to hold individual lengths of lead which are available in a full range of hardness and thickness. The thinner leads do not require sharpening as do the thicker leads but they can snap easily if applied with too much pressure.

Carbon and ebony pencils have thick, soft, black leads whose bold strokes are conducive to quick, expressive sketches. Carpenter pencils are similar but with their rectangular leads, one can produce a variety of stroke widths.

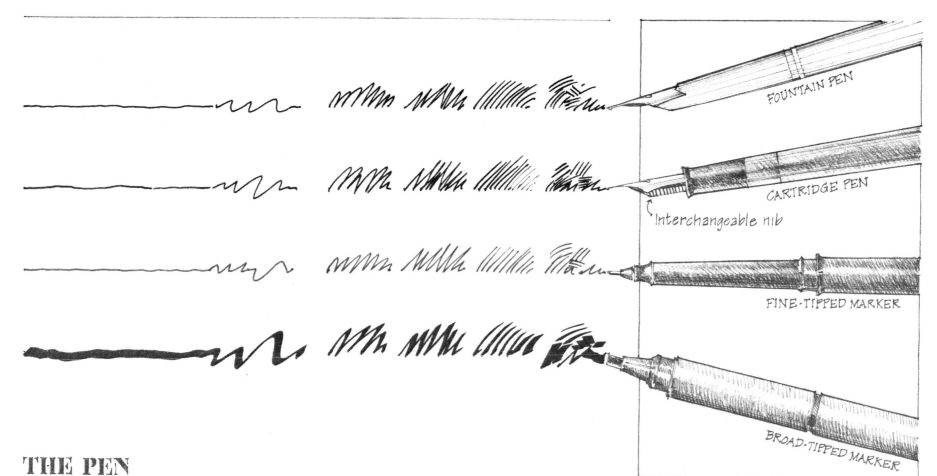

FOUNTAIN PEN

CARTRIDGE PEN

Interchangeable nib

FINE-TIPPED MARKER

BROAD-TIPPED MARKER

THE PEN

Pens are capable of producing fluid, opaque, and permanent lines. There are several types which are suitable for drawing. Felt, fiber, or nylon tip markers come in a variety of sizes and tips. Fine-tip markers can make sharp, incisive lines which lead to precise, detailed drawings. Broad-tip markers encourage bolder lines and quick visualizations with the omission of detail.

Fountain pens have a smoother, firmer feel. A convenient type utilizes ink cartridges and can accept a variety of interchangeable nibs. Writing nibs have a firm, rounded tip which can move easily in all directions. Drawing points have more flexibility and thus can produce lines of varying thickness in response to the pressure one applies while drawing.

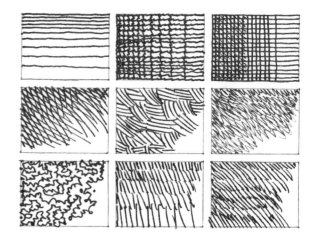

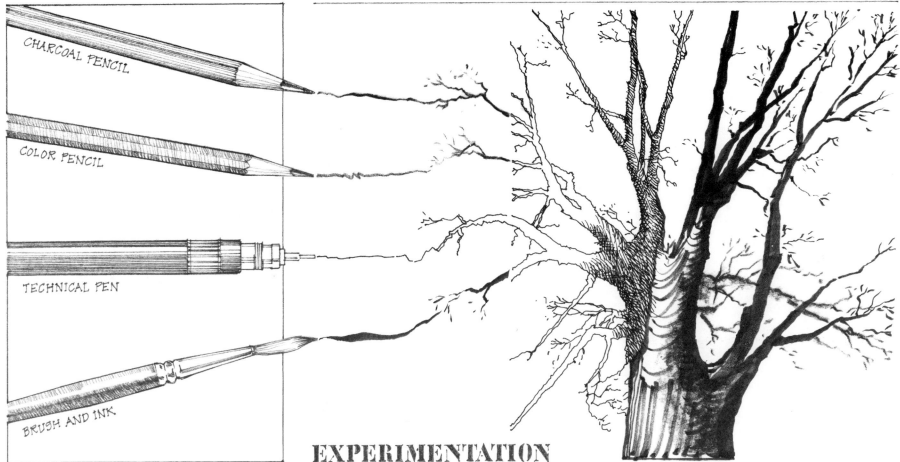

CHARCOAL PENCIL

COLOR PENCIL

TECHNICAL PEN

BRUSH AND INK

EXPERIMENTATION

You will have to discover for yourself the feel and capabilities of each tool and its suitability for your own purposes. Only through direct experimentation can you know for sure what words and illustrations attempt to describe. Experience is the best teacher since the characteristic mark of each tool is transformed by one's sense of touch and the particular cadence of one's stroke.

Through experimentation, you should come to know the chromatic values of color pencils; the tonal values of charcoal sticks; the fine texture of conte' crayon; the dense, glossy lines of wax crayons; the soft, grainy feel of pastels. In a similar manner, working with wet media, you can discover the precision of technical drafting pens and the fluid, painterly strokes of a brush dipped in ink.

COMMUNICATING

In expressing what we see or envision, a drawing has the ability to initiate a visual message. What it communicates will depend on how we, in the normal act of visual perception, read the drawing's lines and interpret the underlying patterns of shapes and structure.

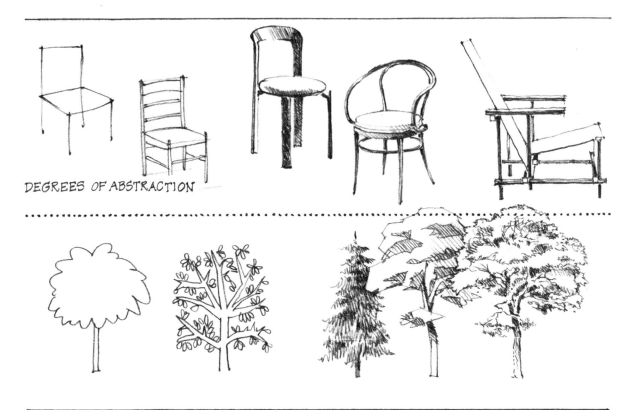

DEGREES OF ABSTRACTION

SUBJECT MATTER

A drawing represents and communicates what we see or envision by calling to mind analogous forms from the immediate or distant past. The forms it depicts must therefore have a graphic similarity or resemblance to what it represents, be it an object, a place, or a visual idea.

A drawing of something is never that thing. It produces at best a structural equivalent, not a mechanical reproduction of reality, no matter how real it may seem. Whether a drawing refers to a specific thing or simply to a general class of things depends on certain visual clues which the viewer can understand — significant details, meaningful context, a recognizable point of view.

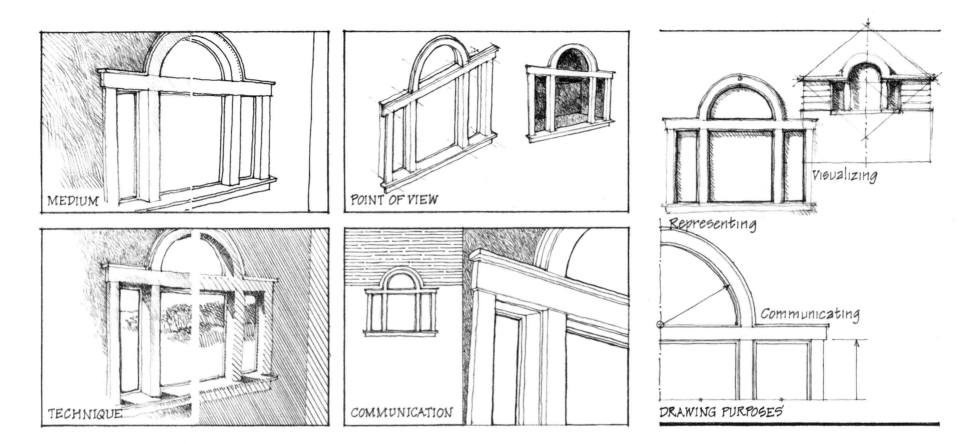

MEDIUM

POINT OF VIEW

Visualizing

Representing

TECHNIQUE

COMMUNICATION

Communicating

DRAWING PURPOSES

GRAPHIC TREATMENT

What gives a drawing meaning is not simply the topic. Its graphic treatment is also part of the message. How something is seen, what medium is used to express that vision, what techniques are employed to crystallize the image, how that image is composed and viewed in context — all of these aspects qualify our perception and understanding of what is drawn.

We make important choices, therefore, in selecting a point of view, using a certain tool or medium, and employing graphic techniques. These choices should be based ultimately on the purpose of a drawing, whether it is to represent what we see, to cultivate visual thought, or to convey graphic information and ideas.

DRAWING AS REPRESENTATION

With representational drawing, we seek to accurately record what we see in reality. The drawing of things we see before us, including the careful copying of a master's work, has traditionally been fundamental training for artists and designers. In this respect, drawing is not simply a skill but an essential discipline which trains the eye, the mind, and the hand in accurate seeing, correct perception, and the making of legible representations.

Representational drawing can also effectively record our observations for others to see and study. There are numerous examples of drawings being used in both the sciences and the arts to illustrate and clarify visual information from the world around us. These reflect not only the skill of the hand, but also the specific interests, perceptions, and understanding of the illustrator.

Unlike photographic snapshots, drawn illustrations can be selective in their viewpoint. In drawing, we have the unique ability to isolate information from irrelevant context and to focus attention on specific features or qualities. With analytical thought and insight, we can capture the essence of something and distinguish it from what it is not. We can note significant details and how they fit into an overall pattern.

CAPITOLI·ROMANI·VERA·IMAGO·VT·NVNC·EST·

DRAWINGS BASED
ON TRAVEL SKETCHES
BY LE CORBUSIER

CHINESE
NOTCHED-STICK
PUZZLE

The act of drawing and the careful seeing it requires can also enhance our understanding of things. By drawing something out, we are better able to understand visual concepts, underlying structural patterns, significant relationships, schematic organizations, and whatever else we cannot see except in the mind's eye.

Drawing also improves our visual memory and aids in the recall of past perceptions. The process of putting our visual perceptions down on paper leaves a map of our impressions, which can remind us of how something was seen and interpreted. It impresses images of what was memorable on our memory.

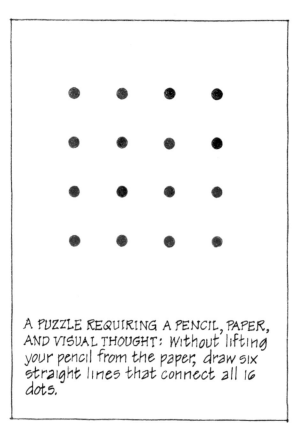

A PUZZLE REQUIRING A PENCIL, PAPER, AND VISUAL THOUGHT: Without lifting your pencil from the paper, draw six straight lines that connect all 16 dots.

Study for an animation sequence

Studies for *Guernica*, 1937 (After Pablo Picasso)

DRAWING AS VISUALIZATION

Visual thinking pervades all human activity. We think in visual terms when we rearrange the furniture in a room, contemplate a move in the game of chess, or plan a car trip on a map. Visual thinking is the essential complement to verbal thought in cultivating insights, seeing possibilities, making discoveries, and imagining the consequences of our actions. Toward these ends, drawing can give form to and clarify our visual thoughts.

An artist studying various compositions for a painting, a choreographer orchestrating a dance sequence for the stage, and an architect integrating the systems of a building — all use drawings in this manner to express what the mind visualizes and to explore possible future courses of action.

This type of exploratory drawing is part of the creative process and often open-ended. It can be used effectively to find one's way about things and to simulate and experience certain tryouts and attempts. It can make visible those relationships which cannot ordinarily be seen by the eye but which are central to the establishment of shape, form, and structure.

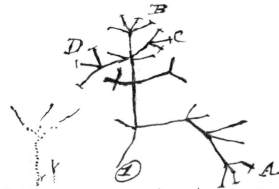

Tree diagrams representing ideas about biological evolution. (After Charles Darwin)

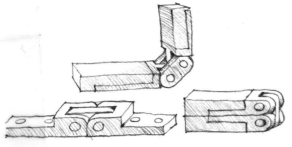

Design study of dismountable hinges, c. 1500 (After Leonardo DaVinci)

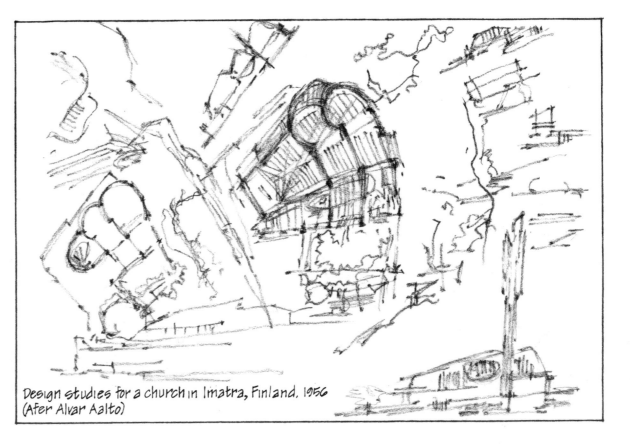

Design studies for a church in Imatra, Finland, 1956 (Afer Alvar Aalto)

Both the process of drawing and the drawn images themselves can stimulate the imagination, further promote the visual thought process, and encourage a metaphoric way of thinking. Drawing often allows us to see other things in what we draw, which can lead to other possibilities. A series of exploratory drawings, even though done in sequence, can be seen side by side and used to compare alternatives and generate new ideas.

The degree of finish and technique for exploratory drawings varies with the nature of the problem and one's individual way of working. These drawings, however, are usually quick, informal, and often personal. While not intended for public display, they can provide valuable insights into an individual's creative process.

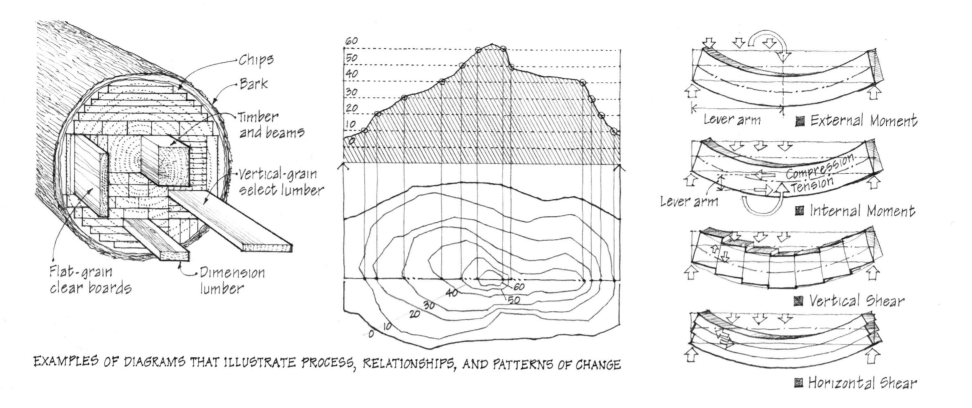

Chips
Bark
Timber and beams
Vertical-grain select lumber
Flat-grain clear boards
Dimension lumber

Lever arm ▨ External Moment

Compression
Tension
Lever arm ▨ Internal Moment

▨ Vertical Shear

▨ Horizontal Shear

EXAMPLES OF DIAGRAMS THAT ILLUSTRATE PROCESS, RELATIONSHIPS, AND PATTERNS OF CHANGE

DRAWING AS COMMUNICATION

All drawings communicate. Representational drawings render likenesses of things for others to see and understand. Exploratory drawings give visible form to one's ideas for others to consider. Still other drawings are used explicitly to transmit a message or to convey information.

Drawings are by nature information-rich. It would be difficult to adequately describe with words what a drawing is able to communicate at a glance. Any drawing used to communicate must therefore have clarity, be explicit, and utilize conventions which are understood by both presenter and receiver.

One of the more common forms of graphic communication is the diagram—a simplified drawing which can illustrate a process, a set of relationships, or a pattern of change or growth. Diagrams often utilize symbols and icons which must have a graphic quality that reminds us of what they represent.

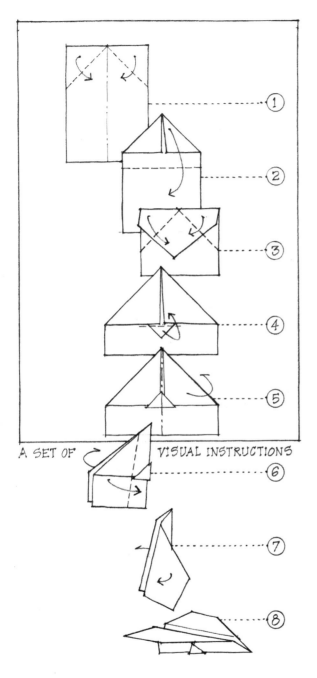

A SET OF VISUAL INSTRUCTIONS

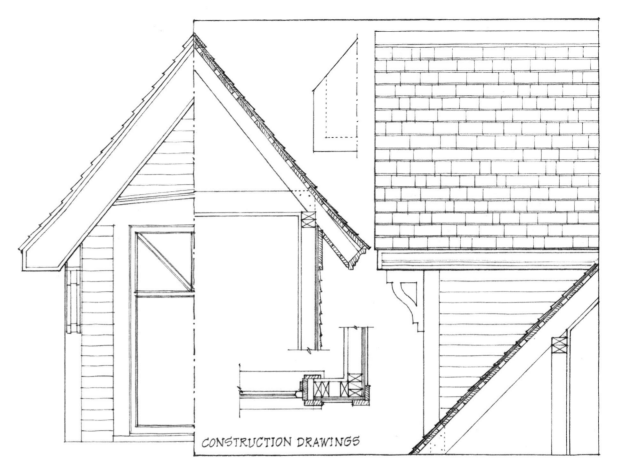

CONSTRUCTION DRAWINGS

Another type of graphic communication is the presentation drawing, which offers a design proposal to others for their review and evaluation. To be effective, presentation drawings must assist the imagination of others, accurately simulate a possible reality, and illustrate the consequences of future events.

More utilitarian forms of graphic communication include design patterns, working drawings, and technical illustrations. These are specific sets of visual instructions which guide others in the construction of a design or the transformation of an idea into reality.

34

LINE
THE ESSENCE OF DRAWING

<div style="text-align:right">2</div>

A line can be conceived as a one-dimensional element characterized by its length, but having no width or depth. Such a line does not actually exist in reality. Yet our vision perceives as lines the contours created by discontinuities in plane, surface, color, or texture. In drawing the images we see or envision, we rely primarily on lines to visually communicate shape and form. The line therefore exists as the quintessential graphic element of drawing.

" Point – rest.
Line – inwardly animated tension created by movement.
The two elements – their intermingling and their combinations – develop their own 'language' which cannot be attained with words. "

<div style="text-align:right">

Point and Line to Plane
Wassily Kandinsky

</div>

LINE

We use gestures to point, give direction, and to describe shape and movement. Drawing is a direct extension of these gestures. The kinetic impulses behind our gestures move down the arm to the hand that guides the moving point of a tool. The resulting linear marks are both intuitive and flexible in their ability to describe the contours which dominate our visual world.

CONTOUR LINES

The line is a graphic convention which we accept since we perceive all contours as lines of contrast. These contrasts are the discontinuities we see in plane, surface, color, or texture. Just as these lines are critical to our perception of the visible world, they are essential in representing what we see or envision in a drawing.

Contour lines first serve to separate one thing from another. In limiting and defining the edges of things, contour lines also describe their shape. If seen as flat, the resulting images are simply two-dimensional silhouettes. When used in combination, however, contour lines can begin to describe three-dimensional form.

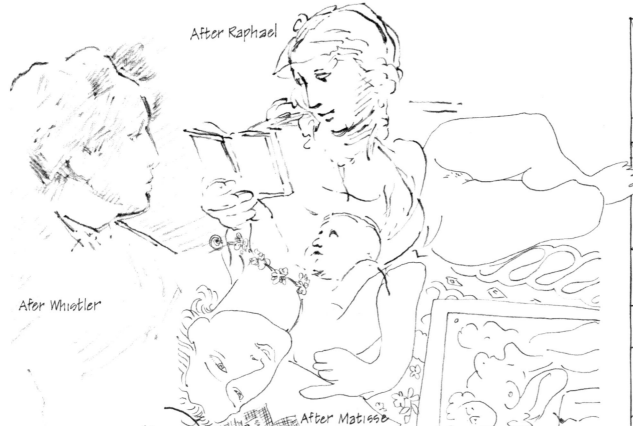

After Raphael

After Whistler

After Matisse

After Beardsley

EXPRESSIVE LINES

Lines have visual qualities of shape, tone, texture, direction, and movement, which enable them to express qualities of form and space. Used in series, lines can describe the tonal and textural values of surfaces. As purely graphic elements, lines can also become stylized and form decorative patterns with a life of their own.

REGULATING LINES

In a drawing, there may also exist lines whose presence is felt but not seen. In drawing what we see before us, we develop these regulating lines in order to explore, give measure to, and structure our perceptions. In drawing what we envision, we use this same type of structural lines as a framework on which we can develop the image seen in the mind's eye.

DRAWING LINES

Drawing requires the same eye-mind-hand coordination as that required for writing words on paper. And like writing, it is definitely a skill which can be acquired. For most of us, as children, learning to draw the letters of the alphabet was initially difficult, laborious, and fun. We became proficient at writing because of the repetitions we performed over a long period of time. Now, we are able to transform thoughts into words on paper quickly, almost transparently. So with drawing, practice over an extended period of time is essential.

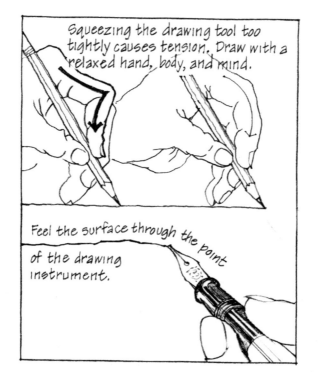

Squeezing the drawing tool too tightly causes tension. Draw with a relaxed hand, body, and mind.

Feel the surface through the point of the drawing instrument.

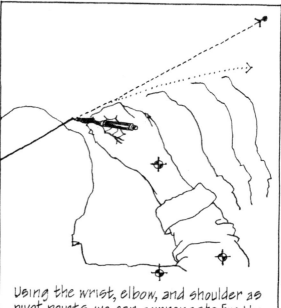

Using the wrist, elbow, and shoulder as pivot points, we can compensate for the natural curvature of long lines.

BEGINNING EXERCISES

Our first goal in learning to draw is to acquire control in drawing lines. The following exercises are intended to help you develop skill and confidence in line drawing. Approach them with a relaxed body and mind. As you draw, become conscious of and sensitive to how you hold the drawing instrument, the pressure with which you mark a surface, and the quality of the drawn mark. Feel the surface texture and the point of the drawing tool as it glides across the surface, leaving a trace of the medium behind it.

Drawing is as much a visual thought process as it is a physical act. We must therefore develop the ability to judge what we draw as we draw it. Draw even, continuous lines, and evaluate each line for its straightness or desired curvature. Drawing too quickly can result in naturally curved lines because we tend to use our arms as pendulums. Compensate by drawing slowly and deliberately. Do not erase or draw over a previously drawn line, but always strive for incremental improvement over the last line drawn.

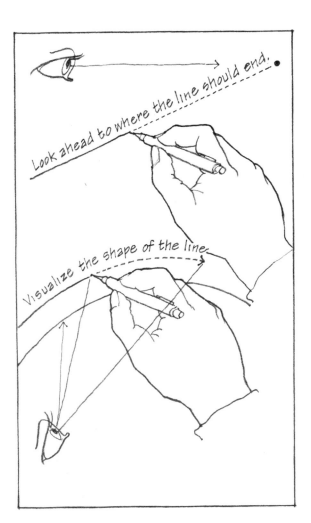

Look ahead to where the line should end.

Visualize the shape of the line.

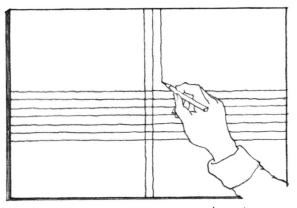

PARALLEL LINES: Draw vertical and horizontal series of parallel lines about 1/2 inch apart from each other. Carefully check each line for straightness and even spacing, and strive to make each line straighter than the last. Use previously drawn lines and the edges of the paper as visual guides.

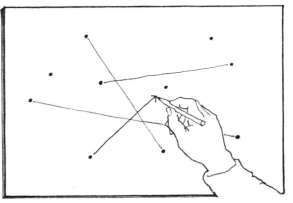

RANDOM LINES: Place ten dots at random on a sheet of paper. Then draw straight lines which connect one point with a more distant one. Draw in all directions without moving your body position relative to the sheet. Do not curve the lines to meet the points. If you miss, try again.

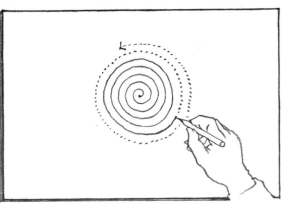

CIRCULAR SPIRALS: From the center point of a sheet of paper, draw a circular spiral. As it spirals outward, the line should remain parallel to the previous ring, with even spacing between each ring. Draw coils both clockwise and counterclockwise.

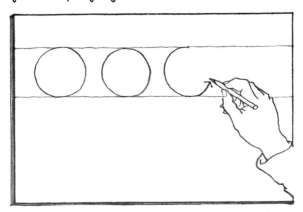

CIRCLES: Practice drawing a row of circles between guidelines 2 to 3 inches apart. Draw with an even, continuous, circular motion so that the curvature of the line is smooth. Avoid elliptical shapes. In a similar manner, draw rows of both smaller and larger circles.

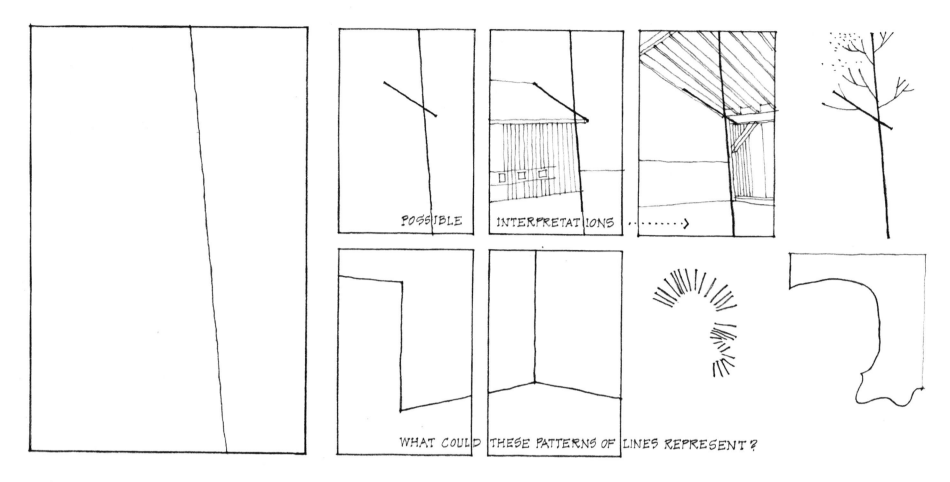

POSSIBLE INTERPRETATIONS ·········>

WHAT COULD THESE PATTERNS OF LINES REPRESENT?

RESPONDING TO DRAWN LINES

The preceding exercises gave you practice in drawing a variety of lines according to a set of instructions. You were first required to visualize according to the verbal directives and then to draw. Now we introduce the idea of drawing in response to lines which already exist.

Before we begin to draw, we face a blank sheet of paper. We overcome the emptiness with the first line we draw. From that point on, we are drawing not only in response to what we envision or see out there, but also to the lines which already exist on paper. As soon as they are drawn, they have a life of their own — a separate reality to which we can respond.

Our visual system seeks patterns that make sense. Thus we tend to complete any pattern which is incomplete according to what we know from past experience. We anticipate as we visualize. Each successive line in a drawing therefore represents a continuing search for the completion of a meaningful pattern.

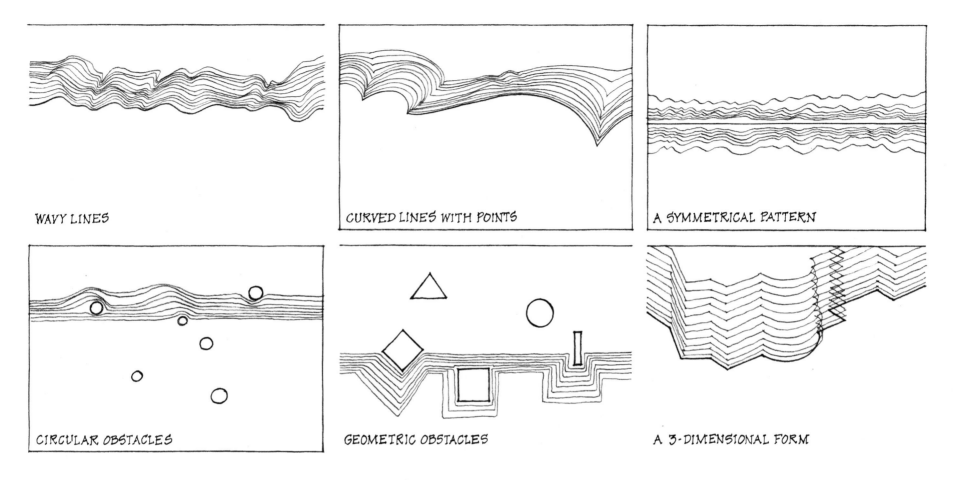

WAVY LINES

CURVED LINES WITH POINTS

A SYMMETRICAL PATTERN

CIRCULAR OBSTACLES

GEOMETRIC OBSTACLES

A 3-DIMENSIONAL FORM

COMPLETING THE IMAGE

In these exercises, the intention is to have you respond to what already exists as partial images, and then complete the images according to your response. Each of us may respond differently, and therefore the images we create may differ. Nevertheless, the practice is in experiencing the interaction of seeing, visualizing, and drawing with lines.

Draw continuous lines from one side of the sheet to the other. Follow the pattern you see established by the existing lines and work around obstacles as you meet them, but try to respond as well to the image as it evolves and transforms itself with each successive line you draw.

As a graphic element, a contour line is a one-dimensional trace on a two-dimensional plane. Yet it is the most efficient graphic means we have in drawing to represent three-dimensional forms in space. A contour line first marks off something from what it is not and gives it shape. But it does more than describe the outline which circumscribes an object. It can also eloquently describe qualities of form.

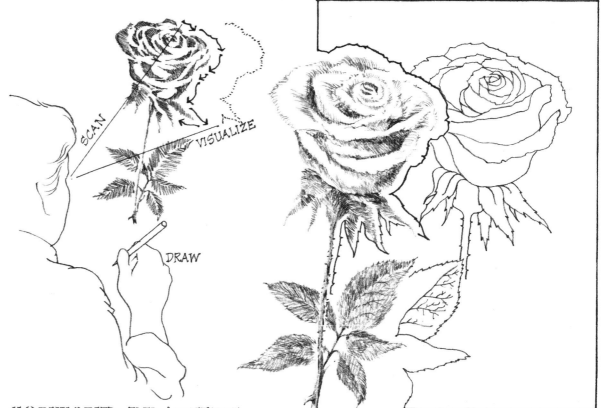

CONTOUR DRAWING

In contour drawing, we draw from observation. We begin by looking carefully at what we see before us. Then we undertake the process of scanning each contour, holding an image of that line, visualizing it on paper, and drawing that contour. The goal is to arrive at an accurate correspondence between the eye, as it follows the contours of a form, and the hand, as it draws the lines which represent those contours.

Contour drawing thus requires accurate observation, sensitivity to qualities of form, and skill in visualizing and drawing lines which graphically represent those qualities. It suppresses the symbolic abstraction we normally use to represent things. Instead, it compels us to utilize our tactile as well as our visual sense, and to see both the whole and its details simultaneously.

Draw as if you were touching each contour with the pen or pencil point.

Respond to each and every modulation of contour line

FOLLOWING THE EYE

Contour drawing is best done with a soft, well-sharpened pencil or a fine felt-tip pen capable of producing a sharp, incisive line. Starting at any convenient point in what we see, begin drawing its contours. Concentrate on having the hand follow the path the eyes take as they trace the undulations and indentations of the edges of a form, breaks in plane, and significant changes in value, texture, and color. Respond to each and every surface modulation with equivalent hand movements.

You may have to stop periodically as you continue to scan the subject, but avoid making these stopping points too conspicuous. Keep the pencil or pen in contact with the paper surface. Draw slowly and deliberately, and imagine the drawing tool is in contact with the subject as you draw. Do not retrace over lines or erase them. Most importantly, do not let the hand move faster than the eye can see; move in pace with the eye and observe carefully.

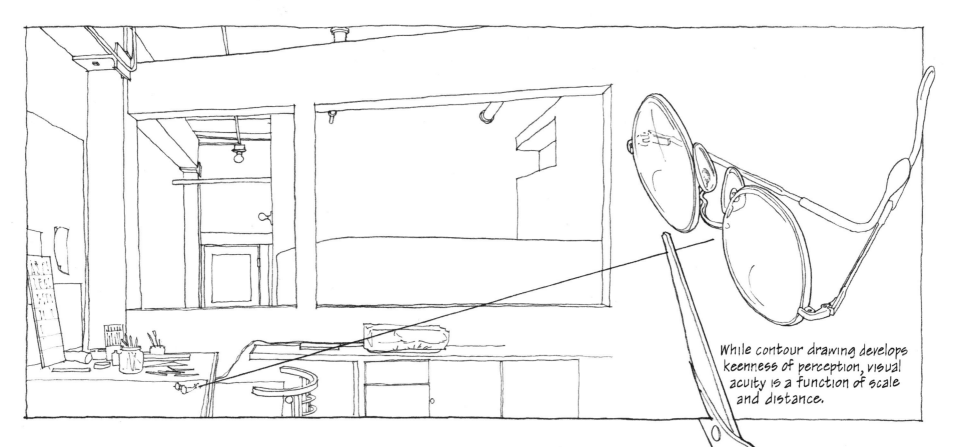

While contour drawing develops keenness of perception, visual acuity is a function of scale and distance.

DEVELOPING VISUAL ACUITY

The slow and deliberate process of contour drawing compels us to see with clarity and accuracy. To draw a convincing representation simply with contour lines, we must understand fully the nature of a form and its qualities of structure and geometry, weight and density, material and texture.

The more deeply we see, of course, the more we will become aware of a form's details— the thickness of its material, how it turns or bends around a corner, how materials meet and are assembled or constructed. When confronted with a myriad of such details, we must judge the relative significance of each detail, and draw only those contours which are absolutely essential for the comprehension and representation of the form.

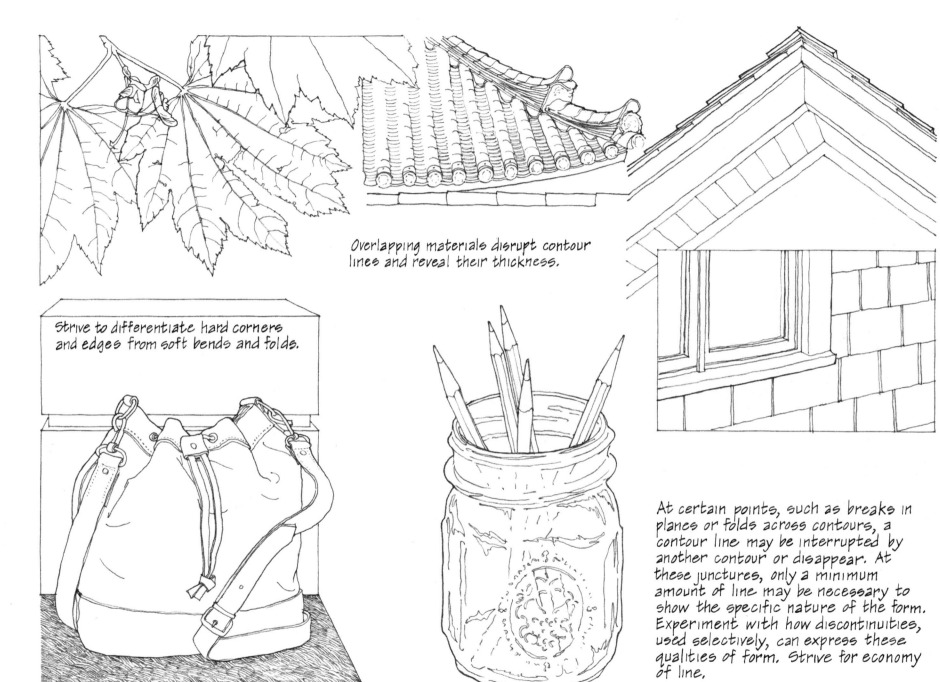

Overlapping materials disrupt contour lines and reveal their thickness.

Strive to differentiate hard corners and edges from soft bends and folds.

At certain points, such as breaks in planes or folds across contours, a contour line may be interrupted by another contour or disappear. At these junctures, only a minimum amount of line may be necessary to show the specific nature of the form. Experiment with how discontinuities, used selectively, can express these qualities of form. Strive for economy of line.

EXPRESSIVE LINES

A single line weight is all that is required for a contour drawing. By virtue of the touch, medium, and surface used to create it, however, a line also has inherent qualities of width, density, texture, continuity, and rhythm. These qualities enable a contour line to be more expressive and communicate a broader range of a form's qualities.

FORM

WEIGHT

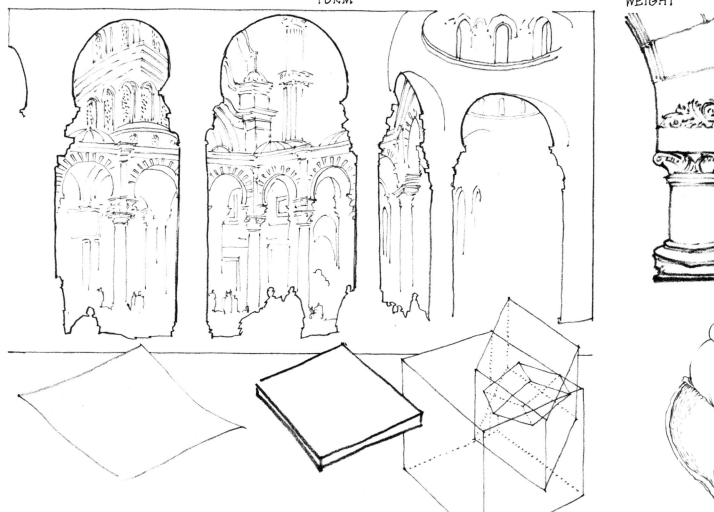

TEXTURE

MATERIAL

LIGHT

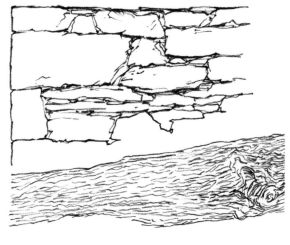

The qualities of form are interrelated. In using line to convey one quality, we necessarily influence the expression and perception of other qualities as well.

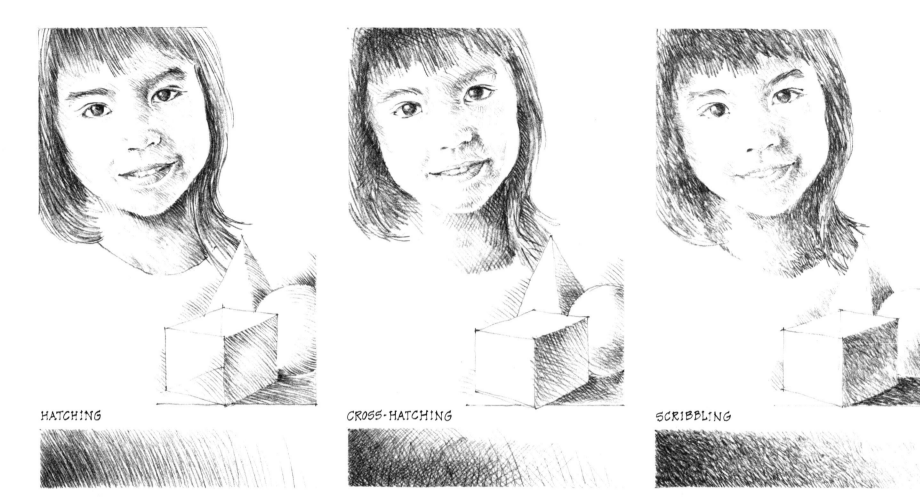

HATCHING

CROSS-HATCHING

SCRIBBLING

MODELING LINES

There are subtleties of form which cannot be rendered with a single contour line. To convey these complexities of form, texture, and material, we can use several types of modeling lines.

Hatching refers to a series of closely spaced parallel lines. Cross-hatching involves layering two sets of hatched lines for greater density and tonal value. Scribbling is a network of more random, multidirectional lines whose visual texture will vary according to the line technique used.

In all cases, one must be conscious of the tonal value being rendered and be careful not to obsure what is essentially a line technique.

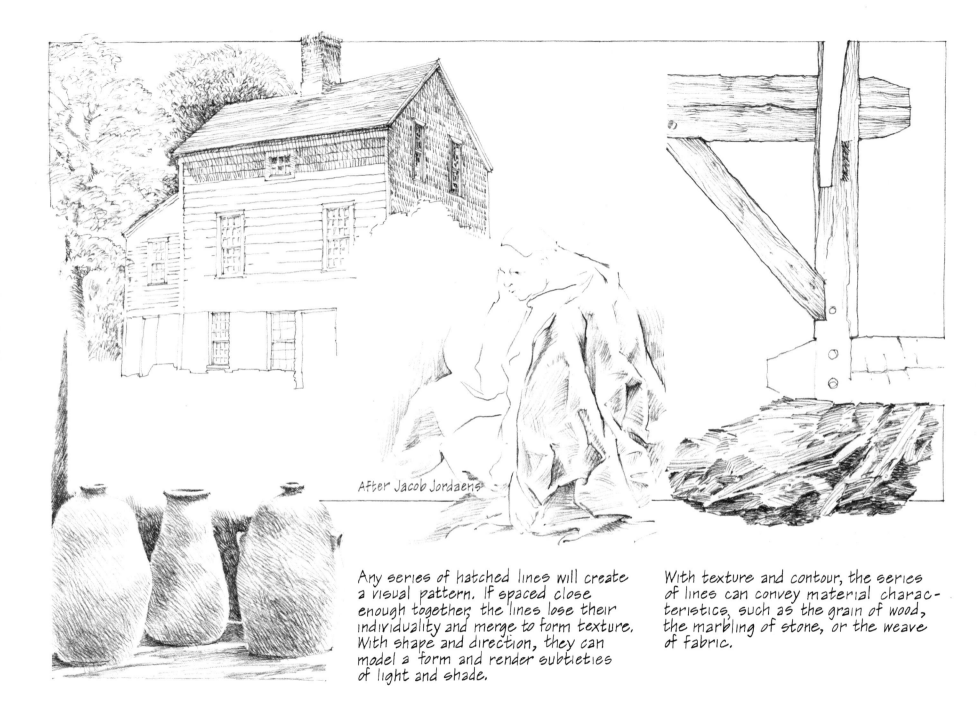

After Jacob Jordaens

Any series of hatched lines will create a visual pattern. If spaced close enough together, the lines lose their individuality and merge to form texture. With shape and direction, they can model a form and render subtleties of light and shade.

With texture and contour, the series of lines can convey material characteristics, such as the grain of wood, the marbling of stone, or the weave of fabric.

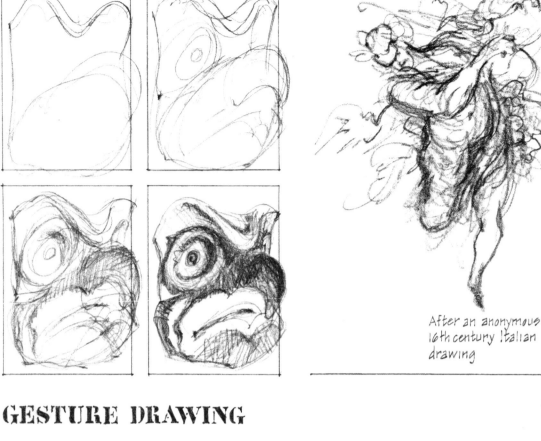

After an anonymous
16th century Italian
drawing

After Edouard Vuillard

After Louis I. Kahn

GESTURE DRAWING

With experience in seeing and fluency in representing the qualities of form, we can proceed from the deliberate nature of contour drawing to the spontaneity of gesture drawing. A single continuous line or a multiplicity of broken lines are drawn freely and quickly across a sheet as we scan a subject and project our perceptions onto paper.

The vital, intuitive nature of gesture drawing requires a unity of seeing, feeling, and drawing. The first lines or gestures we draw usually indicate the overall form, and then significant details are woven into the structure. The lines may follow the contours of the object or run counter to them. Variations in pressure along with the direction of the lines can imply volume. The density of the lines can reveal where we see significant details or what we wish to emphasize.

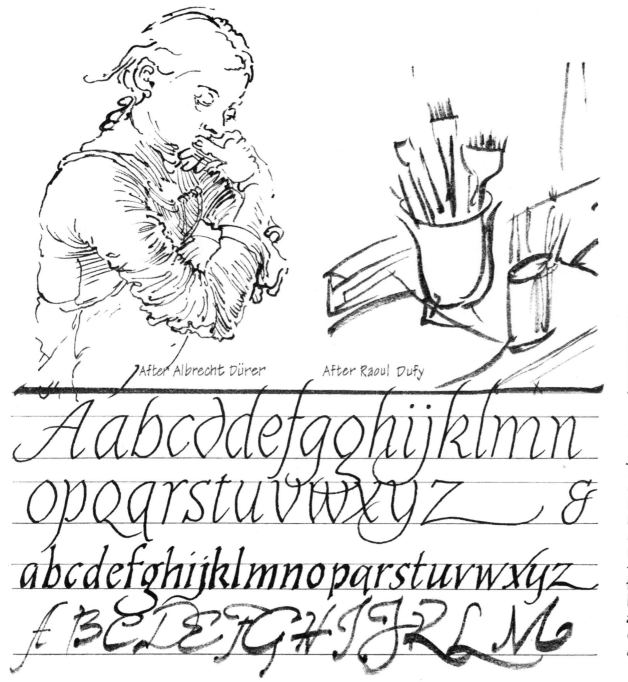

After Albrecht Dürer After Raoul Dufy

After Hokusai

AabcddefgghijklmnopqrstuvwxyzＥ

abcdefghijklmnopqrstuvwxyz

ABCDEFGHIJRLM

CALLIGRAPHIC LINES

The ultimate expression of the line in drawing is calligraphy. Calligraphy refers primarily to elegant handwriting, but the fluent, expressive nature of the linear strokes can also be used in pictorial representation. With a flexible point or a well-pointed brush that responds to the pressure of the hand and the movement of the arm, and a lifetime of experiences, one can express the essential qualities of form in an eloquent manner.

REGULATING LINES

We have seen how lines are able to effectively describe pictorial qualities of form, tonal value, and texture. Lines can also play a more abstract, constructive role in regulating the structural and the spatial relationships of forms in a drawing. Lines are well-suited for this purpose since they naturally and efficiently express length, direction, and movement.

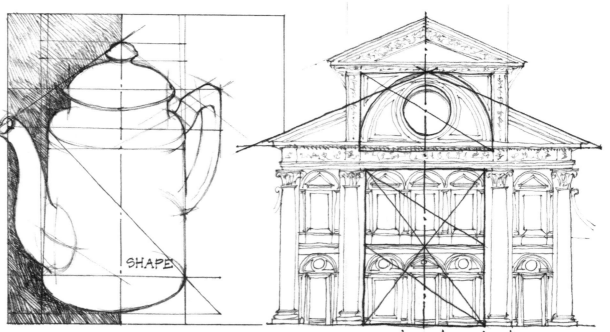

SHAPE

PROPORTION

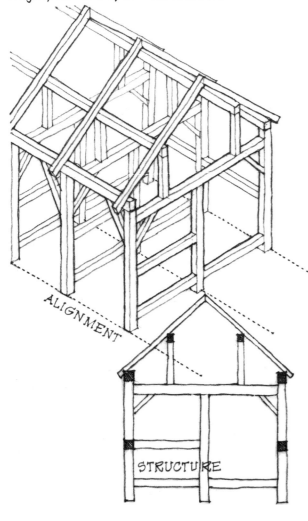

ALIGNMENT

STRUCTURE

STRUCTURAL RELATIONSHIPS

Regulating lines can take measure of the size, shape, and scale of things, and thus control the overall proportional relationships of both forms and spaces. These are straight, transparent lines which are not limited by the boundaries of things. They can cut through forms and extend through space as they link, organize, and give dimension to the various elements of a drawing.

SIZE

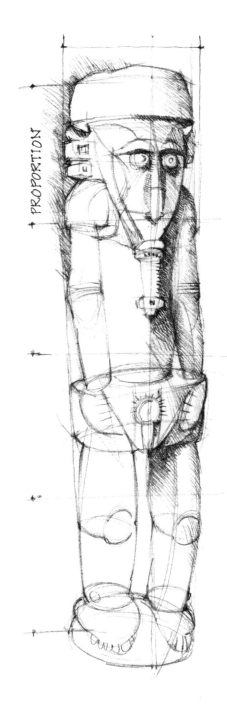

PROPORTION

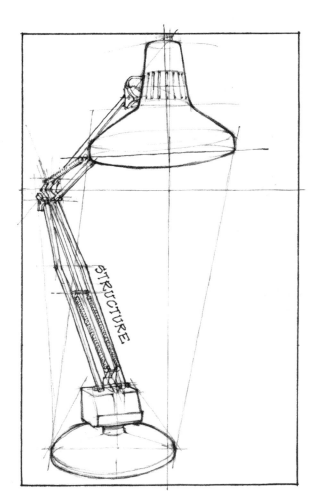

STRUCTURE

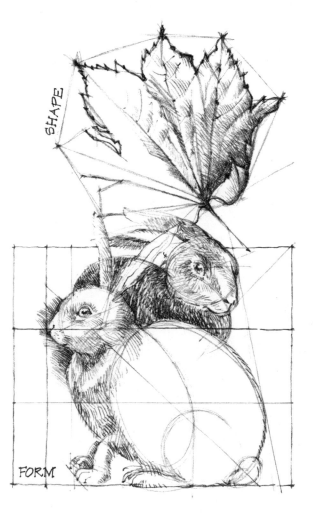

SHAPE

FORM

The easiest visual judgments to make initially are the horizontal and vertical relationships which can measure dimensions, alignments, and offsets. Diagonal and tangential relationships between significant points of a form can then be used to augment and verify these initial judgments.

Regulating lines are often tentative and lightly drawn. They represent visual judgments to be confirmed or adjusted. They can be removed, but they may also remain as part of the final drawing in order to show the working process by which the drawing was made.

ORGANIZING THE DRAWING SURFACE

DEFINING A PATHWAY FOR THE EYE

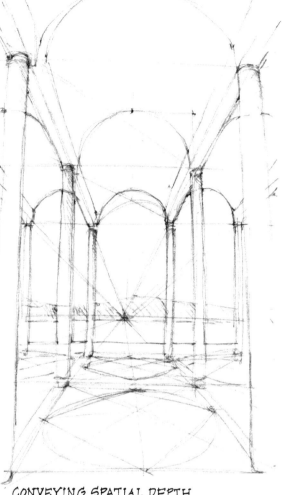

CONVEYING SPATIAL DEPTH

SPATIAL RELATIONSHIPS

Regulating lines can express the spatial relationships among the constituent elements of a drawing composition. These lines may not be visible to the eye, but their presence is felt as they provide a visual framework on which the basic components of a drawing can be shaped and organized.

These regulating lines represent vectors of the perceptual forces which lead the eye as it scans a drawing. They define a structural organization for, and serve as a visible map of, the points of emphasis which must be balanced in any drawing composition.

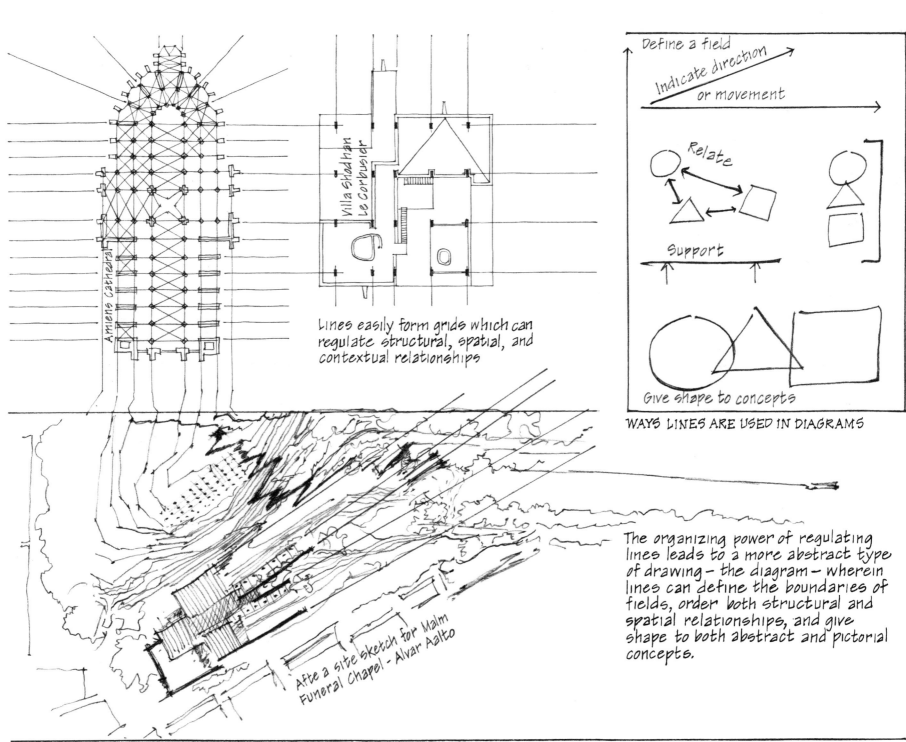

Amiens Cathedral

Villa Shodhan
Le Corbusier

Lines easily form grids which can
regulate structural, spatial, and
contextual relationships

Define a field

Indicate direction

or movement

Relate

Support

Give shape to concepts

WAYS LINES ARE USED IN DIAGRAMS

Afte a site sketch for Malm
Funeral Chapel - Alvar Aalto

The organizing power of regulating
lines leads to a more abstract type
of drawing – the diagram – wherein
lines can define the boundaries of
fields, order both structural and
spatial relationships, and give
shape to both abstract and pictorial
concepts.

SHAPE
THE DEFINITION OF FORM

The role of the line naturally extends from describing the contours of forms to the definition of figures in a visual field. Our perception of the boundary lines which distinguish one thing from another leads to our recognition of shape. It is by shape that we identify, understand, and appreciate the forms which make up our visual world. In drawing, therefore, the pattern of lines that we use to portray objects in real space must, on a two-dimensional surface, convey the shapes of things.

The lines we see in visual space correspond to discernible changes in tonal value, color, texture, and pattern. These lines of contrast, when sharp and distinct enough, enable us to perceive object-forms in space and to distinguish one thing from another.

Separate

Enclose

Define shape

Object-form
Spatial form

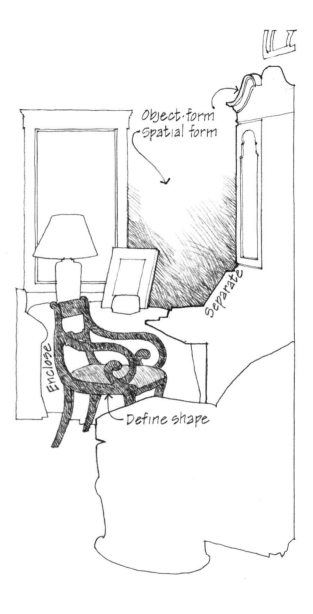

Object-form
Spatial form

Separate

Enclose

Define shape

When we draw, we use visible lines to represent the lines of contrast we perceive. These drawn lines depict in a pictorial way the edges and contours of object- and spatial forms. They enclose a visually perceived area and show where one begins and another apparently ends. In so doing, they give shape to the described areas.

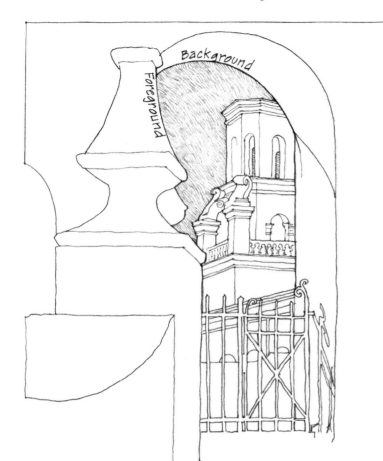

Foreground

Background

Form Space

Light, shade, and shadow

Solids and voids

Drawing based on a photograph by Ansel Adams

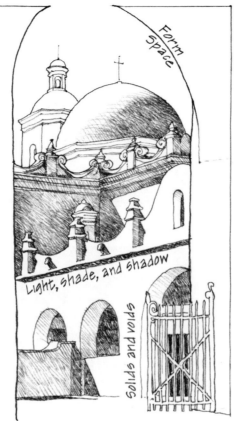

Shape is a two-dimensional concept of a figure contained by its own boundaries and cut off from a larger visual field. Thus shape relies on the line that describes its edge or the contrast of tonal value, color, or texture that occurs along that edge.

Any line that defines a shape on one side of its contour simultaneously carves out space on the other side of its path. A shape can never exist alone. It can only be seen in relation to other shapes or the space surrounding it.

Shape

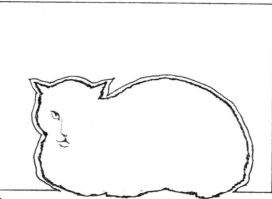

1. The contour line which borders a figure appears to belong to it rather than to the surrounding background.

2. The figure appears to be a self-contained object while its background does not.

POSITIVE AND NEGATIVE SHAPES

For a shape to be recognizable, it must be seen as a figure. At the threshold of perception, we begin to see objects as figures against a background. This relationship between figure and background is an essential concept in the ordering of our visual world, for without this differentiation, we would see as if through a fog. A figure with shape emerges from a background when it has certain characteristics.

3. The figure appears to be closer and the background more distant.

4. The figure appears to be in front of a continuous background.

5. The figure appears to be more solid or substantial than its background.

6. The figure appears to dominate its field and be more memorable as a visual image.

A figure which can be seen relatively clearly against a background is said to have a positive shape. By comparison, the figure's background appears to be shapeless, and is said to have a negative shape. No part of a visual field, however, is truly inert or negative.

Both positive and negative shapes are interdependent; they must coexist and link together to form a unified image. We must see the whole while simultaneously perceiving the parts, in proper relationship to each other, within the whole.

DRAWING SHAPES

Contour drawing is a very deliberate process which emphasizes accurate observation and perception. As we carefully draw contour lines in sequence, one after another, we define the perceived shapes of forms. Since these forms are normally seen as the positive figures in our visual field, their contour lines will naturally define the positive shapes of a drawing composition.

THE SHAPE OF NEGATIVE SPACE

INTERACTIVE SHAPES

THE SHAPE OF SHADOWS

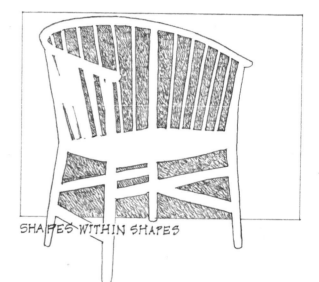

SHAPES WITHIN SHAPES

As we draw the edges of positive shapes, we should also be acutely aware of the negative shapes we are creating. While we normally perceive spatial voids as having no substance, they share the same boundaries as the forms they envelop. In drawing, also, negative spaces share the contour lines that define the edges of positive shapes.

THE SHAPE OF EXTERIOR SPACE

THE SHAPE OF INTERIOR SPACE

INTERLOCKING AND OVERLAPPING SHAPES IN THE LANDSCAPE

In both seeing and drawing, we should give the same attention to the shapes of negative spaces as we do the positive shapes of forms. Since negative shapes do not always have the easily recognizable qualities of positive shapes, they can be seen only if we make the effort.

As we draw a line we should be conscious not only of where it begins and ends, but also of how it moves, and the shapes it carves along the way. Each line leads to another, and then another and another, thereby creating both positive and negative shapes in space.

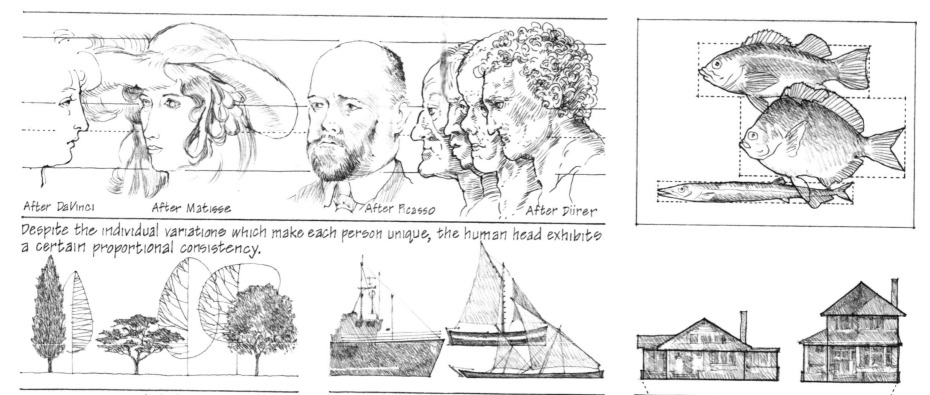

After DaVinci After Matisse After Picasso After Dürer

Despite the individual variations which make each person unique, the human head exhibits a certain proportional consistency.

Seeing proportional differences is necessary to our understanding of the distinctions between and within classes of things.

PROPORTION AND SCALE

As we become more sensitive to the unique visual characteristics of what we see and draw, we should not lose sight of the total image. To ensure things remain in their proper place and relationship to one another — to avoid making mountains out of molehills — we must pay attention to proportion and scale.

Proportion is a matter of ratios, and ratio is the relationship between any two parts of a whole, or between any part and the whole. In seeing, we should perceive the proportional relationships which regulate our perception of size and shape. Correspondingly, by utilizing a coherent series of ratios in our drawings, we are able to convey a sense of unity while allowing for diversity of shape, color, and texture.

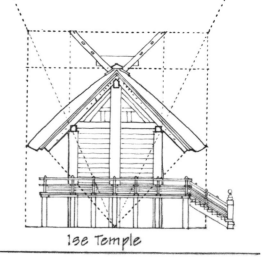

Ise Temple

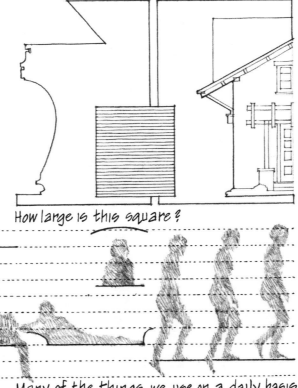

How large is this cube?

How large is this square?

Building elements are scaled to each other as well as to the human body.

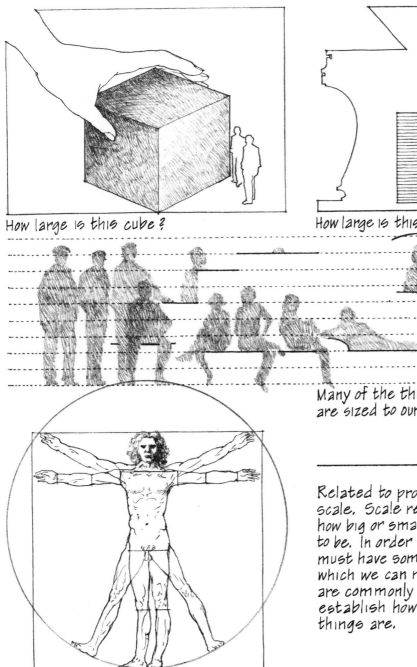

Many of the things we use on a daily basis are sized to our body dimensions.

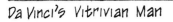

Da Vinci's Vitrivian Man

Related to proportion is the idea of scale. Scale refers to apparent size — how big or small we believe something to be. In order to measure scale, we must have something of known size to which we can refer. Images of people are commonly used in this manner to establish how large or small other things are.

This comparison is based on our familiarity with our own body dimensions, and the result can make the thing we are measuring seem large or small. In a similar manner, we can also use as a measuring standard something whose size is familiar to us, and which, by comparison, can make us feel big or little.

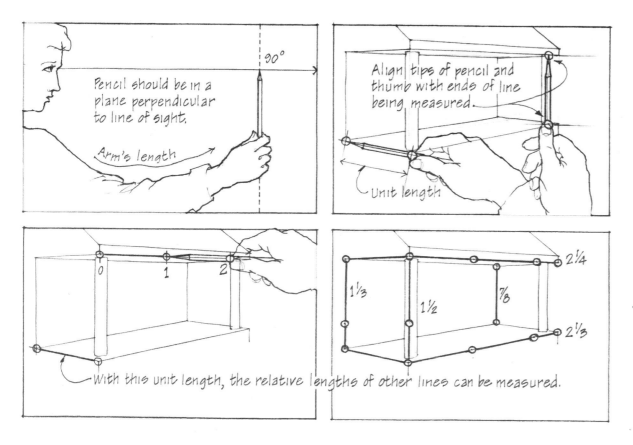

Pencil should be in a plane perpendicular to line of sight.

90°

Arm's length

Align tips of pencil and thumb with ends of line being measured.

Unit length

0 1 2

With this unit length, the relative lengths of other lines can be measured.

1⅓ 1½ ⅞ 2¼ 2⅓

SIGHTING TECHNIQUES

There are several techniques which can help us make visual judgments and ensure that things have proper shape and dimensional relationships. A convenient one to begin with is to use a pencil or other drawing instrument as a visual sighting device. With the pencil held out at arm's length, in a plane parallel with our eyes and perpendicular to our line of sight, we can gauge the relative lengths and angles of lines.

To make a linear measurement, we align the pencil's tip with one end of a line we see and use our thumb to mark the other end. We then shift the pencil to another line and, using the first measurement as a unit of length, measure the second line's relative length. We normally use a shorter line segment to establish the unit of measurement so that other line segments can be multiples of that unit.

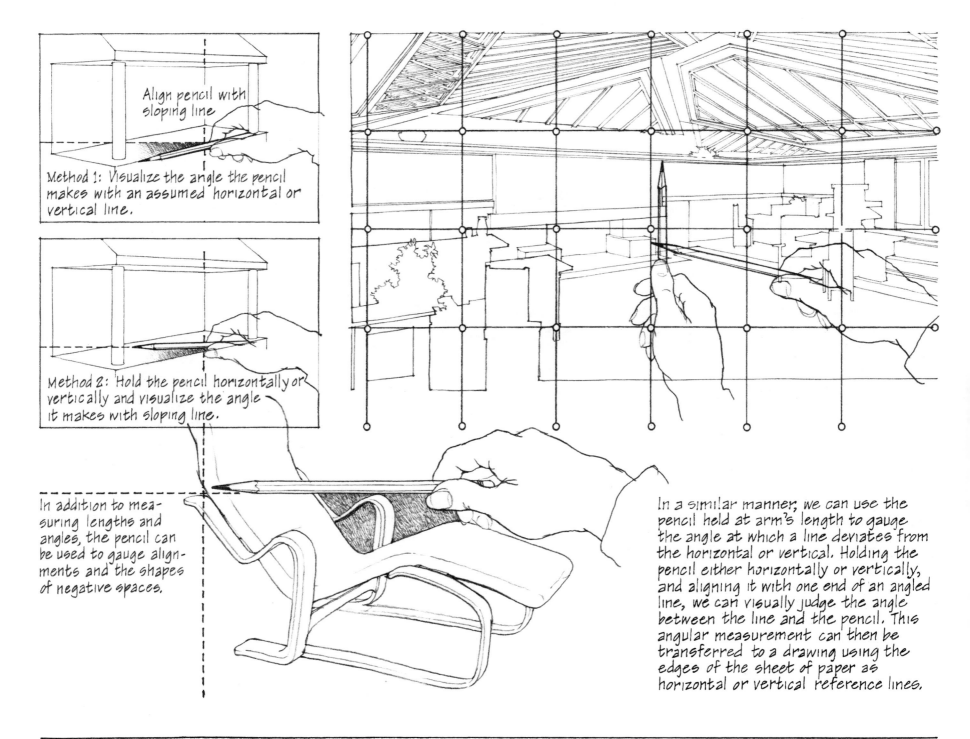

Align pencil with sloping line

Method 1: Visualize the angle the pencil makes with an assumed horizontal or vertical line.

Method 2: Hold the pencil horizontally or vertically and visualize the angle it makes with sloping line.

In addition to measuring lengths and angles, the pencil can be used to gauge alignments and the shapes of negative spaces.

In a similar manner, we can use the pencil held at arm's length to gauge the angle at which a line deviates from the horizontal or vertical. Holding the pencil either horizontally or vertically, and aligning it with one end of an angled line, we can visually judge the angle between the line and the pencil. This angular measurement can then be transferred to a drawing using the edges of the sheet of paper as horizontal or vertical reference lines.

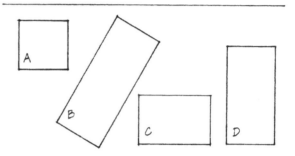

- If Ⓐ is one unit length, how many units long is line Ⓑ? Line Ⓒ? Line Ⓓ?

- If Ⓐ is a square, what proportion is rectangle Ⓑ? Rectangles Ⓒ and Ⓓ?

Before we can exercise visual judgment, we must be able to see shape and structure. With practice, we can project unit lengths, squares, even grids over what we see in order to judge proportional relationships.

VISUAL JUDGMENTS

The ability to estimate dimensional relationships is at the root of all objective drawing. With training and experience, we can utilize the previous sighting techniques without an external device such as a ruler or pencil. Instead, we can develop the ability to measure the dimensions of a form and gauge relationships with our eyes alone.

To do this, we must be able to hold in our mind's eye a visual measuring stick. We can then project this image over other aspects of what we are drawing. When making purely visual judgments, it is important that any preliminary assumptions be checked against what we actually see. When drawing from memory, we must be able to evaluate what we have drawn in light of what we want to convey.

- If lines A·B and B·C are extended, with what other points are they aligned?

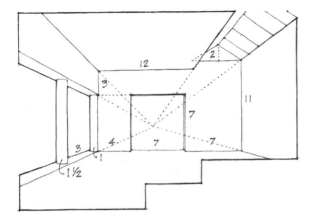

- Using the dimensions given above, complete the drawing to the right. This requires both subdividing and multiplying the base lines already drawn, and then projecting these dimensional judgments as you complete the drawing. You can also try to complete the image by projecting the grid shown in the drawing below.

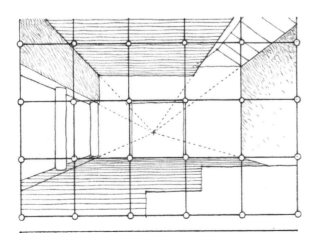

To draw a long line in correct proportion to a shorter one, we can superimpose units of the shorter line over the longer one in an additive manner. With this technique, small errors can accumulate and result in a larger error in the overall length of a line. It is therefore necessary to continually check the overall measurement as we proceed to add units.

In contrast to the previous additive approach, we can begin with a whole measurement and subdivide it into a number of equal parts. The advantage of this method is that the larger relationships are maintained even as we divide them into smaller parts. Thus, large errors can be minimized. This is a useful skill in drawing a series of repetitive elements, or dividing an element on a proportional basis.

ORGANIZING SHAPES

As we begin to draw, we face decisions as to how large the image will be, where it will be positioned, and what orientation it will have. These judgments are made relative to the size, shape, and edges of the surface we are drawing on. We also have to determine what is to be included and what omitted from what we see or envision. These decisions will affect the way we perceive the resulting figure-ground relationships between positive and negative shapes.

1

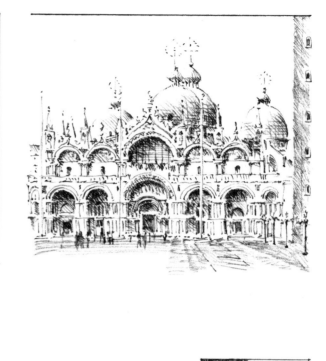

FIGURE·GROUND RELATIONSHIPS

When a figure floats, isolated in a sea of empty space, its presence is emphasized. This type of figure-ground relationship is easy to see. The figure stands out clearly as a positive shape against an empty, diffuse, shapeless background.

When a figure crowds its background field or overlaps other figures in its field, it begins to organize the surrounding spaces into recognizable shapes. A more interactive and integrated figure-ground relationship develops. Visual movement occurs between positive and negative shapes and the resulting tension creates visual interest.

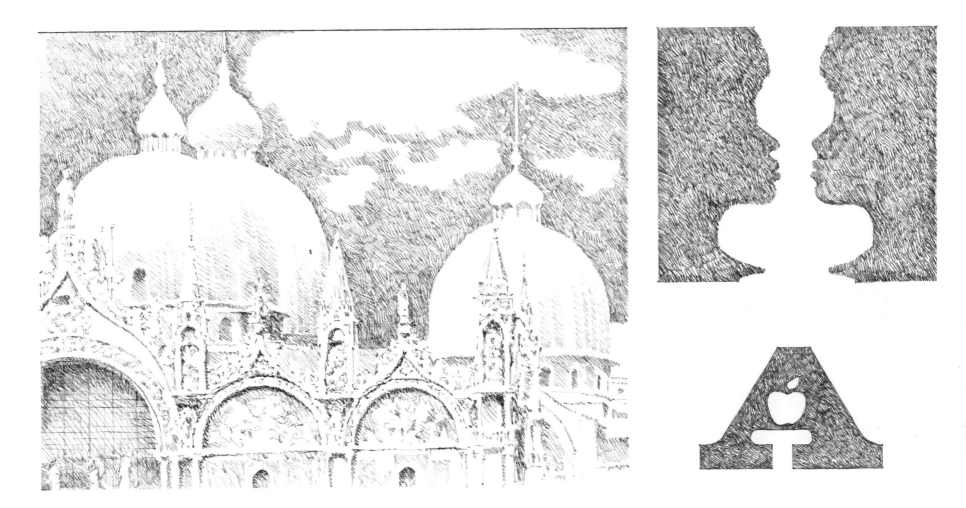

When figure and background both have positive shape qualities, then the figure-ground relationship becomes ambiguous. Initially, we may see certain shapes as figures. Then, with a shift in view or understanding, we may see what formerly were background shapes as the positive figures.

This ambiguous relationship between positive and negative shapes can be desirable at some times and distracting at others, depending on the purpose for a drawing. Whatever ambiguity exists should be intentional, not accidental.

After Jean Dubuffet

GROUPING

A SEARCH FOR PATTERN

What we see and draw often consists of a complex composition of lines and shapes. There may exist not one but a whole series of interrelated sets of figure-ground patterns. How do we make sense of such a complex visual field? We see not individual shapes, but rather a pattern of relationships. According to the Gestalt theory of perception, we tend to simplify what we see, organizing complex stimuli into simpler, more holistic patterns. This grouping can occur according to certain principles.

SIMILARITY

We tend to group things which have some visual characteristic in common, such as a similarity of shape, size, color, orientation, or detail.

PROXIMITY

We tend to group those elements which are close together, to the exclusion of those which are farther away.

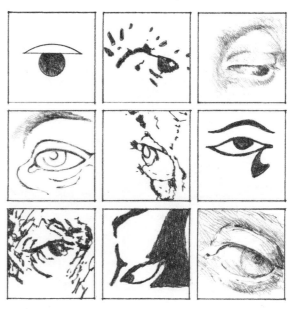

CONTINUITY

We tend to group elements which continue along the same line or in the same direction.

These perceptual tendencies lead us to see the relationships between the various elements of a composition. If these relationships form a relatively regular shape-pattern, then they can organize a complex composition into a perceptually simpler and more comprehensible whole. The principle of grouping thus helps promote the coexistence of unity, variety, and visual richness in a drawing.

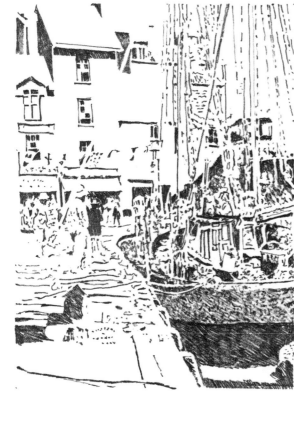

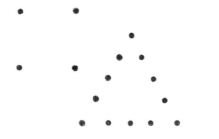

CLOSURE: A SEARCH FOR STABILITY

Closure refers to the tendency for an open or incomplete figure to be seen as if it were a closed or complete and stable form.

Given a pattern of dots, virtual lines connect the points in such a way that a regular, stable shape results. These lines are similar to the ones that complete a regular shape even when part of that shape is hidden. The incomplete figures tend to complete themselves according to simplicity and regularity of form.

There are situations where even if a line does not in fact exist, the mind's eye creates the line in an attempt to regularize a shape and make it visible. These seen but nonexistent lines are illusory and have no physical basis. We see them in visual areas which are completely homogeneous.

Illusionary lines can be either straight or curved. While they appear to define opaque shapes, the figures can also be transparent. In any case, what we tend to perceive are the simplest, most regular structure of lines which can complete the shape.

The principle of closure activates viewer response, encourages the economic use of lines, and provides opportunities for greater efficiency in drawing.

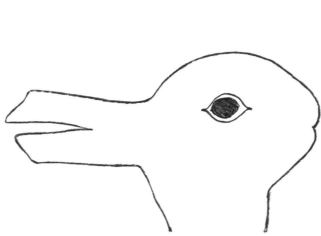

One can interpret this image, devised by psychologist Joseph Jastrow in 1900, to be either a duck or a rabbit.

◀ What do you see in this image?

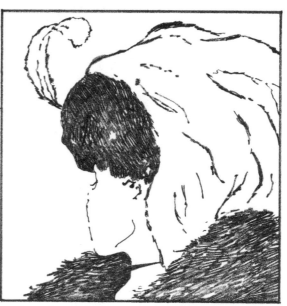

In this illusion designed by psychologist E.G. Boring in 1930, one can see either the profile of a young woman or the head of an older woman.

PROJECTION: A SEARCH FOR MEANING

The grouping principles of similarity, proximity, continuity, and closure operate without regard for representational meaning. They aid us in organizing even the most abstract of patterns. Since the mind's eye constantly searches for meaning in what we see, we also tend to group lines and shapes into familiar images.

Merely looking at an apparently amorphous pattern can sometimes bring to a prepared, interested, and searching mind a more specific image. In its search for meaning, the mind's eye imagines and appears to project familiar images onto seemingly shapeless patterns until it finds a match that makes sense.

"I cannot forbear to mention a new device for study which, although it may seem trivial and almost ludicrous, is nevertheless extremely useful in arousing the mind to various inventions. And this is, when you look at a wall spotted with stains...you may discover a resemblance to various landscapes, beautified with mountains, rivers, rocks, trees... Or again you may see BATTLES and figures in action, OR STRANGE FACES AND COSTUMES and an

endless variety of objects which you could reduce to complete and well-known forms. AND THESE APPEAR ON SUCH WALLS CONFUSEDLY, LIKE THE SOUND OF BELLS IN WHOSE JANGLE YOU MAY FIND ANY NAME OR WORD YOU CHOOSE TO IMAGINE." Leonardo da Vinci. "All thought is a feat of association; having what's in front of you bring up something in your mind that you almost didn't know you knew." Robert Frost.

"I do not seek; I find." Pablo Picasso "You can observe a lot just by watching." Yogi Berra. " The eye sees only what the mind is prepared to comprehend." Robertson Davies.

SHAPE AND SURFACE

In addition to the contour lines which are essential for its delineation, a shape also has surface qualities of material, color, and texture. In drawing, the way we express these qualities is through the rendering of tonal values. These tonal values, in turn, can serve to articulate shape, describe texture, model form, and convey mood and feeling.

LINE DRAWINGS

TONAL VALUE DIFFERENTIATE SHAPES

REVEAL FORM

TONAL VALUES

The line techniques of hatching, cross-hatching, and scribbling are the primary means with which we can render tonal values. Since tonal value is expressed primarily through the relative proportion of light to dark areas, the most important characteristics of these techniques are the spacing and density of the linear strokes used.

DESCRIBE TEXTURE

TEXTURE AND TONE

The primary purpose of rendering tonal values is to differentiate one shape from another. In rendering tones, the visual qualities of the strokes used — their length, contour, and direction — will inherently convey the nature of a surface's material and texture, whether smooth or rough, hard or soft, polished or dull.

We should always be aware of this interrelationship of tone and texture. Any rendering of texture simultaneously produces a tonal value. In most cases, this tonal value is more critical than texture to the representation of light, shade, and the way they model forms in space.

LOCAL VALUES... + LIGHT/SHADE PATTERN... = VALUE PATTERN

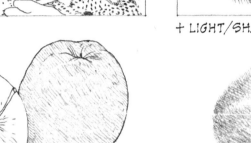

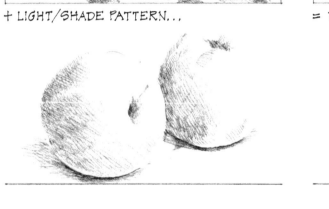

LIGHT AND SHADE

In rendering tonal values, we naturally tend to consider first the local values of a form's surfaces. Local values describe how light or dark a surface's material and color actually are. Local values, however, are modified by the effect of light, shade, and shadow. In rendering tonal values, we should attempt to communicate this interplay of local value, light, and shade.

Contrasting tonal values convey the way light and shade model form. The effects of light on form cannot exist without the contrasting, darker values of shaded surfaces and the shadows they cast. Since we draw primarily with dark media on light surfaces, we define areas of shade and shadow in an attempt to illuminate areas of light.

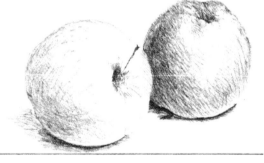

The way shadows are rendered can alter our perception of the shapes described in a line drawing.

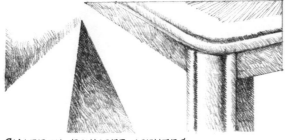

SHARP VS. ROUNDED CORNERS

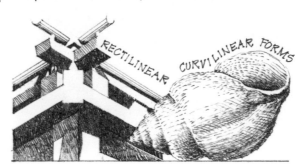

RECTILINEAR CURVILINEAR FORMS

INTENSE VS. DIFFUSE LIGHT

The way light is reflected from a form's surfaces, creating areas of light, shade, and shadow, gives us important clues to its three-dimensional qualities. Light, however, is not static. Sometimes harsh, sometimes diffuse, the quality of a light source is reflected in the way it illuminates the form and pervades the space through which we see the form.

How the edges of a shape are rendered conveys the nature of a form's geometry. Clearly delineated contrasts of value imply sharp edges, abrupt turns at corners, and the illumination of a bright, direct light. Gradual tonal changes, on the other hand, convey soft edges, gently curving forms, and the illumination of indirect light.

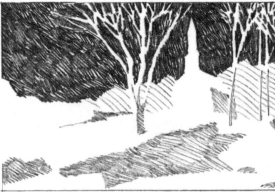 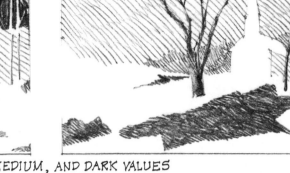 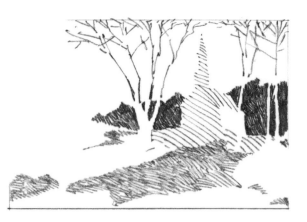

ALTERNATIVES FOR COMPOSING LIGHT, MEDIUM, AND DARK VALUES

VALUE PATTERNS

As we develop the tonal values of the shapes in a drawing, we must be concerned with their overall pattern and composition. The organizational pattern of tonal values can clarify a drawing's complexity, articulate its shapes, make its figure-ground relationships more vivid, and create a sense of space and depth. Thus, we should always develop a strategy for the range, placement, and proportion of tonal values in a drawing.

It is important to note that we perceive tonal values and texture relative to their context. These qualities can be emphasized or diluted depending on the relative characteristics of adjacent surfaces. For example, a light tone in direct contrast with dark tones will appear lighter than when contrasted with lighter tones. A medium texture will appear coarse when contrasted with a smooth surface, but finer when next to a coarser texture.

TIGHT RANGE

BROAD RANGE

HIGH CONTRAST

HIGH KEY

MEDIUM KEY

LOW KEY

The range and pattern of tonal values influence the weight, balance, and harmony of a drawing's composition. Sharp contrasts in value vividly define and attract attention to shapes in space, and create a sense of drama. A broad range of tonal values, with intermediate values providing a transition from the lightest to the darkest, are visually active and animated. Closely related values tend to be more quiet.

The relative proportion of light and dark values and their placement in a composition provide a tonal key for a drawing. A medium range of values has an inherent feeling of harmony and balance. A predominantly light range of values can convey delicacy, elegance, and a sense of illuminating light. A moderately dark value range can give a drawing a sense of heaviness from above, a feeling of stability and strength from below, or perhaps a pervasive, somber quality.

SHAPE AS IMAGE

A shape is a visually perceived area bound by lines or edges of contrast. As an image, shape is seen relative to the space surrounding it and identified by its contours and the pattern of its structural features. The nature of these patterns and contours is the key to our understanding of what shapes represent in a drawing.

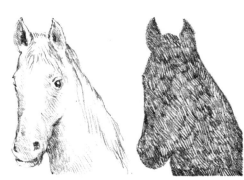

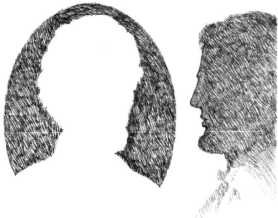

NATURALISTIC SHAPES

In drawing the contours of what we see, we emphasize the natural appearance of a particular thing from a specific point of view. The contour lines define naturalistic shapes. Whether a naturalistic shape conveys what it is supposed to, however, depends on one's point of view.

Some naturalistic shapes require shading, color, and texture to fill out their form and render them recognizable. Others are successful at representing only a class or category of things. Still others communicate their specific identity quite easily without context.

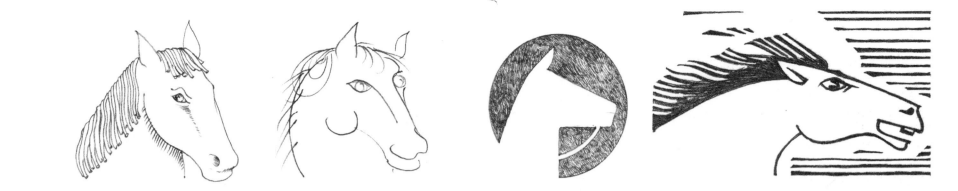

ABSTRACT SHAPES

In order to communicate more effective-
ly, we can abstract naturalistic shapes.
All drawing is an abstraction of reality.
In the process of abstraction, we omit
by choice or circumstance certain
unnecessary details, and we retain
only those essential characteristics
or structural features of a thing
which distinguish it from other things.
There are, of course, varying degrees of
abstraction.

By exaggeration, we can emphasize
one or more features of a thing. This
deliberate distortion can also lead to
idealizing shapes of things by removing
perceived deficiencies in what we see.
When we consistently apply distortion
or exaggeration over an entire drawing,
we stylize a composition of shapes
while retaining the pictorial qualities
of the source material.

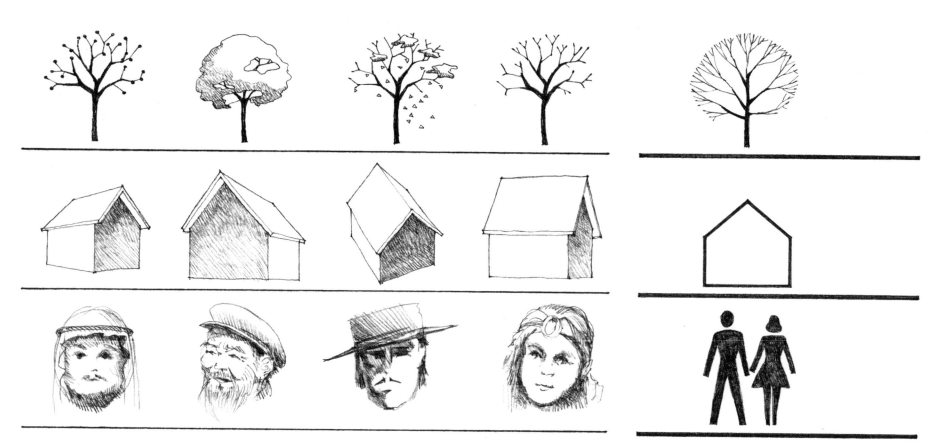

SHAPES AS SYMBOLS

The shape of an object is necessarily altered or transformed by viewing distance and angle. This may simply be a change in size or a more complex transformation of form relationships. We can nevertheless identify things even when the particular images we see shift and move in our perception. This phenomenon, known as shape constancy, enables us to grasp the structural features of something irrespective of how it may appear in reality.

Shape constancy provides the basis for our use of shapes as symbols. In developing symbols, we distill from shifting visual events those invariable aspects which are meaningful to us, and which distinguish one thing from another. Symbols are therefore persistent shapes which are based on significant contours and structural features.

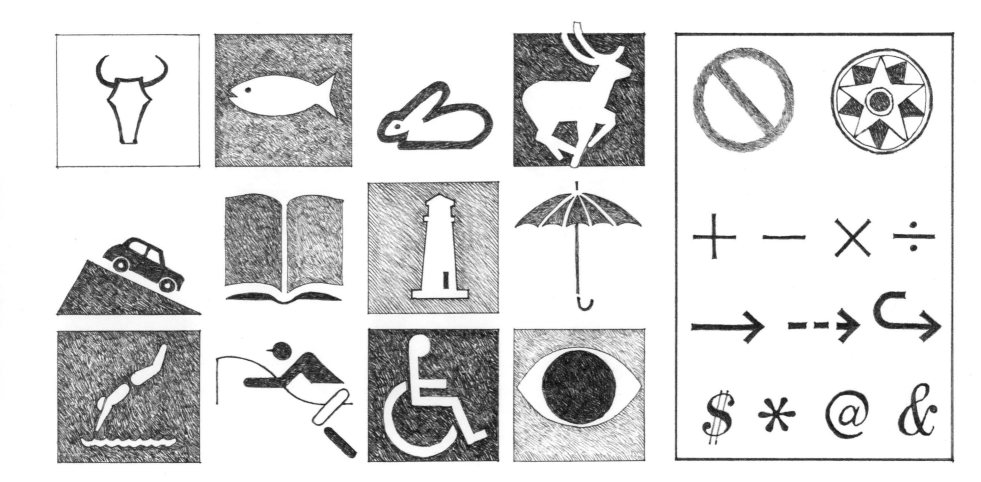

Representational symbols are simplified pictures of what they represent. To be meaningful, they must be generalized yet embody the structural features of what they refer to. Highly abstract shapes, on the other hand, can be very broad in application, but usually need a context or captions to fully explain their meaning.

When symbols become more abstract and lose any visual connection to what they refer, they become signs. Signs refer to a thing or idea without reflecting any of its visual characteristics. They can be understood only by common agreement or convention.

After Kuniyoshi

After John Constable

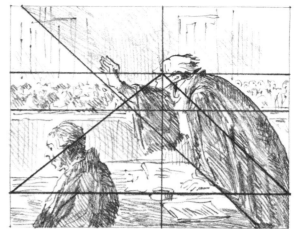
After Honoré Daumier

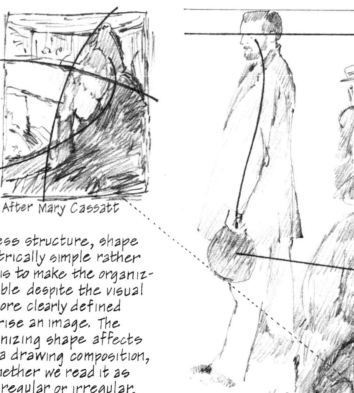
After Edgar Degas

After Mary Cassatt

SHAPES AS VISUAL CONCEPTS

Besides representing what we see or envision, a shape can also exist as the underlying regulating framework for a composition. The lines which define an organizing shape are not necessarily seen. Yet we can sense their existence as they express the relationships between the parts of a greater whole.

When used to express structure, shape tends to be geometrically simple rather than complex. This is to make the organizing shape recognizable despite the visual attraction of the more clearly defined shapes which comprise an image. The nature of the organizing shape affects our perception of a drawing composition, and determines whether we read it as simple or complex, regular or irregular, static or dynamic.

When drawing what we see, a number of compositional possibilities may exist. To evaluate these, we determine those aspects which attract our attention. These form a set of visible relationships and the pattern of these visual forces, in turn, defines shapes.

We should examine these relationships and the compositional possibilities in terms of these shapes. Even when drawing what we envision, we can use shape in this manner to organize our thoughts and structure possibilities.

90

DEPTH
THE ART OF ILLUSION

When we draw, we attempt to transcribe
aspects of three-dimensional reality onto
a flat surface which has only two dimensions.
The resulting pictorial images can be ambiguous
for whatever space and depth we read in a
drawing is illusory. Certain arrangements of
lines, shapes, values, and textures, however,
have the potential of conveying the spatial
array of solid forms in space. It all depends
on how our visual system interprets the
drawn image. In order to convey three-
dimensional forms in space and depth in
our drawings, we must master the art
of illusion.

DEPTH

We live in a three-dimensional world of objects and space. Objects occupy, define the limits of, and give form to space. Space, on the other hand, surrounds and articulates our vision of objects. How can we represent the three-dimensions of reality with two-dimensional drawings?

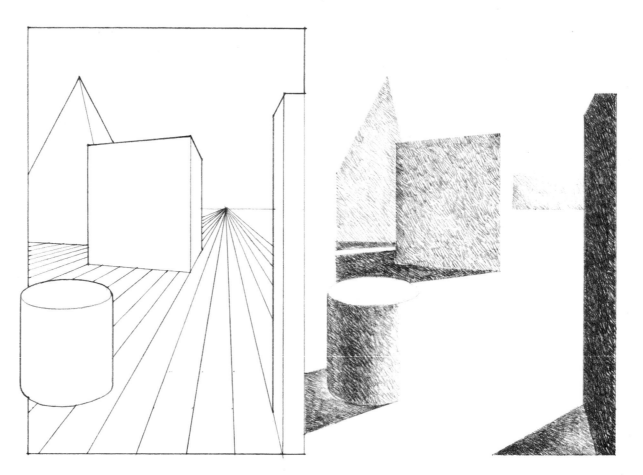

In seeing space, we read the relationships between forms in space. In drawing these spatial perceptions, we create pictorial space. Pictorial space may be flat, deep, or ambiguous, but in all cases, it is illusory. It exists on a two-dimensional surface. But there are fundamental techniques which trigger our visual system to read what we see as having depth in the third dimension.

These techniques are based on our response to certain visual patterns of lines, shapes, values, and textures. Understanding these techniques, we can make an image appear to project forward toward the viewer, or recede into space. We can make a form appear flat or volumetric. We can establish the spatial relationships between forms.

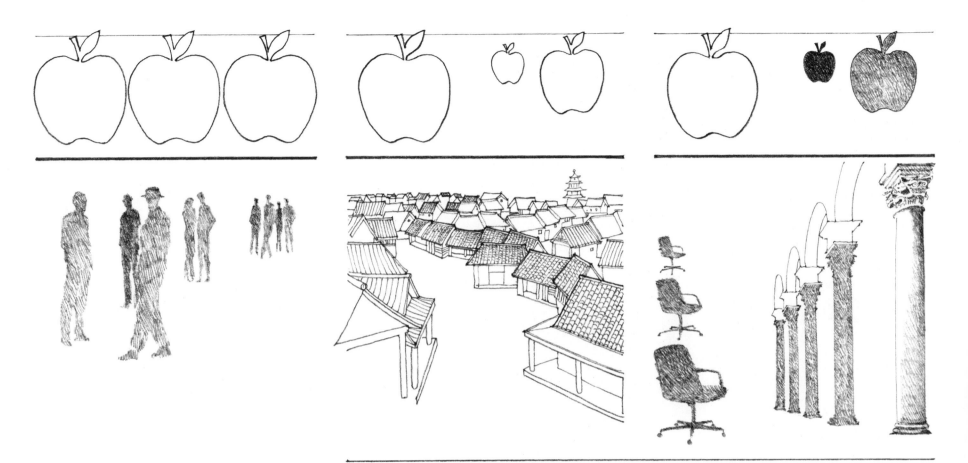

VISUAL DEPTH CLUES: SIZE

An interesting perceptual phenomenon is our ability to ignore apparent differences in actual size in order to identify and categorize things. This phenomenon, known as size or object constancy, leads us to perceive categories of objects as uniform in size with constant color and texture, regardless of where and how distant they are.

Two identical objects, both equidistant from us, will appear to be the same size. As one moves away from us, it will appear to diminish in size. This apparent change in size provides us with a visual clue to depth. When we see two identical or like images of differing sizes, the larger one will appear to be closer and the smaller one farther away.

OVERLAPPING

Two overlapping shapes create an illusion of depth since we tend to see one shape as being in front of, and concealing from our view, a part of another behind it. By itself, overlapping creates very shallow spaces. A greater sense of intervening space and depth can be achieved when overlapping is combined with other depth cues such as spatial edges, shifts in texture or value, and continuity of line.

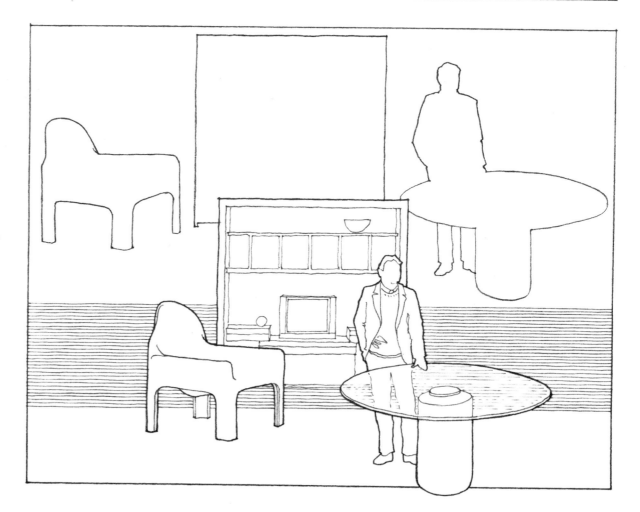

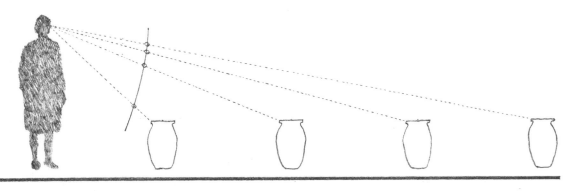

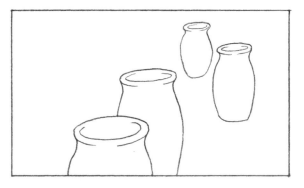

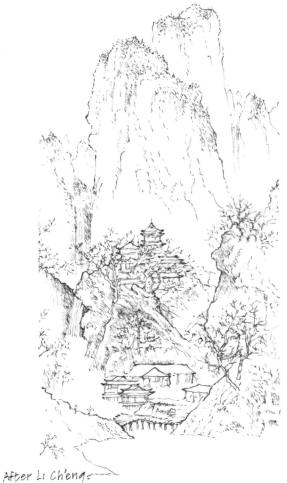

After Li Ch'eng

VERTICAL LOCATION

Imagine standing on a flat piece of ground. As it recedes into the distance, the ground plane appears to move upward toward the horizon. Objects on the ground will also seem to move upward as they get farther away. Therefore, if we want something to be read as distant, we can move it up in the drawing composition.

The higher something is in the picture plane, the farther away it will appear to be. We can thus create a stacked series of images which, when combined with both size differences and over-lapping, conveys a vivid sense of space and depth.

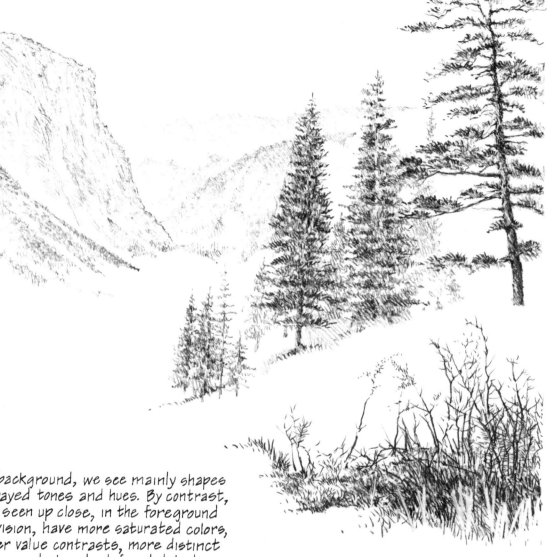

AERIAL PERSPECTIVE

Aerial perspective is based on the softening quality of the intervening air or atmosphere between viewer and object, which affects how we perceive the colors, values, and contours of distant things. As things get farther away, their colors become less intense and more muted. Their values become lighter and grayer, their forms more diffuse and blurry, their details less distinct.

In the background, we see mainly shapes with grayed tones and hues. By contrast, things seen up close, in the foreground of our vision, have more saturated colors, stronger value contrasts, more distinct outlines, and sharply defined details.

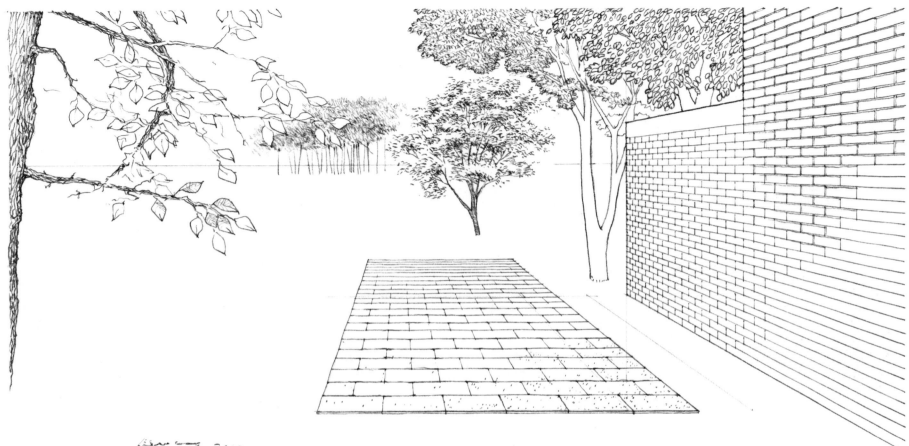

TEXTURE

As a surface texture recedes into the distance, there will be a gradual increase in the density of the texture. This is a result of the diminishing size as well as the spacing of the elements which create the texture we see.

For example, when we view a brick wall up close, we can see both the individual bricks and the thickness of the mortar joints. As we move away, the bricks become smaller and the mortar joints turn into lines until, from a distance, they merge into a textured pattern.

LINEAR PERSPECTIVE

Linear perspective is probably what comes to mind when the term perspective is used to describe pictorial views of our three-dimensional world. While useful in drawing individual objects, linear perspective is particularly adept at illustrating spatial relationships in a pictorial manner which can be readily understood. When combined with the visual depth clues previously discussed, linear perspective gives us the ability to create a vivid illusion of three-dimensional forms, space, and depth on a flat drawing surface.

Linear perspective is based on the laws of geometry. Because of the precise construction methods which have been developed based on these laws, a perspective drawing is often evaluated solely on the correctness of its construction. We should, however, also use our eyes and not entrust the drawn image to a method of construction.

Just because a perspective is meticulously constructed does not mean that the drawing appropriately and accurately illustrates one's point of view without distortion. The intent here is not to detail the mechanical construction of perspectives, but rather to develop an understanding of perspective elements and principles which will enable us to draw freehand perspectives.

Understanding perspective is not absolutely essential in drawing what we are able to see. We can instead rely on the accurate depiction of contour lines and the positive and negative shapes they define. However, in order to transform these lines and shapes, describe their three-dimensional forms, and locate them properly in space, we should understand the elements and principles of linear perspective.

This is particularly important if we want to go beyond external appearances and understand the underlying geometry and structure of things, as defined by the lines which describe and regulate their relationships in space.

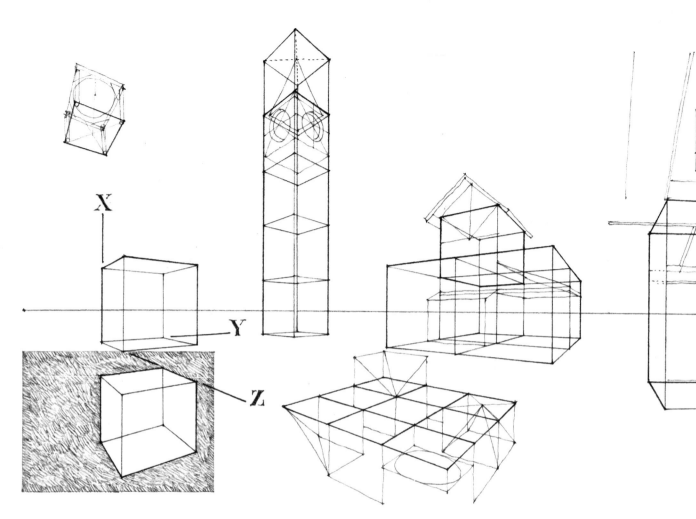

X

Y

Z

As its name implies, linear perspective is concerned primarily with the drawing of lines in perspective. Many of these perspective lines do not represent visible contours but rather describe the structure and geometry of three-dimensional forms and their locations in space. Thus, the illustrations in this section utilize the familiar geometry of the cube as a basis for describing three-dimensional forms.

With the cube, we can measure the three dimensions of things simultaneously. More importantly, we can use the cube to describe a variety of forms, from the simplest to the most complex. This reduction of forms to their component geometries and the measurement of proportion, scale, and relationships in space require both analytical and visual thought.

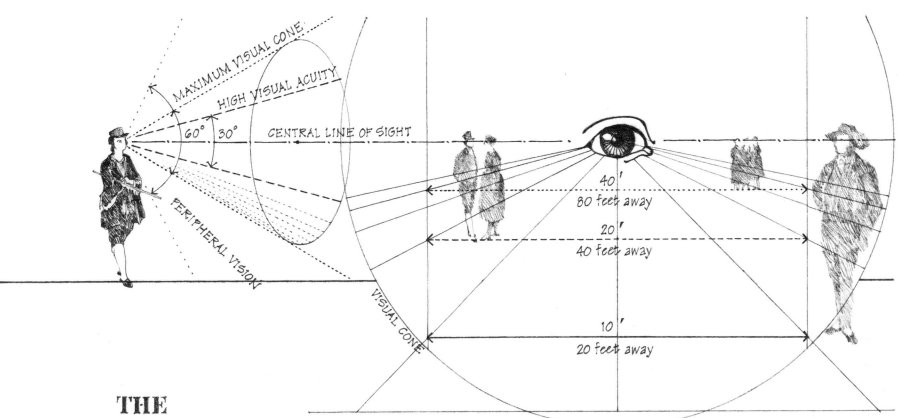

Labels within the diagram:
MAXIMUM VISUAL CONE
HIGH VISUAL ACUITY
CENTRAL LINE OF SIGHT
60° 30°
PERIPHERAL VISION
VISUAL CONE
40'
80 feet away
20'
40 feet away
10'
20 feet away

THE ELEMENTS OF PERSPECTIVE: CONE OF VISION

For all of its apparently dynamic qualities, a perspective drawing is a single, static image, fixed in time, and seen from a specific point of view. Once we fix our viewpoint, then a normal field of vision extends like a cone radiating outward from the eye. This cone of vision consists of lines of sight which form a 15° to 30° angle with the central axis of vision.

This cone of vision should serve as a guide when we determine our viewpoint and what is to be included within the boundaries of a perspective drawing. Only a small portion of the immediate foreground falls within the cone of vision. As it reaches out to gather in what we see, it widens its field, and the middleground and background become more expansive.

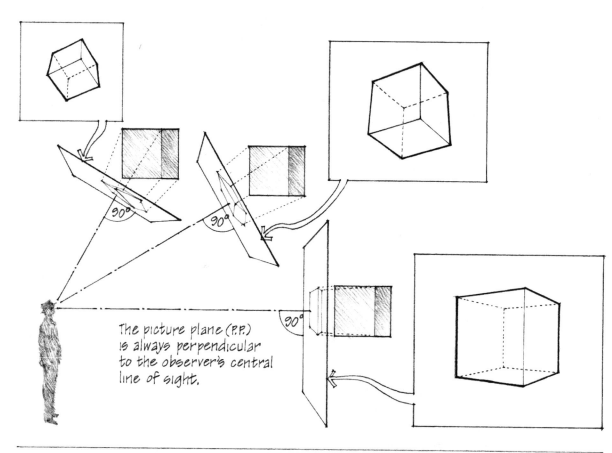

The picture plane (P.P.) is always perpendicular to the observer's central line of sight.

G.P. = Lake surface

G.P. = Street

PICTURE PLANE (P.P.)

When we draw a perspective, we transfer onto a drawing surface what we see through an imaginary, transparent picture plane; the drawing surface becomes the equivalent of the picture plane. This picture plane cuts through the cone of vision and always remains perpendicular to our central line of sight. Thus, if we shift our line of sight left or right, up or down, the picture plane moves with it.

GROUND PLANE (G.P.)

The ground plane is a horizontal plane of reference from which heights in perspective can be measured. It can be the ground on which the viewer stands, the lake surface on which a boat is sailing, or the platform on which a building rests. It can also be the floor plane when drawing an interior space, or even the top of a table when drawing a still life.

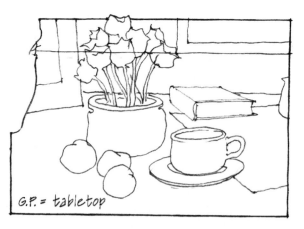

G.P. = tabletop

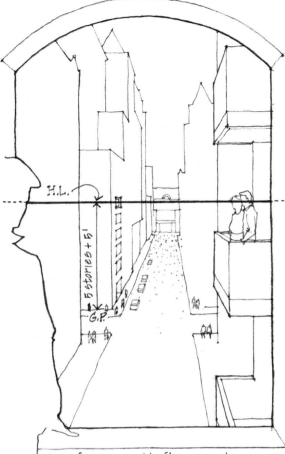

H.L.

5 stories + 5'

G.P.

View from a sixth floor window

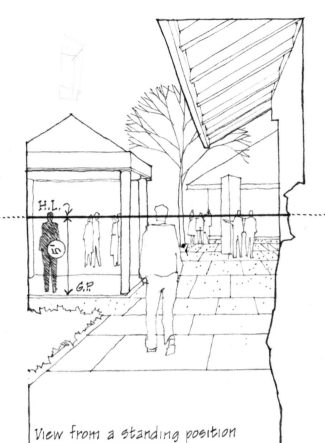

H.L.

5

G.P.

View from a standing position

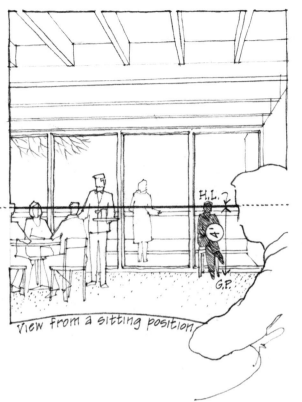

H.L.

4

G.P.

View from a sitting position

HORIZON LINE (H.L.)

The horizon line runs horizontally across the picture plane and corresponds to the viewer's eye level above the ground plane. For a normal eye-level perspective, the horizon line is at the standing height of the observer's eyes. It moves down if we sit down in a chair; it moves up if we look out from a second story window; it rises still further if the view is from a mountaintop.

Even if not actually seen, the horizon line should be drawn lightly across the drawing surface to serve as a level line of reference for the entire composition. Any horizontal plane which lies at our eye level will be seen as a line coinciding with the horizon line. We will see the tops of horizontal planes which lie below the horizon line and the under- sides of those which are above.

Convergence is the primary distinguishing characteristic of linear perspective. As two parallel lines recede into the distance, the space between them will diminish and they will appear to converge. If the lines are extended to infinity, they will appear to meet at what is commonly termed a vanishing point.

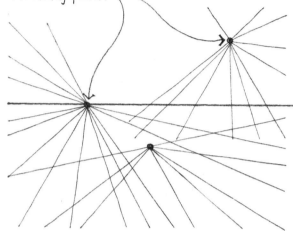

Each set of parallel lines has its own vanishing point.

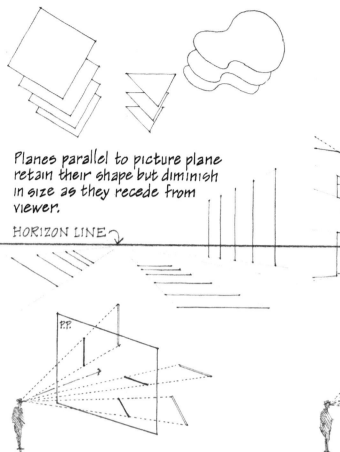

Planes parallel to picture plane retain their shape but diminish in size as they recede from viewer.

HORIZON LINE

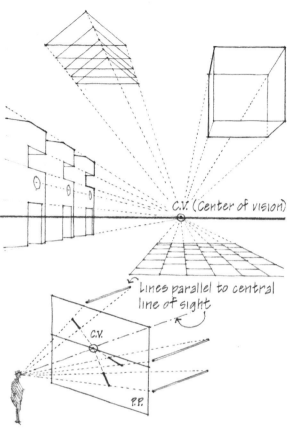

C.V. (Center of vision)

Lines parallel to central line of sight

CONVERGENCE

The first principle of convergence is each set of parallel lines has its own vanishing point. A set of parallel lines consists only of those lines that are parallel to one another. If we look at a cube, for example, we can see that its edges form three sets of parallel lines — one vertical set and two horizontal sets.

LINES PARALLEL TO PICTURE PLANE

If parallel to the picture plane and perpendicular to the observer's central line of sight, a set of parallel lines will not appear to converge. Instead, it will retain its orientation, whether horizontal, vertical, or inclined. Each line, however, will vary in apparent length according to its distance from the viewer.

LINES PERPENDICULAR TO PICTURE PLANE

If a set of parallel lines is perpendicular to the picture plane and therefore parallel with the observer's central line of sight, its vanishing point will coincide with the point where the central line of sight meets the horizon line. This point is known as the center of vision.

We must always be aware of how many sets of parallel lines actually exist in what we are drawing, how each relates to the picture plane, and where each will appear to converge.

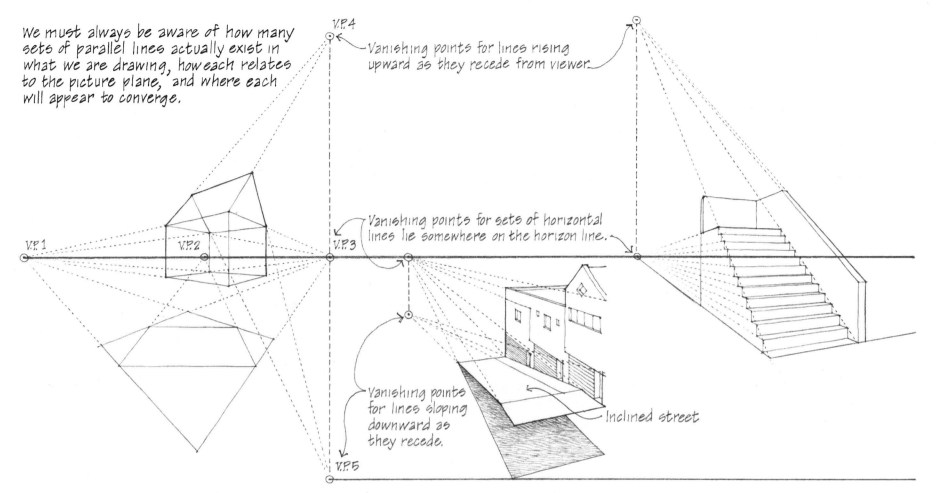

Vanishing points for lines rising upward as they recede from viewer.

Vanishing points for sets of horizontal lines lie somewhere on the horizon line.

Vanishing points for lines sloping downward as they recede.

Inclined street

V.P 4

V.P 1

V.P 2

V.P 3

V.P 5

LINES OBLIQUE TO PICTURE PLANE

If a set is oblique to the picture plane, its parallel lines will appear to converge toward a common vanishing point as they recede. If the set is horizontal, its vanishing point will lie somewhere on the horizon line—either to the left or to the right, depending on the direction of the set as it recedes from the viewer.

If the set rises upward as it recedes from the viewer, then its vanishing point will be above the horizon line, directly above where it would converge if it were level. If the set slopes downward as it recedes, then its vanishing point will lie below the horizon line, directly below where it would converge if it were level.

Another distinguishing characteristic of linear perspective is foreshortening, which refers to the apparent change in form an object undergoes in perspective. It is usually seen as a contraction in size, length, or depth so that an illusion of projection or extension in space is obtained. Three factors affect the degree of foreshortening we see in perspective.

FORESHORTENING

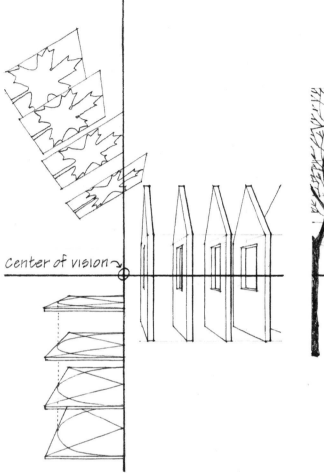

RELATIONSHIP TO CENTER OF VISION

First, the closer and more parallel a line or plane is to our center of vision, the less we will see of its length or surface and the more compressed will be its apparent depth.

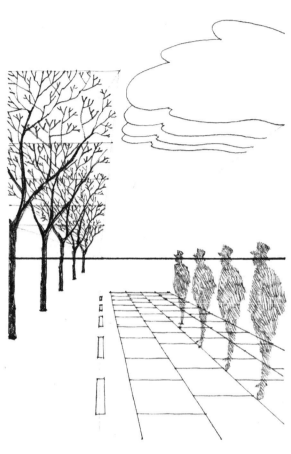

DISTANCE FROM VIEWER

Second, the farther away a line or plane is, the less we will see of its length or surface and the shorter or flatter it will appear to be.

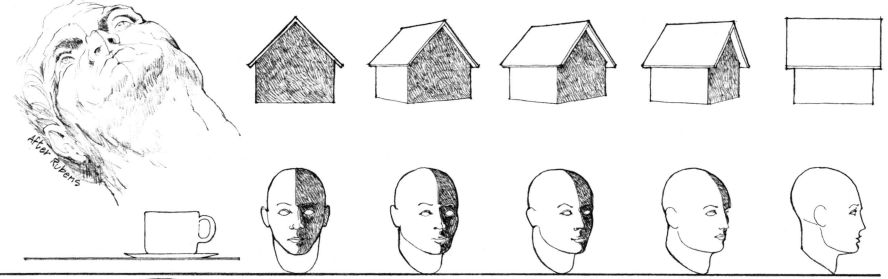

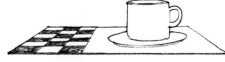

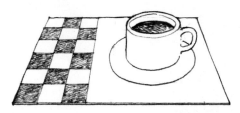

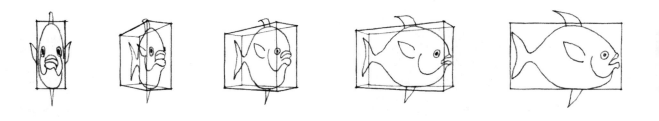

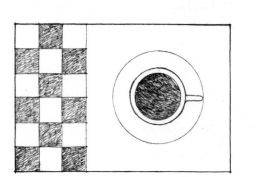

ROTATION

Third, the more a line or plane is rotated away from us and the picture plane, the less we will see of its length or surface.

In addition to its effect on the apparent form of lines or planes, foreshortening can also compress spatial relationships in a perspective drawing.

TYPES OF LINEAR PERSPECTIVE

The edges of a cube form three sets of parallel lines — one vertical and two horizontal. Each set has its own vanishing point in perspective. Based on these three major sets of lines and the rules of convergence, we can say there are three types of linear perspective: 1-, 2-, and 3-point perspectives. What distinguishes each type is simply our point of view. The subject matter does not change, just our view of it and how the sets of parallel lines will appear to converge.

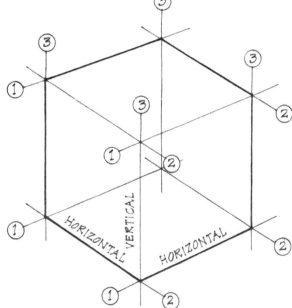

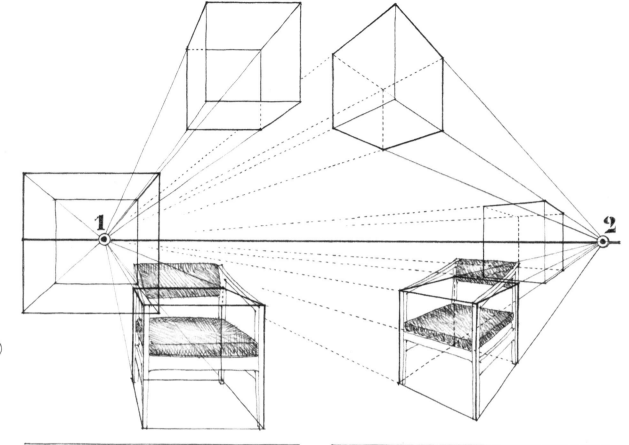

1·POINT

If we view a cube with our central line of sight perpendicular to one of its faces, the vertical and horizontal lines which are parallel with the picture plane remain vertical and horizontal. Those horizontal lines which are parallel with the central line of sight will appear to converge at the center of vision. This is the one point referred to in 1-point perspective.

2·POINT

If we shift our view so that the same cube is viewed obliquely but keep our central line of sight horizontal, the vertical lines will remain vertical. The two sets of horizontal lines, however, are now oblique to the picture plane and will appear to converge, one set to the left and the other to the right. These are the two points referred to in 2-point perspective.

View looking up at cube.

1 **2**

View looking
down at
cube.

3

3 · POINT

If we tilt the cube off the ground plane,
or if we shift our central line of sight
to look down or up at the cube, then all
three sets of parallel lines will be
oblique to the picture plane and appear
to converge at three different vanishing
points. These are the three points
referred to in 3-point perspective.

Note that these perspective views do
not imply that there are only one, two,
or three vanishing points in a per-
spective. The actual number of vanish-
ing points will depend on our point of
view and how many sets of parallel
lines actually exist in what we see or
envision.

1·POINT PERSPECTIVE

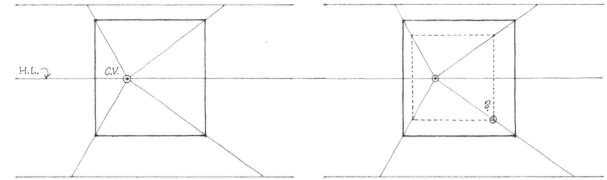

In 1·point perspective, we view one face of a transparent cube straight on. We can therefore begin by drawing that face as a square. Next, we draw a horizontal line through the square and across the sheet. This horizon line represents the eye level of the viewer. Assuming the face we are looking at is 10 feet square and our eye level is 5 feet above the ground plane, the horizon line would cut across the middle of the square.

Establish the center of vision on the horizon line and draw lines from the center of vision through each corner of the square. These represent the horizontal edges of the cube which are parallel to our central line of sight and which converge at the center of vision. If the center of vision is located to the left of center, then more of the right side of the cube will be seen; if moved to the right, more of the left will be seen.

Next comes an important step. How far back is the rear face of the cube? In other words, how foreshortened are the top, bottom, and sides of the cube? It depends on how far away we are from the cube. The closer we are, the more we will see of the top, bottom, and sides. The farther away we are, the flatter the top, bottom, and sides will appear.

A useful method for estimating this degree of foreshortening is based on the 45° right triangle. From geometry, we know that the sides of a 45° right triangle are equal. If we can draw it in perspective, its diagonal will mark off equal segments of perpendicular lines.

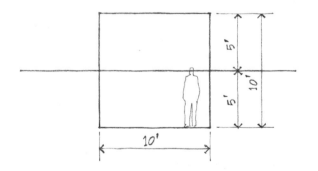

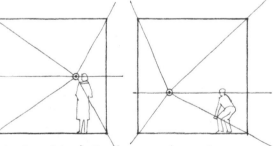

The height of the horizon line above the ground plane and the position of the center of vision affects the perspective effect.

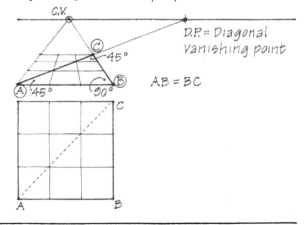

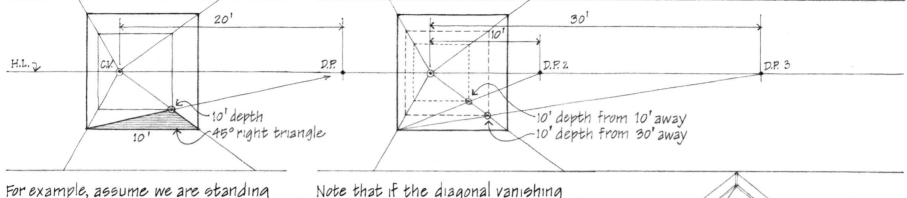

H.L. C.V. 20' D.P.

10' depth
45° right triangle

10'

30' 10' D.P. 2 D.P. 3

10' depth from 10' away
10' depth from 30' away

For example, assume we are standing 20 feet away from the front face of the cube. Establish, at the same scale as the original square, a point on the horizon line which is also 20 feet to the right of the center of vision. This is the vanishing point for all 45° diagonals receding to the right. From the left end of the square's baseline, draw a line to the diagonal vanishing point. This line will cut off a segment of the right-hand baseline which is equal to the front baseline.

Note that if the diagonal vanishing point is moved toward the center of vision, this is equivalent to moving closer to the cube, and more of the cube's receding planes will be seen. If it is moved away from the center of vision, we have also moved farther away from the cube and the cube's receding planes will be more foreshortened.

20' away

50' 40' 30'

C.V. D.P.

Once we have one cube drawn in perspective, we can extend its geometry up and down, forward and back, and to the sides.

2·POINT PERSPECTIVE

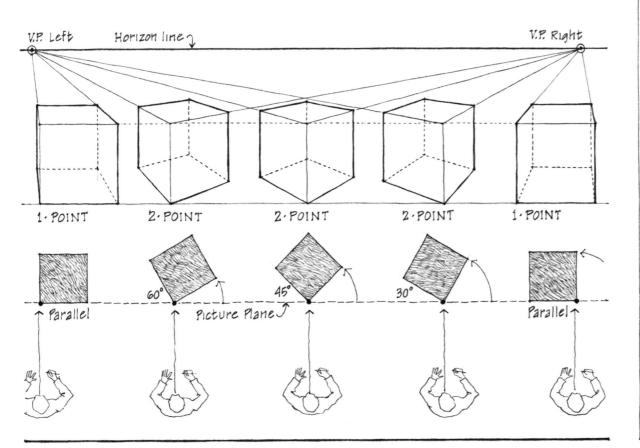

V.P. Left Horizon line V.P. Right

1·POINT 2·POINT 2·POINT 2·POINT 1·POINT

60° 45° 30°

Parallel Picture Plane Parallel

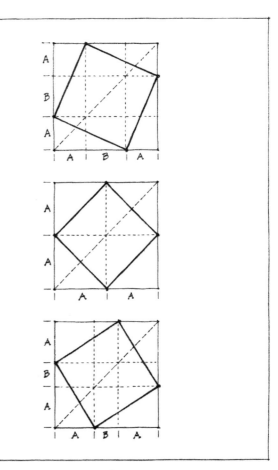

When we rotate the cube seen in 1·point perspective, the two sets of horizontal lines are both oblique to the picture plane. One set will appear to converge to the left, the other to the right. Thus we have two vanishing points on the horizon line. Since the verticals are parallel to the picture plane, they remain vertical in perspective.

Illustrated above is a series of perspective views in which a cube rotates about a forward vertical edge. From left to right, a 1·point perspective view is followed by a sequence of 2·point perspective views. The cube finally rotates back to where its front face is parallel to the picture plane. It is thus seen in 1·point perspective.

For the purpose of sketching a 2·point perspective view, we can build on our familiarity with a 1·perspective cube. We must first understand that a square can be rotated at any angle and be inscribed within a larger square, as shown above. In each case, note that the inscribed square touches the larger square at points equally distant from each corner.

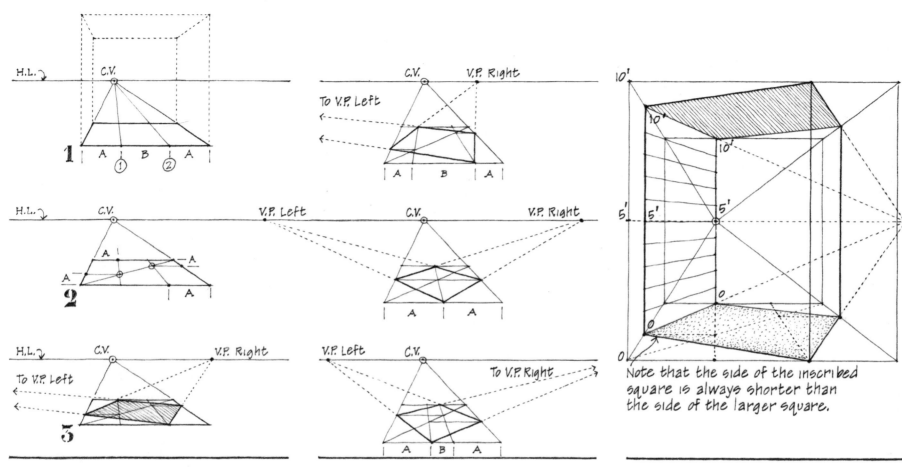

H.L. ↷ C.V.

1 A ① B ② A

C.V. V.P. Right

To V.P. Left

A B A

10'

10' 10'

5' 5' 5'

0 0

0

H.L. ↷ C.V. V.P. Left V.P. Right

2 A A A A

C.V.

A A

Note that the side of the inscribed square is always shorter than the side of the larger square.

H.L. ↷ C.V. V.P. Right

To V.P. Left

3

V.P. Left C.V.

To V.P. Right

A B A

Using the square base plane of a cube drawn in 1-point perspective, we can mark off the distance A from both ends of the front baseline. Next, draw lines from points 1 and 2 to the center of vision. Then draw a diagonal. Where this diagonal cuts across the lines from 1 and 2, draw horizontal lines. We have now located the four corners of the inscribed square as seen in perspective.

The ratio between distances A and B will determine the size of the inscribed square and how much it is rotated. The diagram below illustrates this relationship between the angle of rotation and the size of the inscribed square.

Assume the 1-point perspective cube is 10 feet high and the horizon line is 5 feet above the ground plane. We can extend the inscribed square upward to any desired height by using the verticals of the 10-foot cube as measuring lines.

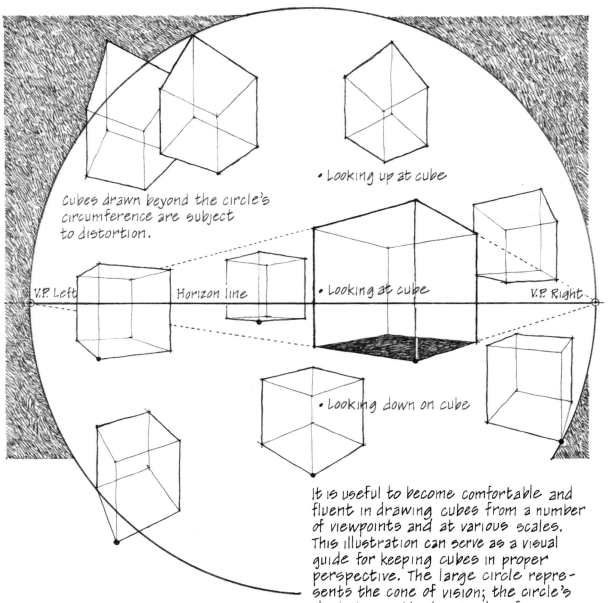

Cubes drawn beyond the circle's circumference are subject to distortion.

• Looking up at cube

V.P. Left Horizon line • Looking at cube V.P. Right

• Looking down on cube

It is useful to become comfortable and fluent in drawing cubes from a number of viewpoints and at various scales. This illustration can serve as a visual guide for keeping cubes in proper perspective. The large circle represents the cone of vision; the circle's diameter is the horizon line from one vanishing point to the other.

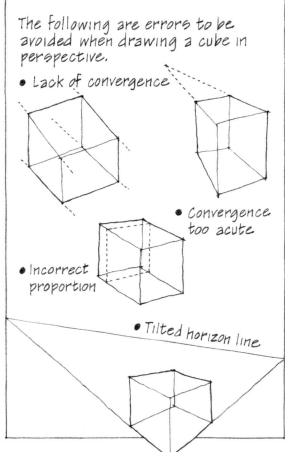

The following are errors to be avoided when drawing a cube in perspective.

• Lack of convergence

• Convergence too acute

• Incorrect proportion

• Tilted horizon line

In the lower half of the circle, the points represent where the leading edges of cubes meet the ground plane. Note that as the points get closer to the horizon line — as they recede into the distance — the angle defined by the receding baselines gets flatter. As the points approach the circle's circumference, the angle approaches, but is never less than, ninety degrees.

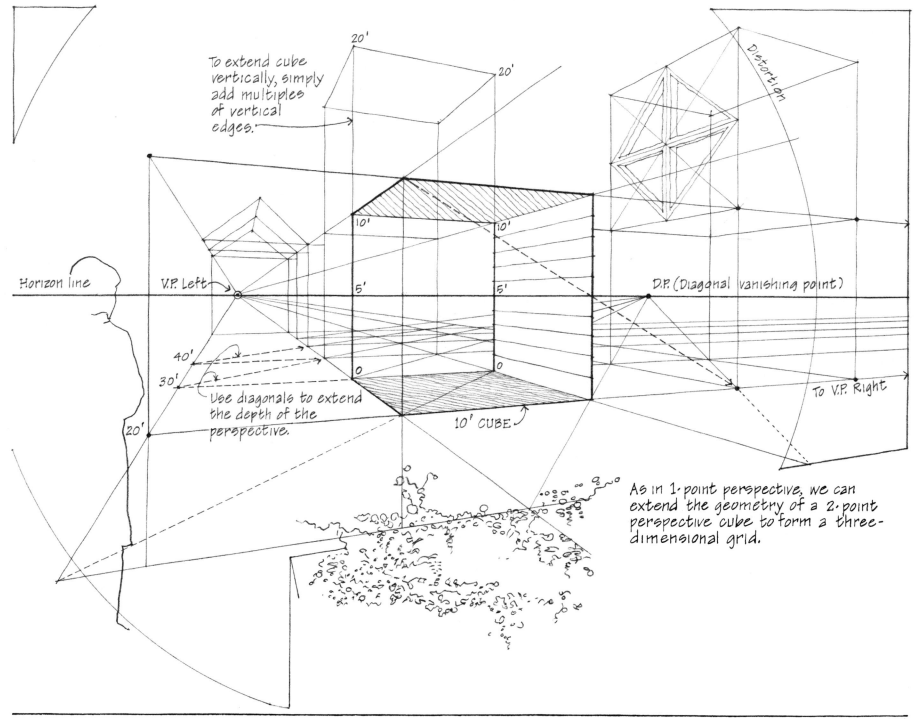

To extend cube vertically, simply add multiples of vertical edges.

Distortion

20'

20'

10'

10'

5'

5'

0

0

Horizon line

V.P. Left

D.P. (Diagonal vanishing point)

To V.P. Right

40'

30'

20'

Use diagonals to extend the depth of the perspective.

10' CUBE

As in 1-point perspective, we can extend the geometry of a 2-point perspective cube to form a three-dimensional grid.

5·POINT PERSPECTIVE

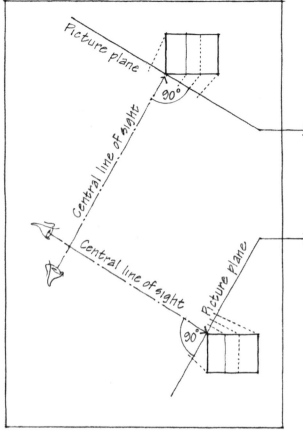

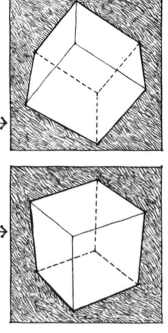

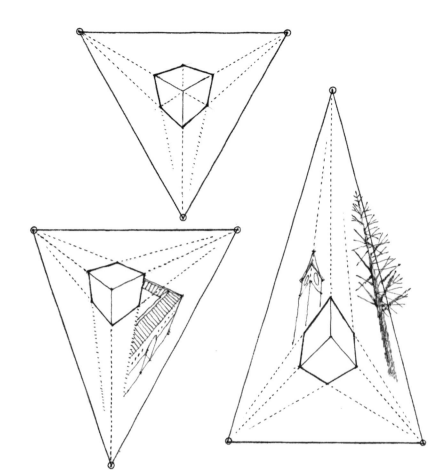

If we look up or down at the cube seen in 2·point perspective, our central line of sight is no longer horizontal and the picture plane is no longer vertical. The vertical edges of the cube are now oblique to the picture plane and must therefore appear to converge. If we look upward, the vertical edges will appear to converge at a point above the horizon line. The same edges will converge at a point below the horizon if we look downward.

We can use the three points of a triangle as the vanishing points for a cube in 3·point perspective. One side of the triangle is horizontal and connects the left and right vanishing points for horizontal lines. The third vanishing point for vertical lines is located above or below, depending on our point of view.

Using an equilateral triangle assumes the faces of the cube are at equal angles to the picture plane. Extending the vanishing point for vertical lines away from the horizontal alters our point of view and the perspective effect.

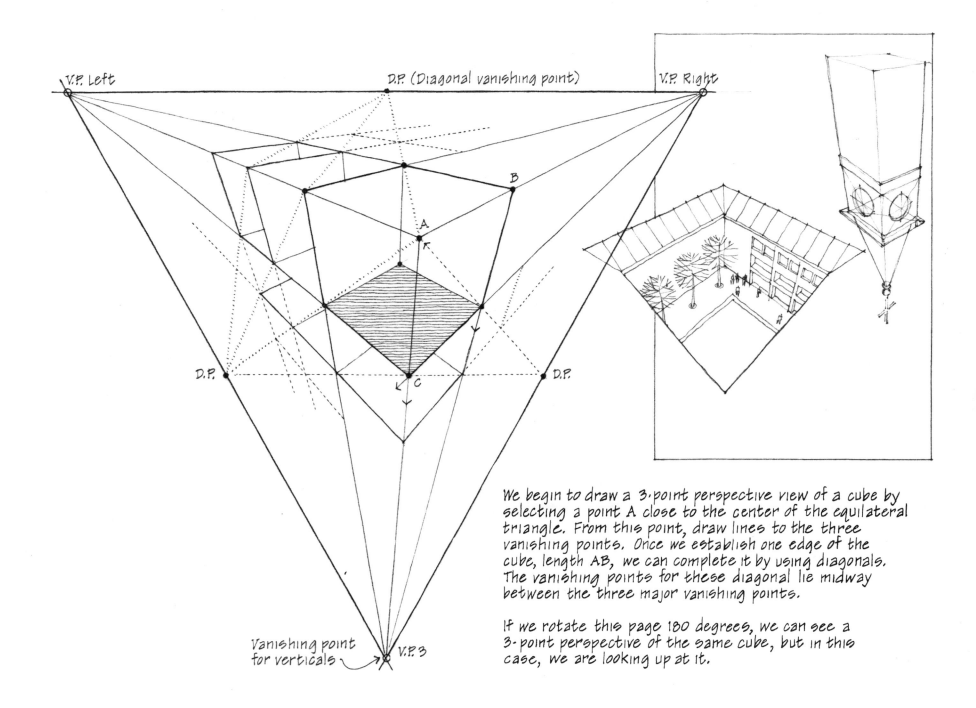

V.P. Left

D.P. (Diagonal vanishing point)

V.P. Right

B

A

D.P.

D.P.

C

Vanishing point
for verticals

V.P.3

We begin to draw a 3-point perspective view of a cube by
selecting a point A close to the center of the equilateral
triangle. From this point, draw lines to the three
vanishing points. Once we establish one edge of the
cube, length AB, we can complete it by using diagonals.
The vanishing points for these diagonal lie midway
between the three major vanishing points.

If we rotate this page 180 degrees, we can see a
3-point perspective of the same cube, but in this
case, we are looking up at it.

PERSPECTIVE MEASUREMENTS

Because of the effects of diminishing size, convergence, and foreshortening, measurements in perspective cannot all be drawn at the same scale. But there are methods for determining the relative width, height, and depth of forms and spaces when seen in linear perspective.

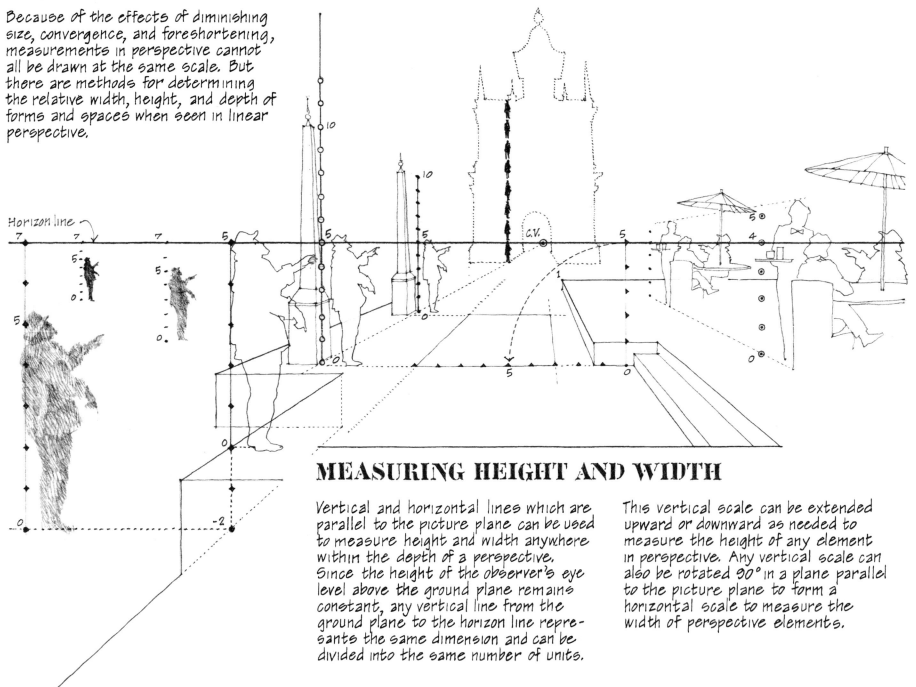

MEASURING HEIGHT AND WIDTH

Vertical and horizontal lines which are parallel to the picture plane can be used to measure height and width anywhere within the depth of a perspective. Since the height of the observer's eye level above the ground plane remains constant, any vertical line from the ground plane to the horizon line represents the same dimension and can be divided into the same number of units.

This vertical scale can be extended upward or downward as needed to measure the height of any element in perspective. Any vertical scale can also be rotated 90° in a plane parallel to the picture plane to form a horizontal scale to measure the width of perspective elements.

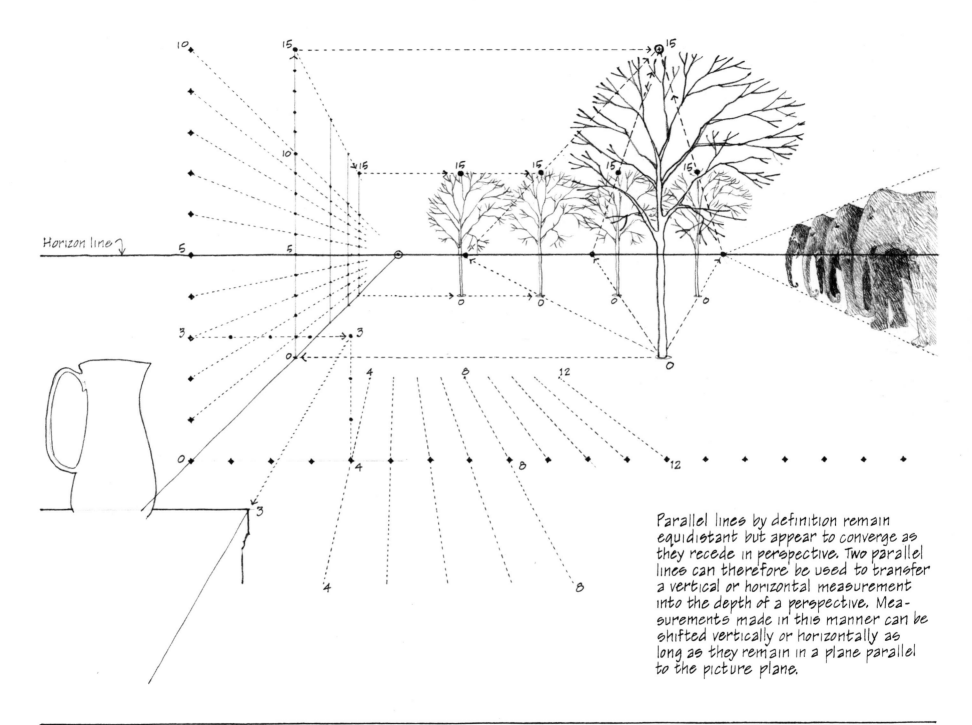

Horizon line

Parallel lines by definition remain
equidistant but appear to converge as
they recede in perspective. Two parallel
lines can therefore be used to transfer
a vertical or horizontal measurement
into the depth of a perspective. Mea-
surements made in this manner can be
shifted vertically or horizontally as
long as they remain in a plane parallel
to the picture plane.

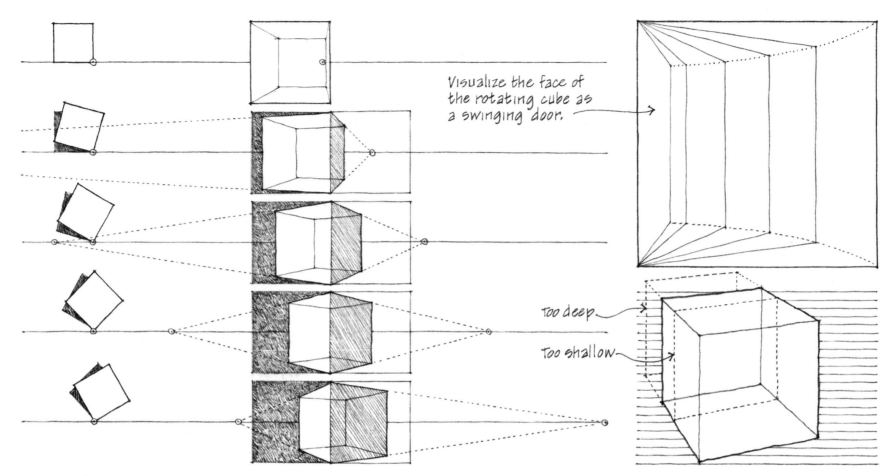

Visualize the face of the rotating cube as a swinging door.

Too deep.

Too shallow.

MEASURING DEPTH

To measure depth in perspective requires judgment which is based on direct observation and nourished by experience. Once an initial depth judgment is made, then succeeding depth judgments must be made in proportion to the first.

If we rotate a cube so that we see more of the right face, the left vanishing point will move closer to our center of vision and the right vanishing point will move farther away. The more frontal a face is, the less foreshortened it will be; the more oblique a face is, the more compressed it will be in depth.

These drawings provide visual guidelines for judging the shape and proportion of square planes in perspective.

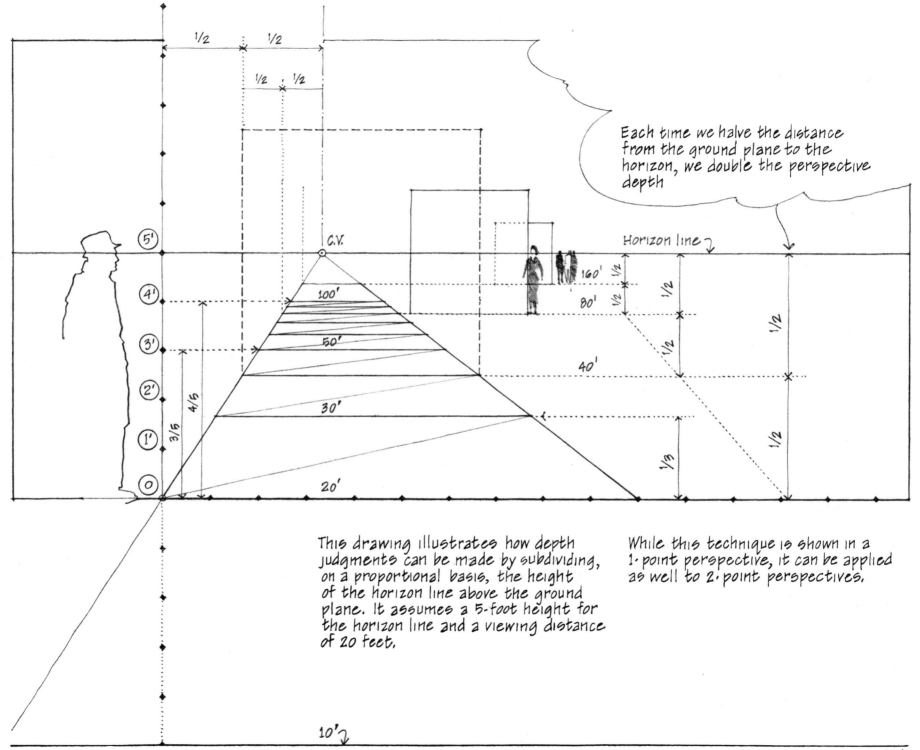

Each time we halve the distance from the ground plane to the horizon, we double the perspective depth

1/2 1/2
1/2 1/2

5'
4'
3'
2'
1'
O

C.V.

Horizon line

100'
50'
30'
20'

160' 1/2
80' 1/2
40'
1/2
1/2
1/2

1/3

4/5

3/5

10'

This drawing illustrates how depth judgments can be made by subdividing, on a proportional basis, the height of the horizon line above the ground plane. It assumes a 5-foot height for the horizon line and a viewing distance of 20 feet.

While this technique is shown in a 1-point perspective, it can be applied as well to 2-point perspectives.

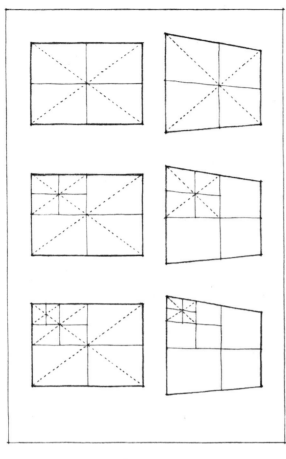

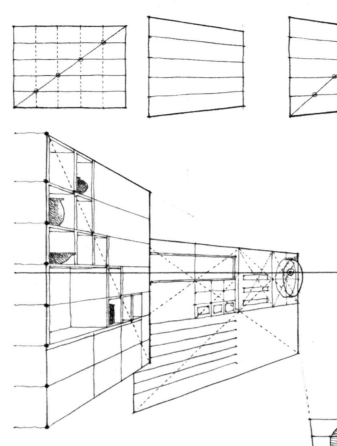

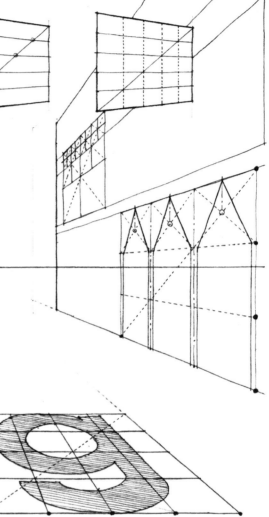

DIAGONAL LINES

With diagonals, we are able to conveniently subdivide or extend depth judgments in a perspective. For example, if we draw two diagonals across a rectangular plane in perspective, they will intersect at the plane's center. Lines drawn through this midpoint, parallel to the edges of the plane, will subdivide the rectangle into four equal parts. This procedure can be repeated to subdivide a rectangle into any even number of equal parts.

A rectangle can also be subdivided by first dividing the forward vertical edge into the desired number of parts. From these points, draw lines which are parallel to the top and bottom edges and which therefore converge at the same point. Then draw a diagonal. Where this diagonal cuts across the receding horizontal lines, draw vertical lines. These mark off the desired number of spaces, which diminish as they recede in perspective.

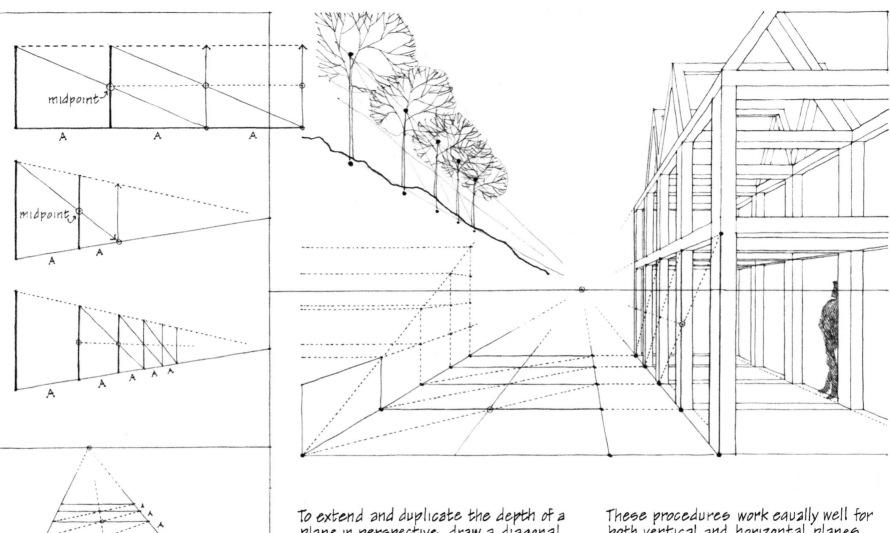

To extend and duplicate the depth of a plane in perspective, draw a diagonal from the top of the forward vertical edge through the midpoint of the rear vertical and down to meet the receding base line. At this point, draw another vertical. The distance from the first to the second vertical is then equal to the space between the second and the third.

These procedures work equally well for both vertical and horizontal planes, and can be repeated as many times as necessary to arrive at the desired number of spaces.

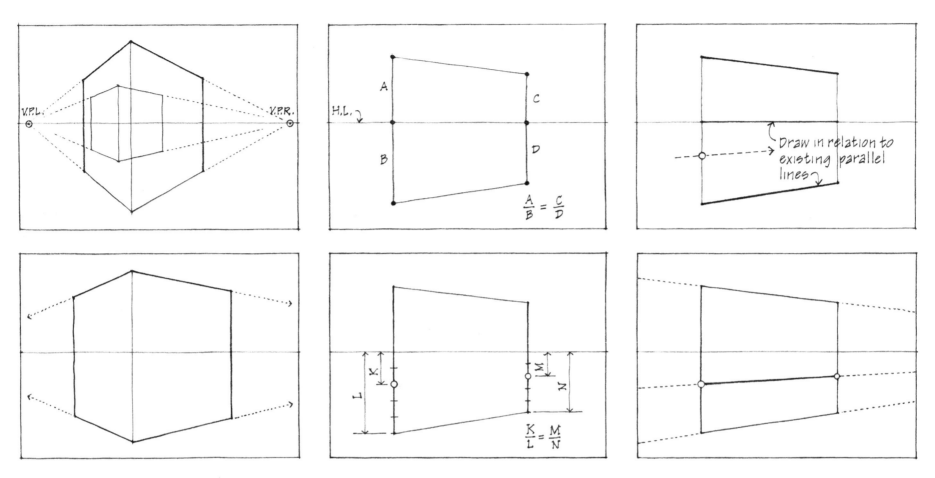

DISTANT VANISHING POINTS

In drawing a perspective, we should not be limited to points of view which result in vanishing points being on the drawing surface. We must also be able to draw perspective views where sets of parallel lines appear to converge at distant vanishing points.

If we have a rectangular plane already drawn in perspective, we can use its top and bottom edges and the horizon line as visual guides to draw another parallel line which converges at the same vanishing point.

First mark where the perspective line to be drawn would cross a vertical edge of the plane. On the other vertical edge, reproduce the same proportional distance to the horizon line as the first. The perspective line should pass through these two points if it is to converge at its vanishing point.

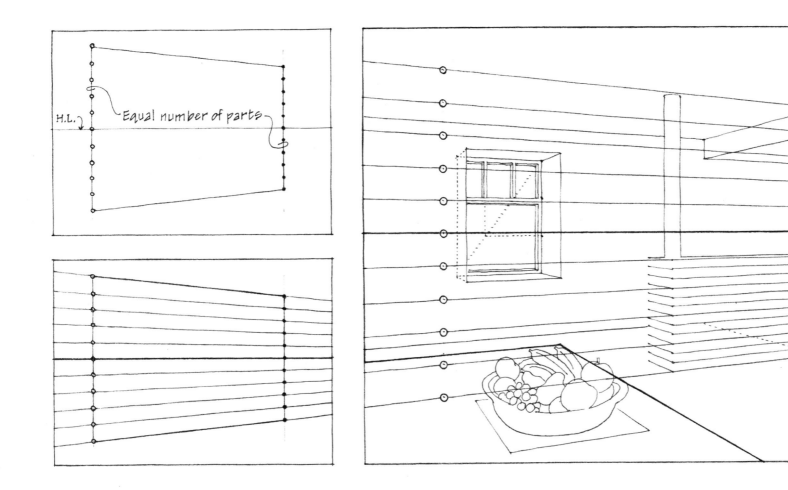

H.L.

Equal number of parts

We can also establish a series of equally spaced parallel lines which appear to converge at a distant vanishing point. We do this by dividing both vertical edges of the rectangular perspective plane into the same number of equal parts.

We can then draw lines through the corresponding points on each vertical line. These lines will appear to converge at a common vanishing point, even if it lies off the drawing sheet.

PERSPECTIVE GEOMETRY

Once we are familiar with and confident in drawing perspective cubes, we can use their rectilinear geomtry as a basis for drawing perspective views of inclined planes, circles, shadows, and reflections.

The steeper the angle of the inclined line, the further above or below the horizon is its vanishing point.

Horizon line

Inclined lines

Horizontal lines

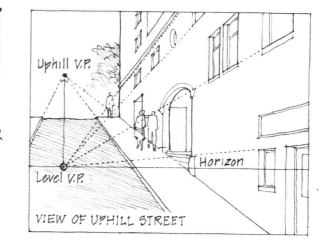

Uphill V.P.

Level V.P.

Horizon

VIEW OF UPHILL STREET

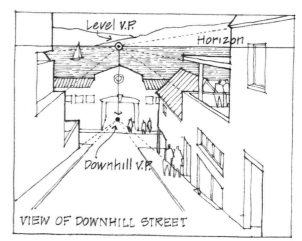

Level V.P.

Horizon

Downhill V.P.

VIEW OF DOWNHILL STREET

INCLINED LINES

We can draw a single inclined line in perspective if we are able to see it as the hypotenuse — the long side — of a right triangle. By drawing the vertical and horizontal sides of the right triangle in proper perspective, we establish the end points for the inclined line.

When there are a number of parallel inclined lines, it is useful to know where they appear to converge in perspective. Since inclined lines are by definition not horizontal, their vanishing point will not fall on the horizon line. If the set slopes downward as it recedes from us, it will appear to converge below the horizon line. If rising upward as it recedes, its vanishing point will lie above the horizon line.

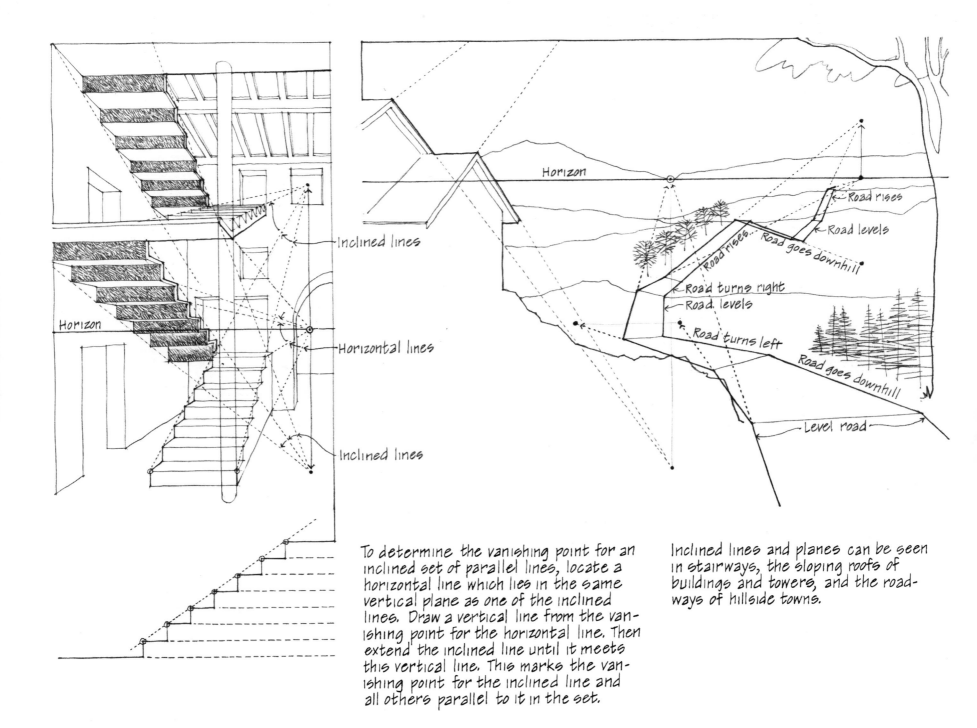

Inclined lines

Horizontal lines

Inclined lines

Horizon

Horizon

Road rises

Road levels

Road goes downhill

Road rises

Road rises

Road turns right

Road levels

Road turns left

Road goes downhill

Level road

To determine the vanishing point for an inclined set of parallel lines, locate a horizontal line which lies in the same vertical plane as one of the inclined lines. Draw a vertical line from the vanishing point for the horizontal line. Then extend the inclined line until it meets this vertical line. This marks the vanishing point for the inclined line and all others parallel to it in the set.

Inclined lines and planes can be seen in stairways, the sloping roofs of buildings and towers, and the road-ways of hillside towns.

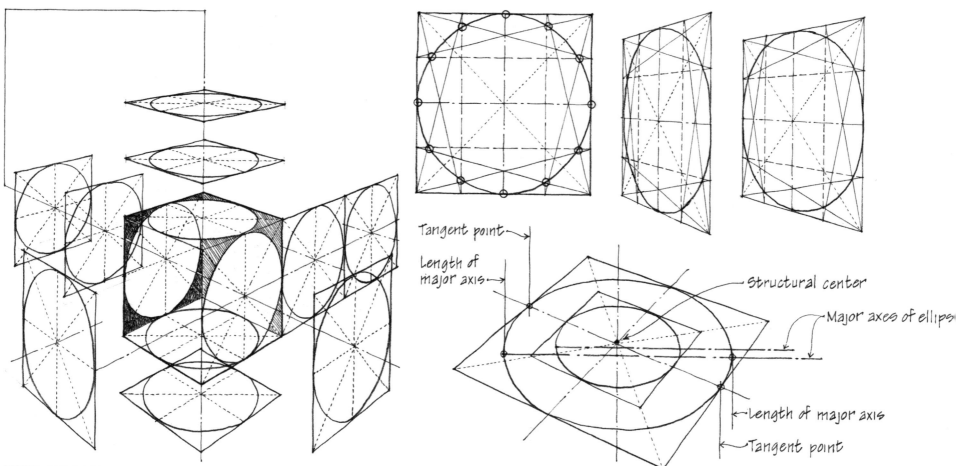

Tangent point

Length of
major axis

Structural center

Major axes of ellips

Length of major axis

Tangent point

CIRCLES

A circle in perspective is seen as a circle only when it is parallel to the picture plane. In all other cases, when viewed in an oblique manner, a circle is seen as an elliptical shape.

To draw a circle in perspective, first draw the square which circumscribes the circle. Then draw the diagonals of the square and the lines that divide the square into four smaller squares. Use these lines to guide the drawing of the elliptical shape which represents the circle in perspective.

Note that just as the forward half of a square in perspective is greater than the rear half, so is the near half of a perspective circle fuller than the far half. Thus the major axis of the elliptical shape representing a circle in perspective is always slightly forward of its structural center.

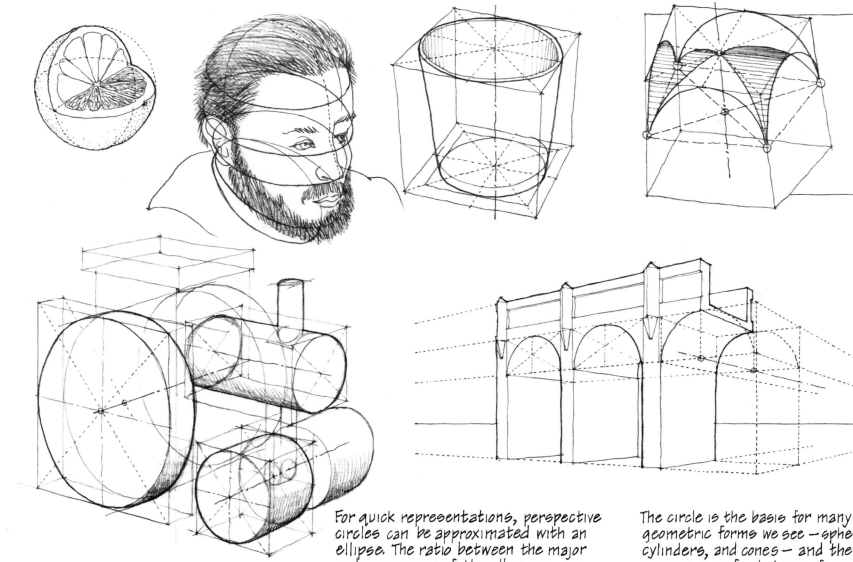

For quick representations, perspective circles can be approximated with an ellipse. The ratio between the major and minor axes of the ellipse is an important indicator of the foreshortening we see. Be careful not to exaggerate the length of the minor axis, which should appear to be perpendicular to the plane of the circle.

The circle is the basis for many of the geometric forms we see — spheres, cylinders, and cones — and their various manifestations, from everyday objects to the arches and vaults of buildings.

NATURAL LIGHT SOURCE

V.P. for parallel light rays

ARTIFICIAL LIGHT SOURCE

Source of radial light rays

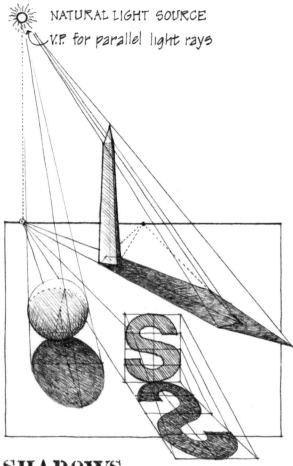

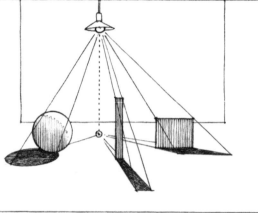

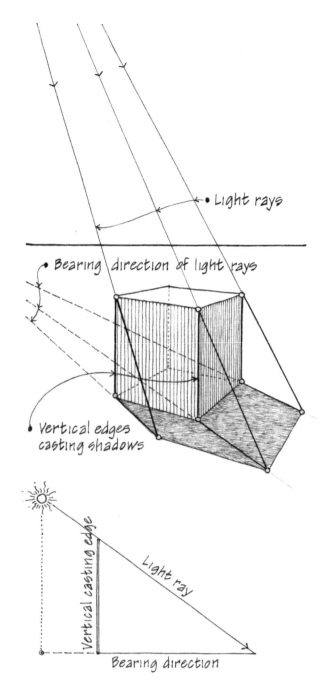

• Light rays

• Bearing direction of light rays

• Vertical edges casting shadows

Vertical casting edge

Light ray

Bearing direction

SHADOWS

The shape of a shadow cast in perspective is determined by three factors— the type and position of the light source, the shape of the object casting the shadow, and the form of the surface receiving the shadow.

There are two types of light sources. The sun, because of its distance from us, radiates parallel light rays. Artificial sources, being closer to what they illuminate, emit radial light rays. In both cases, it is useful to visualize the bearing direction of a light ray as being the horizontal side of a right triangle, the edge casting a shadow as the vertical side, and the light ray itself as the hypotenuse.

LIGHT SOURCE IN FRONT OF VIEWER

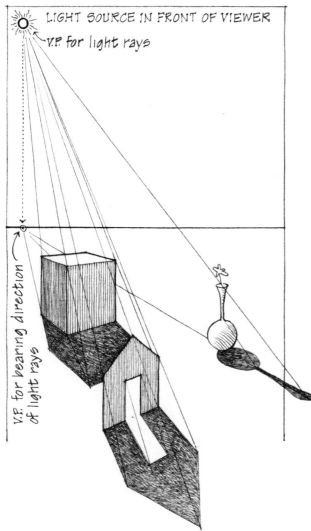

V.P. for light rays

V.P. for bearing direction of light rays

LIGHT SOURCE BEHIND VIEWER

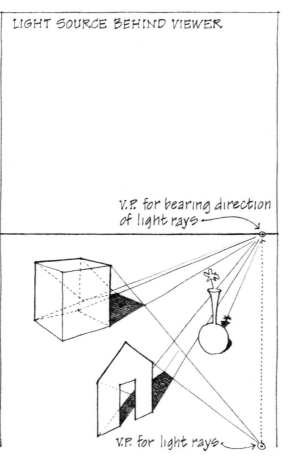

V.P. for bearing direction of light rays

V.P. for light rays

LIGHT SOURCE TO THE SIDE OF VIEWER

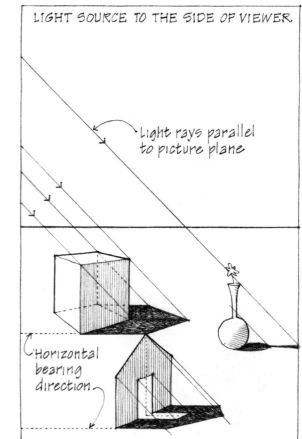

Light rays parallel to picture plane

Horizontal bearing direction

The bearing direction for a set of parallel light rays is a horizontal line and its vanishing point must therefore lie on the horizon line. The vanishing point for the light rays themselves must lie above this point for a source in front of us, or below for a source behind us.

When the light source is to the side and emits rays in a vertical plane parallel to the picture plane, the light rays do not converge. They remain parallel and retain their orientation in perspective.

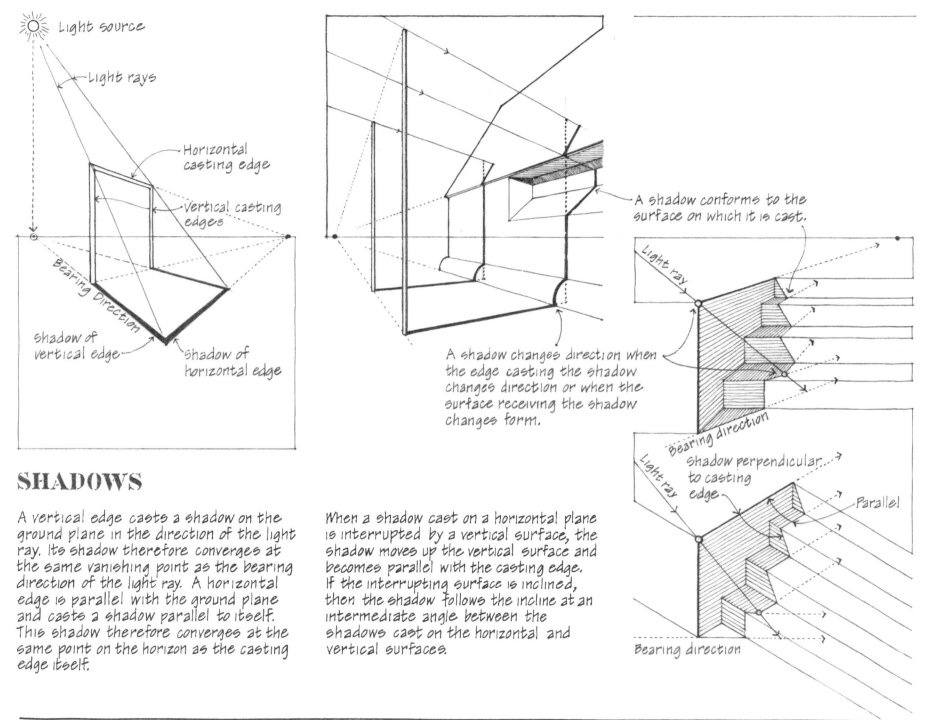

Light source

Light rays

Horizontal casting edge

Vertical casting edges

Bearing Direction

Shadow of vertical edge

Shadow of horizontal edge

A shadow conforms to the surface on which it is cast.

A shadow changes direction when the edge casting the shadow changes direction or when the surface receiving the shadow changes form.

Light ray

Bearing direction

Light ray

Shadow perpendicular to casting edge

Parallel

Bearing direction

SHADOWS

A vertical edge casts a shadow on the ground plane in the direction of the light ray. Its shadow therefore converges at the same vanishing point as the bearing direction of the light ray. A horizontal edge is parallel with the ground plane and casts a shadow parallel to itself. This shadow therefore converges at the same point on the horizon as the casting edge itself.

When a shadow cast on a horizontal plane is interrupted by a vertical surface, the shadow moves up the vertical surface and becomes parallel with the casting edge. If the interrupting surface is inclined, then the shadow follows the incline at an intermediate angle between the shadows cast on the horizontal and vertical surfaces.

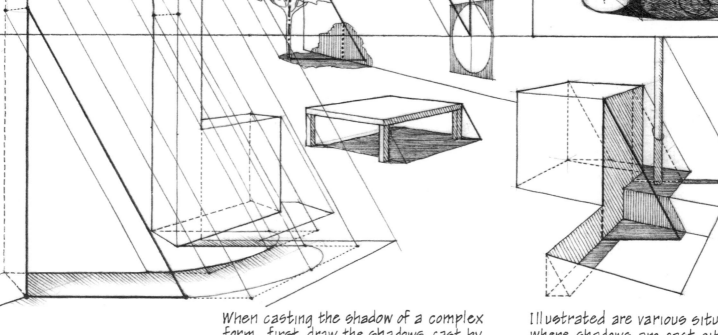

When casting the shadow of a complex
form, first draw the shadows cast by
the simpler components of the form.
Then combine the shadows into a single
shape with a continuous outline. Note
that this outline reflects both the shape
of the casting edges and the form of
the surfaces receiving the shadow.

Illustrated are various situations
where shadows are cast either by or
onto complex forms. The principles
remain the same, using vertical
triangles along the casting edge to
determine the shape of the
shadows.

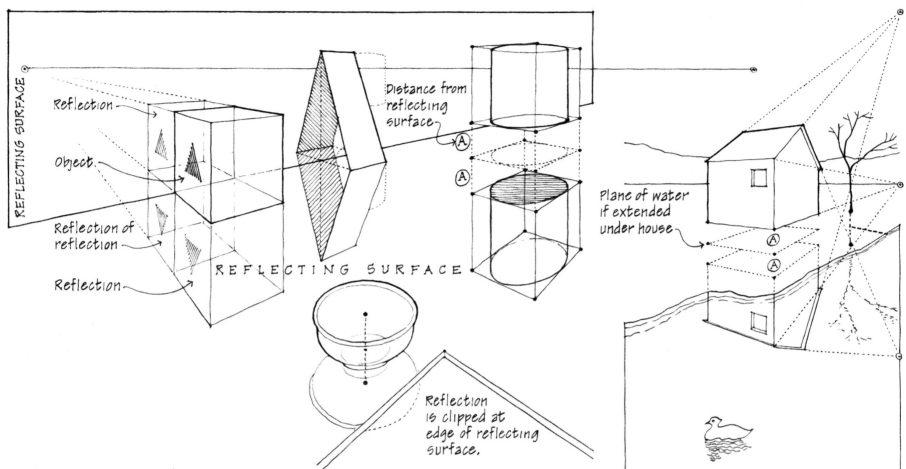

Reflection

Object

Reflection of reflection

Reflection

REFLECTING SURFACE

REFLECTING SURFACE

Distance from reflecting surface

Ⓐ

Ⓐ

Reflection is clipped at edge of reflecting surface.

Plane of water if extended under house

Ⓐ

Ⓐ

REFLECTIONS

A reflecting plane, such as water or a mirror, extends the perspective system. Anything which appears in front of or above the reflecting surface will appear to be behind or below the reflecting surface. The reflecting surface thus presents a mirror or inverted image of the object being reflected.

If an object is sitting directly on the reflecting surface, the reflection of each point on the object lies on a line perpendicular to the reflecting surface, at a distance equal to that from the point being reflected to the reflecting plane. The reflected image follows the same perspective system of lines already established for the original image.

If the object being reflected is at some distance from the reflecting surface, the perpendicular distance from each point on the object to the reflecting surface should first be reflected. Then draw the object's reflection as before. The plane of the reflecting surface should appear to be halfway between the object and its reflected image.

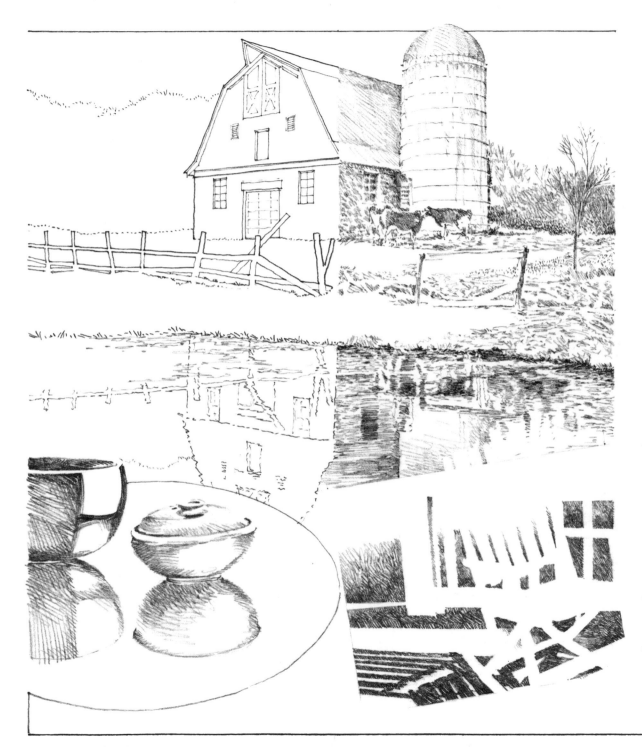

An understanding of linear perspective, and the perspective of shadows and reflections, is useful only if it goes beyond being an exercise in geometry. In order to reveal the depth of our vision, it must be integrated into a drawing composition along with the elements of line, shape, and tonal value.

ENVISIONING
DRAWING FROM IMAGINATION

5

The mind's eye is capable of an inner vision which is not limited to the here and now. It can form, manipulate, and transform images beyond the normal bounds of time and space. These images, however, are often vague and elusive, and can easily be lost to awareness. In drawing what we envision, we take advantage of our ability to think in visual terms and give form to our thoughts and ideas. These drawn images feed back to the mind's eye, further stimulate our imagination, and provide a dialogue between self and image for further exploration and development of ideas. Drawing from imagination thus is an instrument of thought which enhances the creative process.

ENVISIONING

Our perception is not limited to what we can see in the here and now. Images are often summoned or appear spontaneously in response to a sensory perception — something seen, touched, heard, tasted, or smelled. Even without any sort of sensory stimulation, we have the mental faculty of perceiving recollected or imagined images. These images are products of an inner vision as seen through the mind's eye. They are creations of our imagination.

IMAGINATION

To imagine is to form a mental image of something not present to the senses. Easily, almost effortlessly, you can imagine something as soon as it is suggested to you. As you read these words, you can easily visualize:

PEOPLE, such as a close friend or relative, a TV newscaster, or a character from a novel.

PLACES, such as a childhood bedroom, the street where you live, or a scene described in a book.

THINGS, such as a triangle or square, a balloon floating in the air, or a grandfather's clock.

ACTIVITIES, such as riding a bicycle, throwing a baseball, or eating a sandwich.

EVENTS, such as a cube rotating in space, a ball rolling down an incline, or a bird taking off in flight.

CALLING ON VISUAL MEMORIES

Imagination is built on the visual memories of past perceptions. Thus the more we have seen and experienced in a meaningful way, the richer our store of visual images and the more fertile our imagination.

With hindsight we can visualize memories of things, places, and events from the past. With foresight, we are also able to look forward in time and use our imagination to envision a possible future. Imagination therefore enables us to have a sense of history as well as a plan for the future. It establishes connections—visual bridges between the past, the present, and the future.

DRAWING FROM IMAGINATION

We all have the ability to imagine, to think in images, and to foresee. In fact, we use this active image-making process in our day-to-day activities and to acquire many of our skills. Our thought has visual form when we build a cabinet from a set of drawings, evaluate the pattern of pieces on a chessboard, or search for constellations in the night sky. This power of image-making and the creative thought and action it engenders is not limited to the specially gifted few. It is available to all of us.

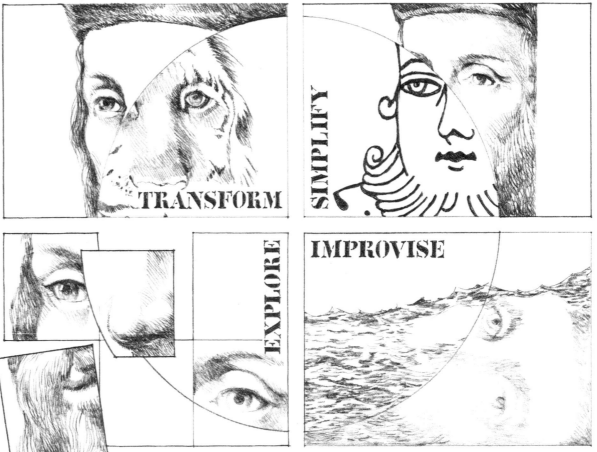

TRANSFORM

SIMPLIFY

EXPLORE

IMPROVISE

For some, the images of the mind's eye can be vivid, controlled, and manipulated. More often, however, they are hazy, brief, and all too illusory. Even if vivid and clear, they can come to mind and just as suddenly disappear. They can easily be lost in awareness and replaced by others in the stream of consciousness, unless captured in a drawing.

The drawing exercises on the following pages can help stimulate you to draw from the imagination. Remember that the drawings you use are not finished renderings, but rather graphic means to visual thought.

Through a series of drawings, progressively TRANSFORM the images on the left to the ones on the right.

THINKING ON PAPER

In drawing, we convert a perception or an idea into lines on paper; we make thought visible. Each image, once drawn, becomes part of our visual world and takes on a life of its own. It stands apart from the creator and begins to direct its own creation.

There is an intrinsic reciprocity between the mind and the act of drawing. Images of thought made visible can be seen and acted upon. They play back into the mind and consequently bring forth further elaboration. They excite and free the mind to explore, develop, and clarify the ideas presented. In this way, they further stimulate the imagination.

FROM THOUGHT TO IMAGE

The act of drawing is a creative process of visualization. It transforms a blank sheet of paper into a visual image which can communicate, inform, instruct, or delight. The source of the image we draw may be what we see in front of us, a visual memory from past experience, or more typically, a combination of both — a marriage of perception and imagination.

PERCEPTION:

FROM THE CONCRETE
TO THE ABSTRACT

Through a process of abstraction, progressively SIMPLIFY these images.

When transcribing what we see onto a piece of paper, we have object images to guide us in our drawing. We can use devices such as grids and visual sighting to measure the accuracy of the drawn image.

We usually start with the concrete, and in the process of drawing, we tend to abstract the perceived image and emphasize what is important to us. The drawing is thus a visual map of how we see and perceive what is significant, and what interests us at the moment.

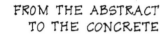

IMAGINATION:

FROM THE ABSTRACT TO THE CONCRETE

IMPROVISE a sequence of drawings based on the images in the first frames.

When we attempt to transcribe what we envision, we have to rely on the pictures in our head, as seen through the mind's eye, to generate the drawn image. This act of drawing cannot be a one-way, linear process. There must be an active interplay between seeing, imagining, drawing, and seeing anew.

In this case, we generally proceed from the abstract to the concrete. We start with a conceptual construct of what we envision, drawing the significant structural features as defined by lines and shapes. This visual framework can then be filled out with matter, form, and details.

 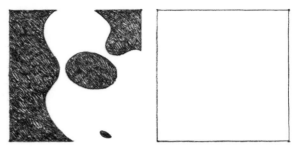

SEARCH for pattern and meaning as you modify and complete these images.

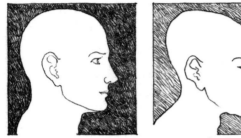

MANIPULATE the structure of these images by reproportioning or rearranging the parts.

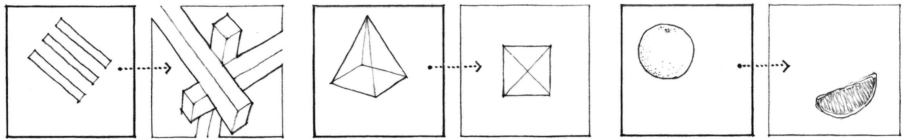

CREATE the illusion of depth and movement in a drawing sequence which relates each pair of images.

EXPLORE: Drawing allows us not only to represent preconceptions but also to explore new possibilities. As we draw, each line has the potential of clarifying, altering, or adding depth to the meaning of the image.

In these exercises, explore the interactive nature of drawing. Be open to the possibilities it presents as you search for pattern, manipulate structure, and create the illusion of depth and movement.

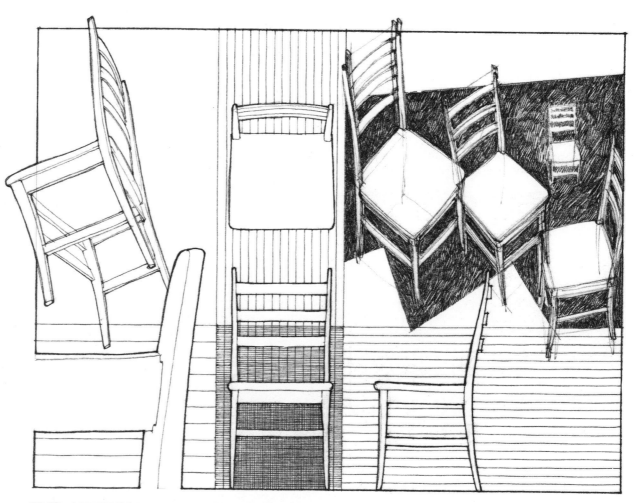

DRAWING VIEWPOINTS

In exploratory drawing, we are able to see or envision from a variety of viewpoints. These alternative points of view give us flexibility in representing our visual thoughts and perceptions. Each type differs, however, in its capacity to facilitate the development of ideas.

The following section discusses the major types of viewpoints and the drawing conventions to which they lead.

2·DIMENSIONAL VIEWS

Orthographic views portray the two-dimensional aspects of a three-dimensional whole. Because they offer fragmentary views of reality, they must be seen as a series of related views. No single orthographic view can adequately communicate a three-dimensional object-form or the space defined by an arrangement of such forms.

Top

Back Side Side

Bottom

Elevation Plan

Section

Elevation

Is this a hat or a doughnut?

These three forms have identical plan views.

ORTHOGRAPHIC VIEWS

Orthographic views are abstract in the sense that they do not match optical reality. Yet, they do have one advantage over more pictorial views. When representing a plane parallel to the picture plane, orthographic views are able to show the plane's true shape and proportions, and can be drawn to scale. This makes orthographic drawings useful in communicating accurate information for the production of designed objects and constructions.

Since orthographic views do not inherently convey depth in the third dimension, whatever depth they have must be implied through the use of graphic depth clues, such as varying line weights and tonal values. In addition, planes which are curved or oblique to the picture plane are shown foreshortened or distorted. This distortion is difficult to convey in a line drawing, which can lead to ambiguity in the reading of an object's true form.

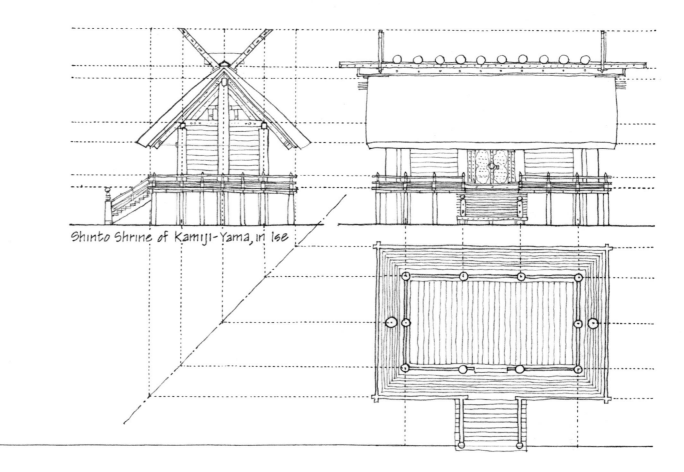

Shinto Shrine of Kamiji-Yama, in Ise

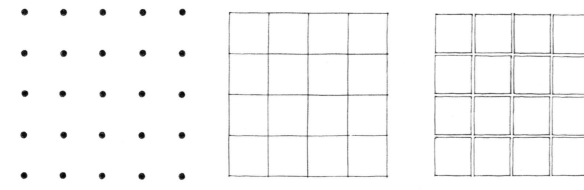

A two-dimensional grid is a useful device for the layout and organization of orthographic views. It provides a neutral base upon which relationships of shape and size can be explored. A grid may consist of dots, lines, or shapes. Dots are subtle reminders of position. Lines represent the vertical and the horizontal, and regulate the spacing of elements. Shapes define areas and emphasize space rather than position.

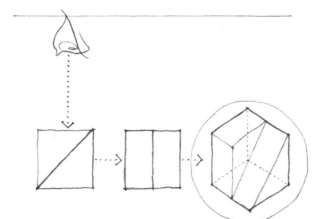

Plan views reveal the horizontal aspects of form and spatial relationships.

Maps are almost always aerial or plan views from above.

Plan views present a conceptual field of action for horizontal forces and movement.

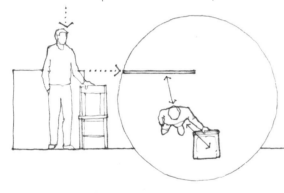

WIND

PLAN VIEWS

A plan view is a view looking down vertically from above. When viewing a small object in this manner, the image is commonly known as a top view.

The strength of plan views is their ability to illustrate the horizontal relationships of what we see or envision. These may be relationships of function, form, interior or exterior space, or of parts within a greater whole. In this way, plan views match our conceptual view of things and display the field of action for our thoughts and ideas.

Charles Bradley's Twist: Black to move and mate in three.

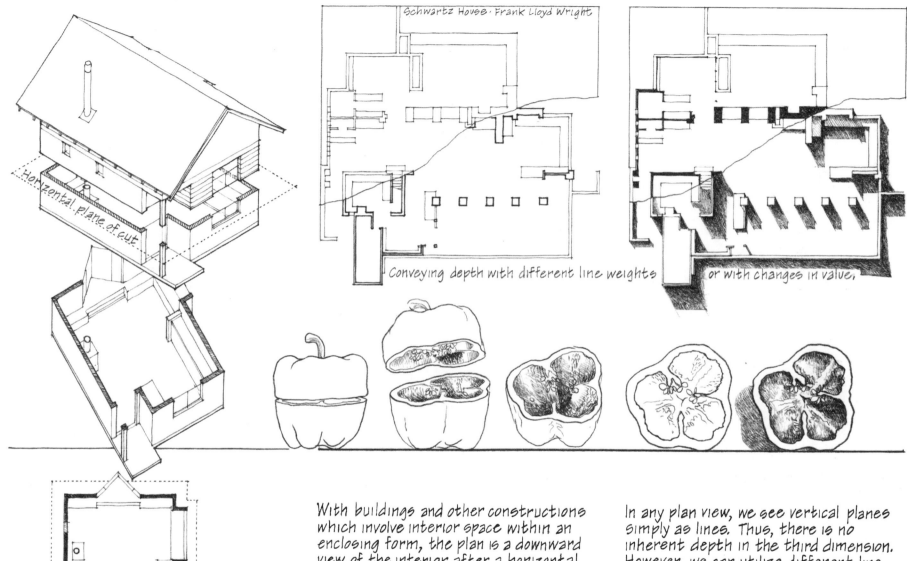

Horizontal plane of cut

PLAN

Schwartz House · Frank Lloyd Wright

Conveying depth with different line weights or with changes in value.

With buildings and other constructions which involve interior space within an enclosing form, the plan is a downward view of the interior after a horizontal plane has been cut through the construction and the top part removed. In this type of plan drawing, it is important to emphasize in a graphic way what has been cut, and what can be seen through space beyond the plane of the plan cut.

In any plan view, we see vertical planes simply as lines. Thus, there is no inherent depth in the third dimension. However, we can utilize different line weights, a range of tonal values, and shadows to convey the desired sense of depth.

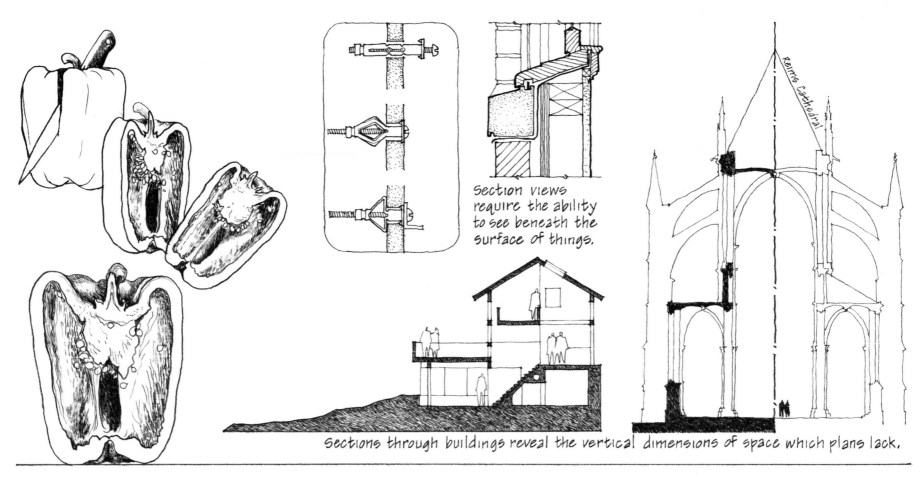

Section views require the ability to see beneath the surface of things.

Reims Cathedral

Sections through buildings reveal the vertical dimensions of space which plans lack.

SECTION VIEWS

A section view is similar to a plan view in that it also involves a cut through what we are drawing. In this case, the cut is a vertical slice and the view is horizontal.

Section views are useful in portraying the vertical and one of the horizontal dimensions of a form's interior material, composition, or assembly. Sections cut through buildings and other constructions with interior spaces can also illustrate the vital relationships between forms and the spaces they define.

Section views of interior spaces include interior elevations seen beyond the vertical plane of the cut. In order to convey a sense of depth, it is important to emphasize the materials that are cut in section and to distinguish these sections from what is seen beyond in elevation.

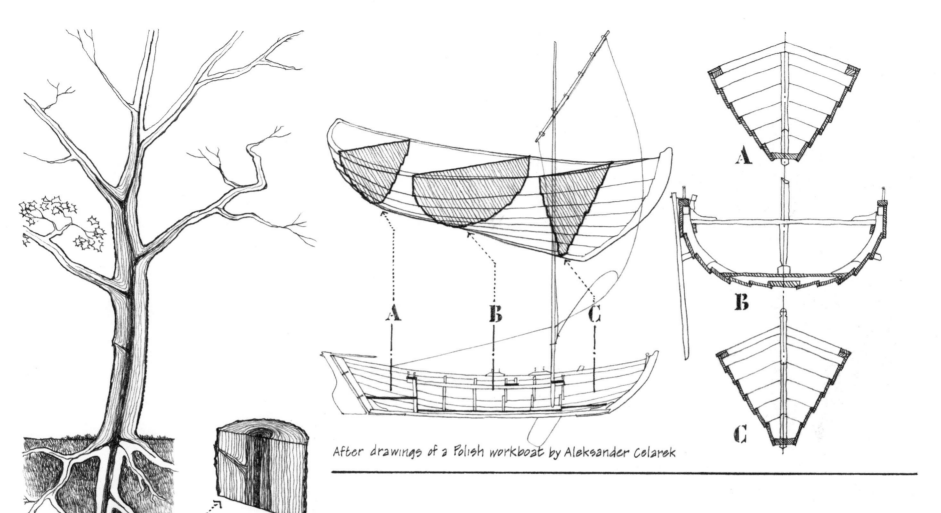

After drawings of a Polish workboat by Aleksander Celarek

Cross-sections refer to sections cut through the short dimension of things, while longitudinal sections are cut through the long dimension. In either case, it is necessary to relate section drawings to the plan view by indicating in the plan where the section cuts are made and in what direction we are looking.

A series of section views, taken in sequence, can often reveal changes in complex and irregular forms better than a single sectional view.

A simple line drawing of an elevation can be ambiguous without the use of graphic depth clues.

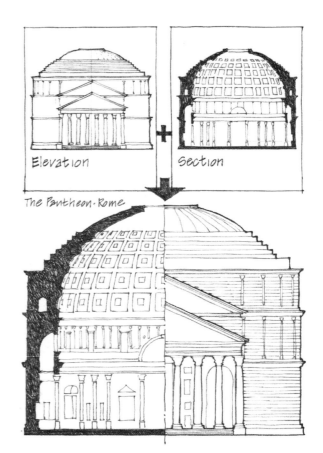

Elevation

Section

The Pantheon·Rome

ELEVATION VIEWS

An elevation view is a horizontal view looking at something from the outside. Elevations therefore emphasize the exterior vertical surfaces of object-forms and their silhouettes in space.

Frontal views of vertical surfaces are closer to perceptual reality than either plan or section views. Yet they cannot represent the diminishing size of planes as they recede from the viewer. When we draw an object's surfaces in elevation, we must again rely on graphic cues to convey depth, curvature, or obliqueness.

While an elevation drawing can show the context of object-forms and the relationships between a number of forms in space, they do not reveal any information about their interiors. Elevations and sections, however, can be combined when drawing symmetrical forms and constructions.

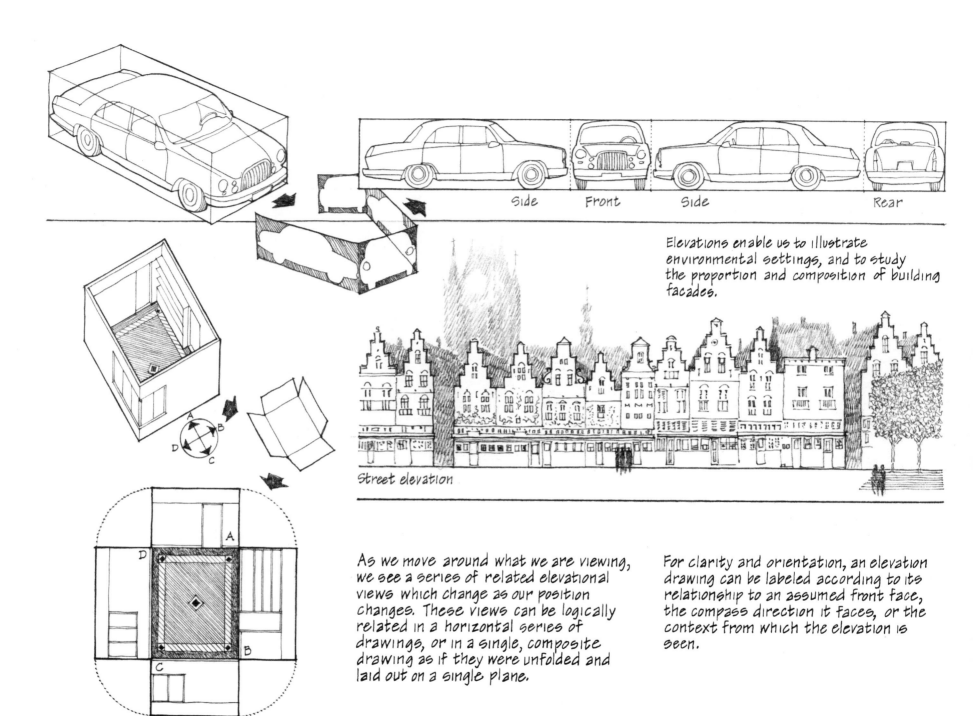

Side Front Side Rear

Elevations enable us to illustrate environmental settings, and to study the proportion and composition of building facades.

Street elevation

As we move around what we are viewing, we see a series of related elevational views which change as our position changes. These views can be logically related in a horizontal series of drawings, or in a single, composite drawing as if they were unfolded and laid out on a single plane.

For clarity and orientation, an elevation drawing can be labeled according to its relationship to an assumed front face, the compass direction it faces, or the context from which the elevation is seen.

3 · DIMENSIONAL VIEWS

Three-dimensional views minimize the abstraction of orthographic views and deal simultaneously with height, width, and depth in a single image. They are therefore closer to our perceptual view of reality. The two principal types of three-dimensional views are paraline and perspective views. Both of these can be effectively laid out and composed with a three-dimensional grid.

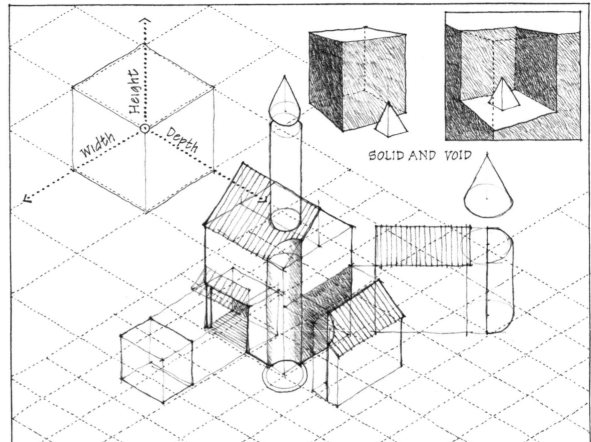

SOLID AND VOID

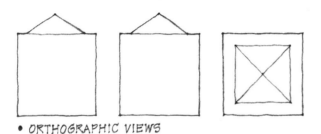

• ORTHOGRAPHIC VIEWS

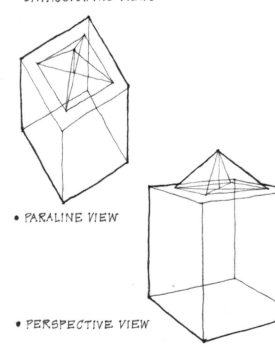

• PARALINE VIEW

• PERSPECTIVE VIEW

The cube is the basic form upon which we can build a three-dimensional grid. It is useful since its edges and planes are parallel to the x, y, and z coordinate system. It can therefore be used as a unit of measurement to scale height, width, and depth concurrently in any three-dimensional view.

A cube can be subtracted from or added on to. It can be subdivided or multiplied. In these ways, various derivations and combinations of the cube can be generated and used to define the geometry and structure of more complex forms and spaces.

The use of 2-dimensional views leads to the development of symbols and diagrams.

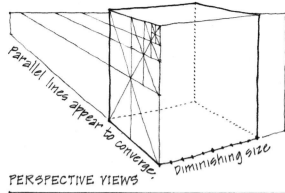

PERSPECTIVE VIEWS

Parallel lines appear to converge. Diminishing size.

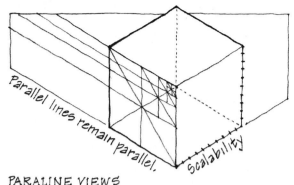

PARALINE VIEWS

Parallel lines remain parallel. Scalability.

When drawing what we envision, however, we tend to add depth to even the flattest representations. We can do this easily with paraline drawings.

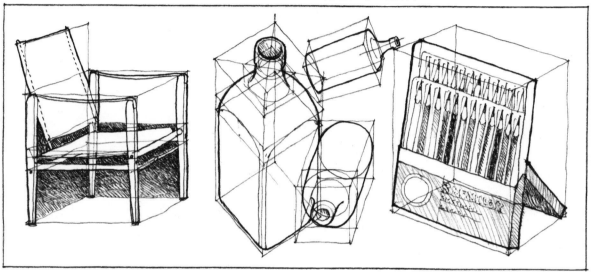

PARALINE VIEWS

Paraline views are pictorial views which can communicate three-dimensional forms and spatial relationships. They can be distinguished from perspectives by the following conventions. Parallel lines remain parallel and do not converge as they do in perspective. In addition, lines parallel to the x-, y-, and z-axes are normally not foreshortened and can be drawn to scale.

Because of their scalability and lack of convergence, paraline views are more easily drawn than perspectives and provide a quick method for visualizing things in three dimensions. They are particularly appropriate for drawing small-scale objects since their forms, even in perspective, do not exhibit a sharp degree of convergence of parallel lines.

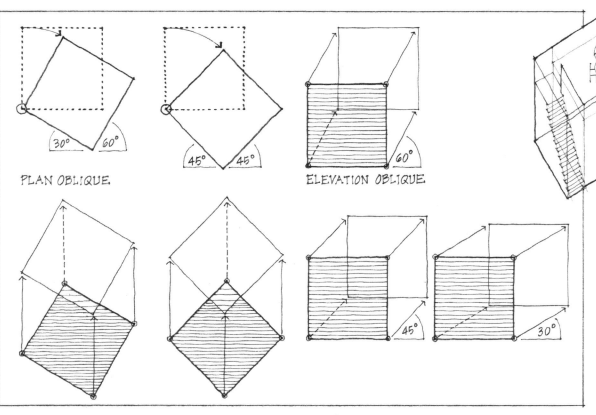

PLAN OBLIQUE. ELEVATION OBLIQUE.

OBLIQUE VIEWS

An oblique view is a paraline drawing which uses a horizontal or vertical surface of what we are drawing as a base plane. To illustrate this, imagine a cube. We can take its bottom face and draw it as a square. We can rotate this square at some angle to the horizontal. Next, we can project vertical lines a distance equal to the side of the cube from each of the base square's four corners. Then we can draw the top face of the cube at the same size and orientation as the base square.

We can also draw the front face of the cube as a square, and then project the top, bottom, and sides back at some angle to form an elevation oblique. If we use drafting triangles, the angle for receding planes in an oblique view may be 30°, 45°, or 60°. In sketching, we need not be as precise, but once we establish an angle, then we should use it consistently. We should also remember that the angle we use affects how much we see of the receding planes.

An oblique view can combine the orthographic views of plan, section, and elevation into a single drawing.

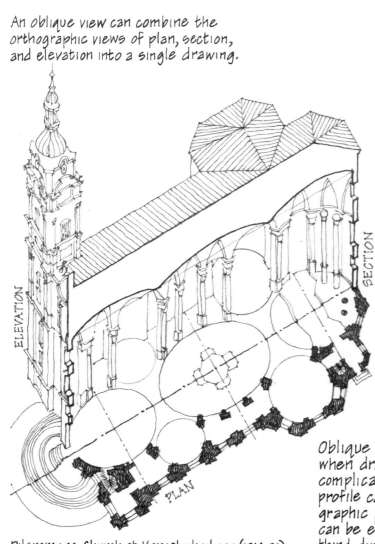

ELEVATION

SECTION

PLAN

Pilgramage Church at Vierzehnheiligen (1744-72)
Balthasar Neumann

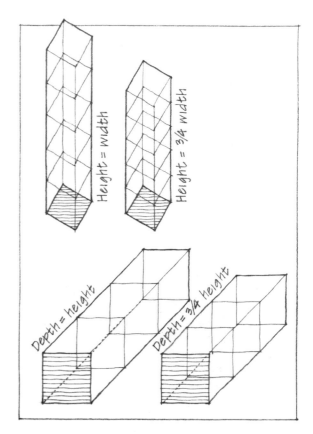

Height = width

Height = 3/4 width

Depth = height

Depth = 3/4 height

Oblique views are particularly useful when drawing an object which has a complicated or curvilinear profile. This profile can first be drawn in an orthographic plan or elevation view. Then it can be extended or extruded into the third dimension by simply drawing a series of parallel lines.

When drawing oblique views, dimensions perpendicular to the base which are relatively long or deep can appear to be exaggerated. In such cases, it is possible to foreshorten lines in that direction, as long as all lines in that direction are foreshortened to the same degree.

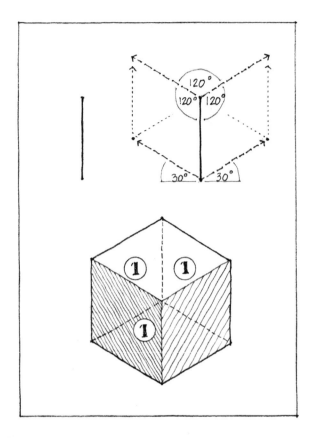

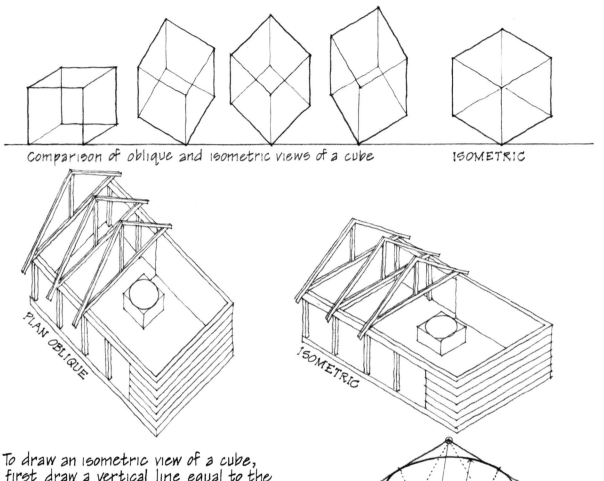

Comparison of oblique and isometric views of a cube ISOMETRIC

PLAN OBLIQUE

ISOMETRIC

An isometric view is a paraline drawing where the primary x-, y-, and z-axes are equally 120° degrees apart on the picture plane. All horizontal and vertical planes are projected back into the depth of the drawing. It presents a slightly lower angle of view than an oblique view and tends not to emphasize one plane over another. It gives a truer image of relative proportions and is not subject to the distortion inherent in oblique views.

To draw an isometric view of a cube, first draw a vertical line equal to the height of the cube. Then draw lines from the top and bottom of the vertical. These should be at a 30° angle from the horizontal and be the same length as the vertical. Complete the cube by drawing lines which are parallel to the lines already drawn.

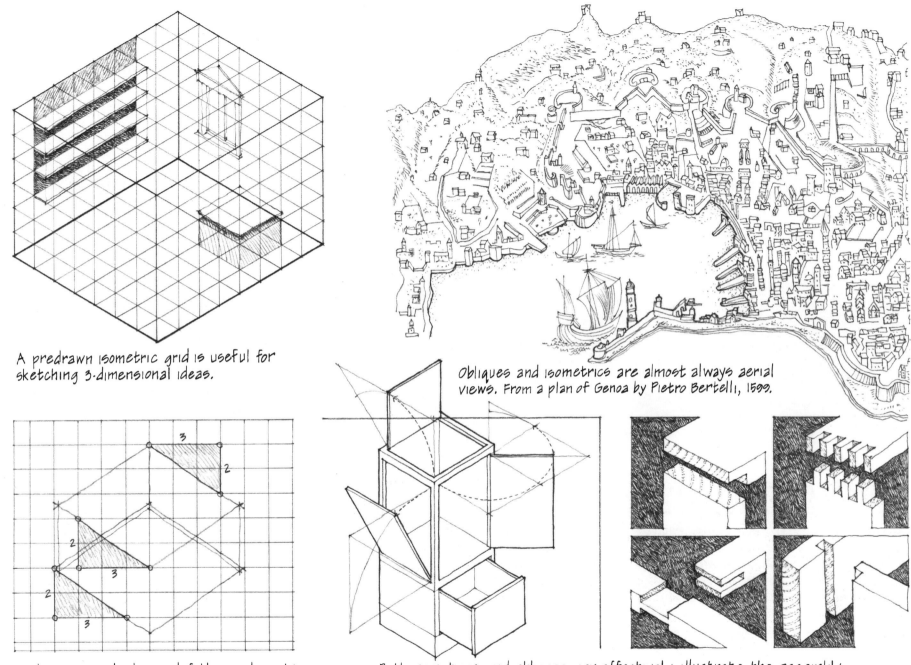

A predrawn isometric grid is useful for sketching 3-dimensional ideas.

Obliques and isometrics are almost always aerial views. From a plan of Genoa by Pietro Bertelli, 1599.

Grid paper can also be used if the grid points are seen as reference points for angled lines.

Both isometrics and obliques can effectively illustrate the assembly and operation of designed objects.

159

- Looking up at cube

- Looking at cube

- Looking down at cube

- Extending the geometry of the cube

- Filling the cube with related geometric forms

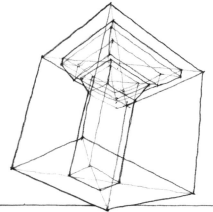

- Grouping cubes

PERSPECTIVE VIEWS

Perspective views are more illustrative of how we perceive reality than either orthographic or paraline views. They are highly pictorial and ideal for representing architectural-scale forms and spaces. But because they can easily be distorted, visual judgment based on experience is required to properly portray scale and depth.

In drawing perspective views, we can again begin with the basic cube. Once we are able to draw cubes from various viewpoints in perspective, we can generate other geometric solids — the cylinder, cone, and pyramid. These regular forms can be composed and organized in a number of ways to form the structural framework for more complex forms.

The act of drawing is the only way to develop skill in sketching cubes and the related forms they generate. Practice, therefore, is essential. Begin by tracing the cubes in the illustrations above. Also refer back to the discussion of linear perspective, pages 98-135.

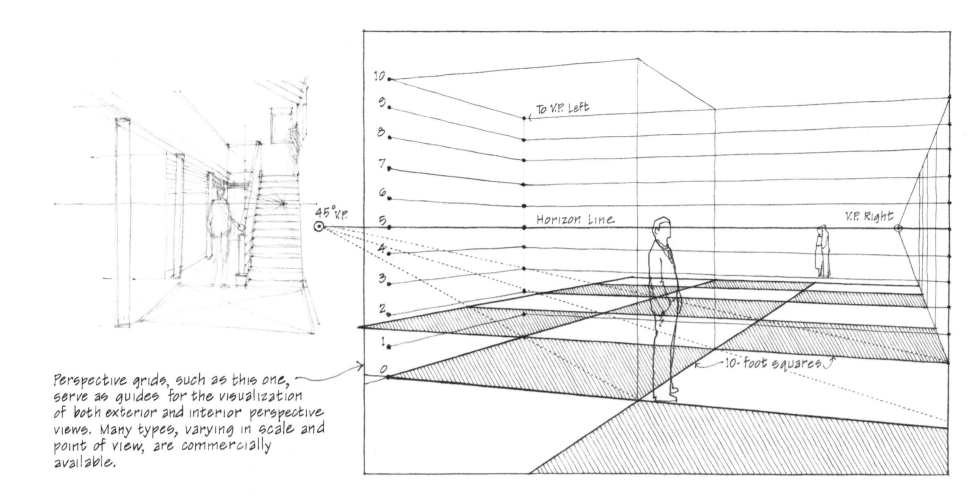

To V.P. Left

10
9
8
7
6
5 Horizon Line V.P. Right
4
3
2
1
0 10-foot squares

45° V.P.

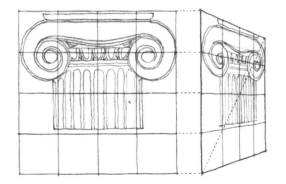

Perspective grids, such as this one, serve as guides for the visualization of both exterior and interior perspective views. Many types, varying in scale and point of view, are commercially available.

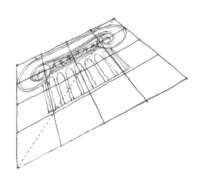

When attempting to draw a freeform or irregular shape in perspective, we can first draw a regular grid over the shape in an elevation or plan view. After drawing the same grid in perspective, we can transfer to this perspective grid the points where the shape crosses the grid lines in the elevation or plan view. Using these points as a guide, we can draw the shape in perspective.

BUILDING ON GEOMETRY

If we are able to break down what we see or envision into regular geometric solids, we can more easily draw them and study their relationships. We can reorganize the forms in an additive manner, or transform them in a subtractive manner. The resulting geometric structure can then serve as a framework for the development and refinement of the forms and spaces we are designing.

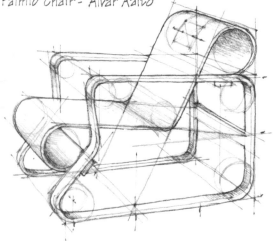

Paimio Chair - Alvar Aalto

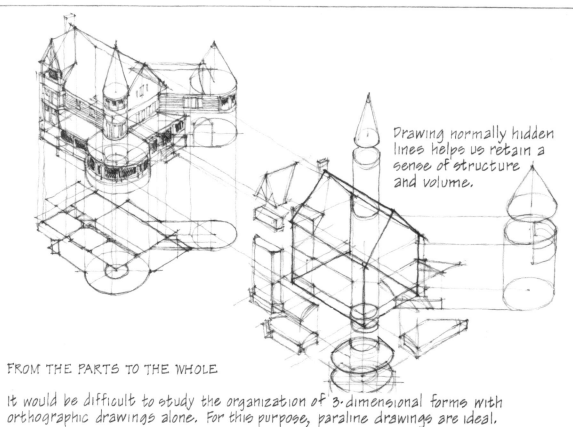

Drawing normally hidden lines helps us retain a sense of structure and volume.

FROM THE PARTS TO THE WHOLE

It would be difficult to study the organization of 3-dimensional forms with orthographic drawings alone. For this purpose, paraline drawings are ideal.

ADDITIVE FORMS

A cube can be extended horizontally, vertically, as well as into the depth of a paraline or perspective view. The cube thus becomes a three-dimensional unit of measurement, which can be used to structure and regulate a variety of derivative compositions.

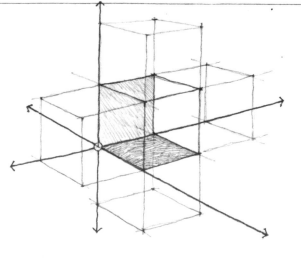

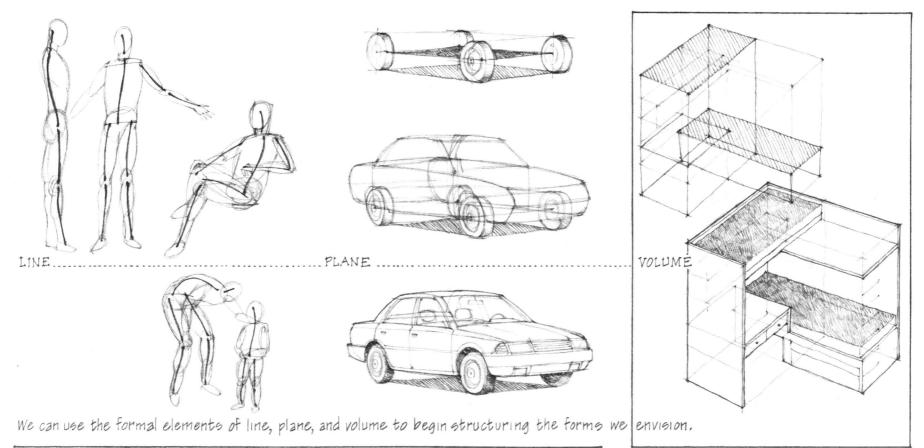

LINE..PLANE...VOLUME

We can use the formal elements of line, plane, and volume to begin structuring the forms we envision.

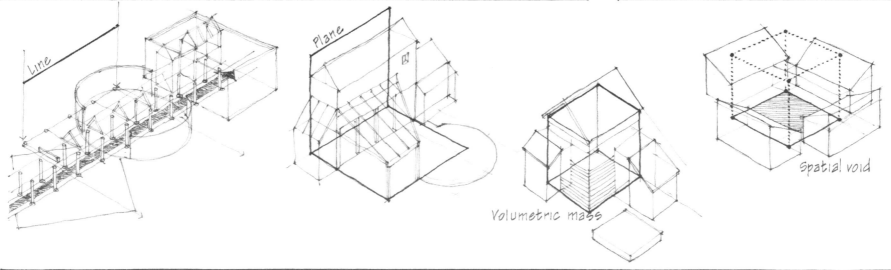

Line

Plane

Volumetric mass

Spatial void

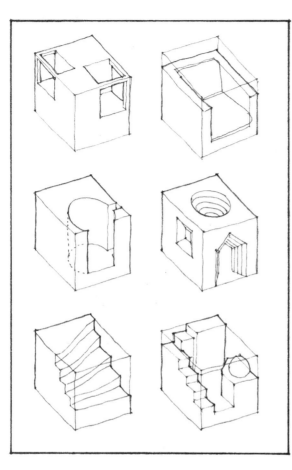

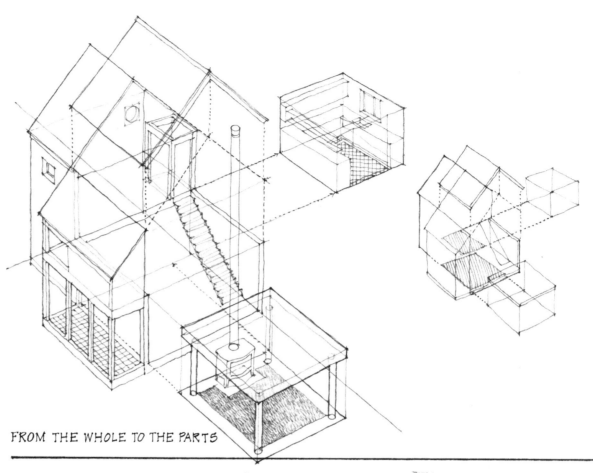

FROM THE WHOLE TO THE PARTS

SUBTRACTIVE FORMS

Working from a simple, regular form, we can selectively remove portions without losing the identity and sense of the whole. In this subtractive process, we use the solid-void relationship between form and space as the generating principle for what we create.

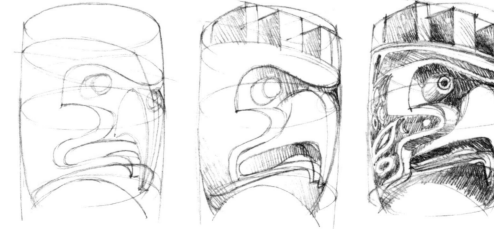

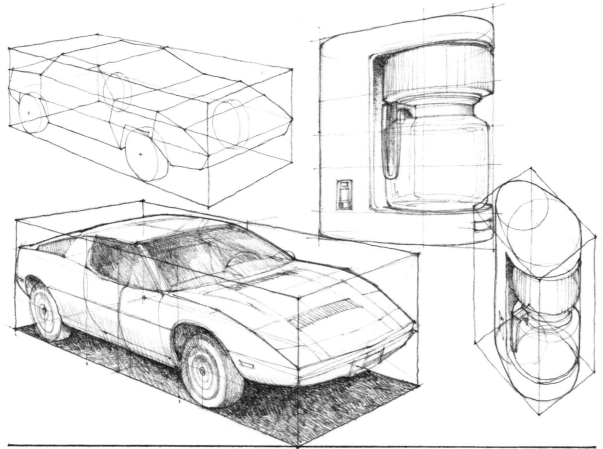

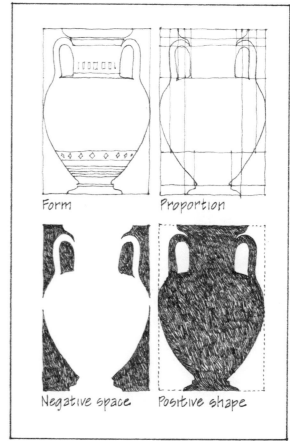

Form Proportion

Negative space Positive shape

We must be willing to try different points of view to see which combination of orthographic, paraline, and perspective drawings best illustrates our vision.

In any single view we draw, we must be continually aware of shape and proportion.

• STRUCTURE OF THE HUMAN BODY

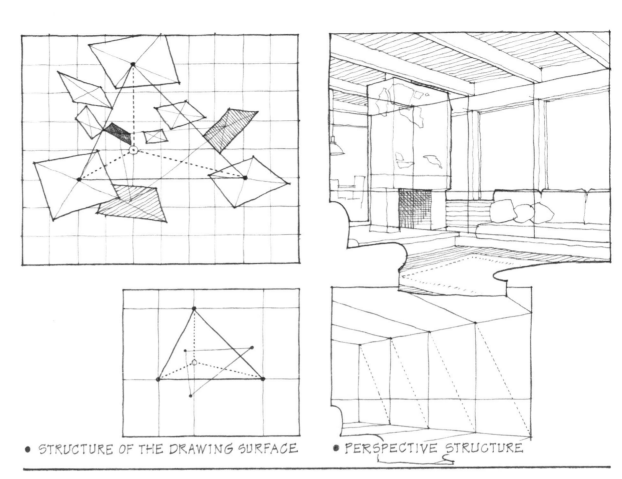

• STRUCTURE OF THE DRAWING SURFACE

• PERSPECTIVE STRUCTURE

COMPLEX FORMS

When drawing a complex organization of forms, we can work in both an additive and a subtractive manner. The resulting formal and spatial composition is usually an outcome of structure, whether physical, visually perceived, or conceptual.
In this process of seeing structure, we must first create the organizing framework before filling out and refining the image.

• PHYSICAL STRUCTURE

● SPATIAL STRUCTURE

● URBAN STRUCTURE

REFINING THE IMAGE

Once we have the basic arrangement of forms in space, or the structure of a space as defined by the forms, we can begin to refine the image. Working from the general to the specific, we can begin to describe qualities of form, space, texture, and light without losing a sense of the whole.

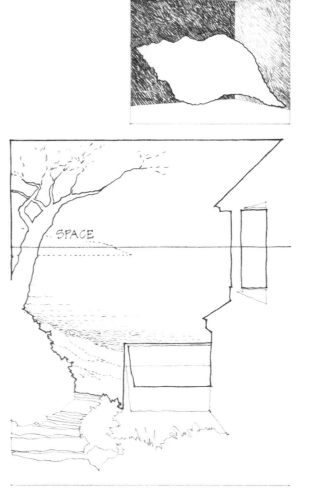

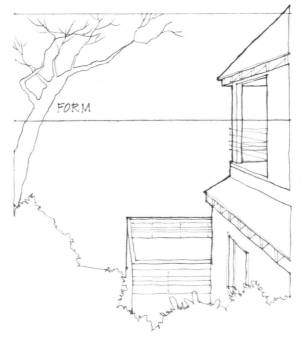

It is important to understand that we need not be concerned with the rendering of a photographic reality. Instead, we should attempt to communicate specific qualities of form and space, and this often means tolerating a degree of incompleteness.

The very incompleteness of a drawn image acknowledges the viewers of that image and invites them to participate in its completion. Even our perception of optical reality is usually incomplete, being edited by the knowledge we bring to the act of seeing and our momentary needs and concerns.

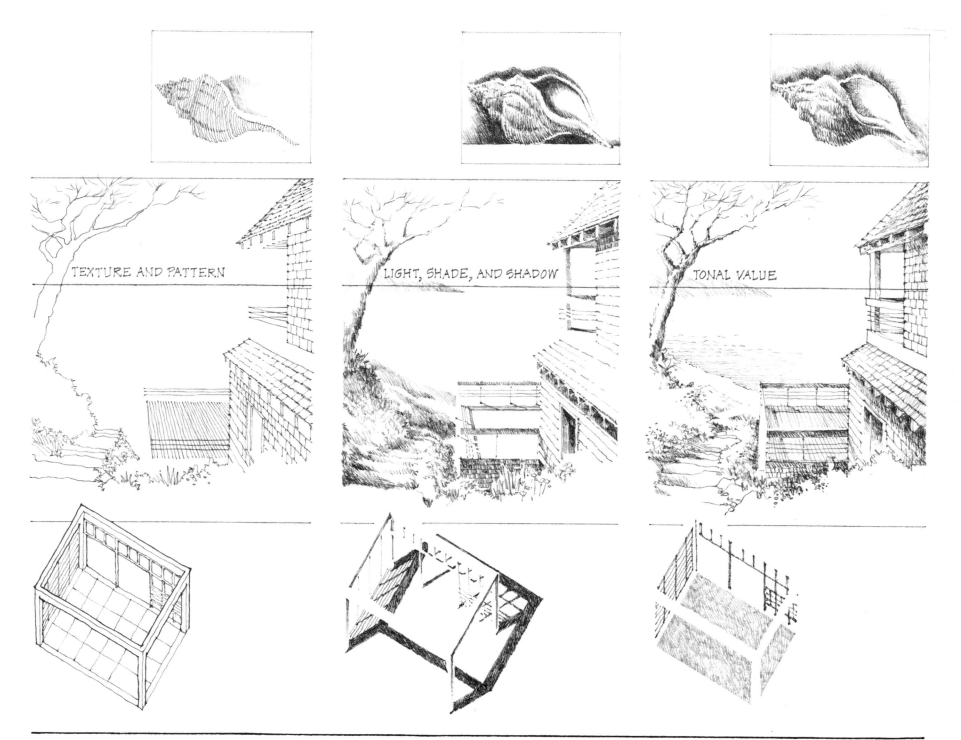

TEXTURE AND PATTERN

LIGHT, SHADE, AND SHADOW

TONAL VALUE

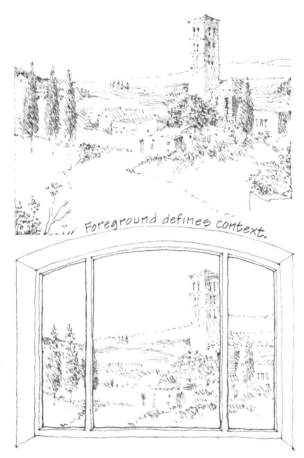

Foreground defines context.

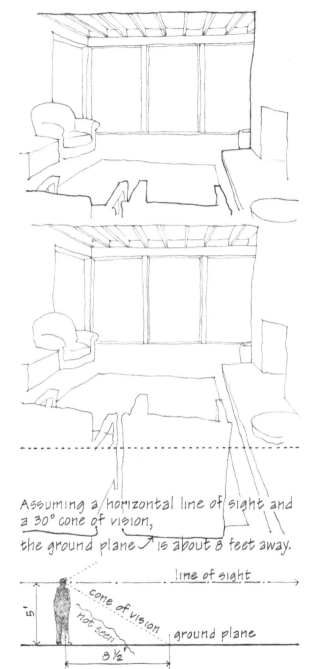

CONVEYING SPACE

In drawing views of an exterior or interior space, we should attempt to give the viewer a sense of being in a place with distinctive characteristics. However, before refining the parts — material surfaces, colors, and textures, and the quality of light — we must first define the form, scale, and enclosure of the space.

We should select a viewpoint which frames the view in such a way that suggests the viewer is within a space, not merely on the outside looking in. To do this, we should include foreground elements — overhead, to the side, or immediately in front of us — through which or beyond which we experience the space.

Assuming a horizontal line of sight and a 30° cone of vision, the ground plane is about 8 feet away.

line of sight

cone of vision

not seen

ground plane

5'

8½'

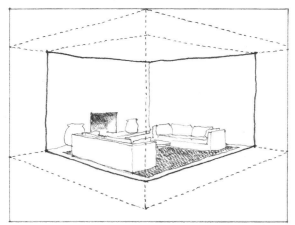

We can see a space in its entirety only if we stand outside its boundaries.

Maintain continuity of space into the depth of a perspective.

Avoid symmetrical views into a corner.

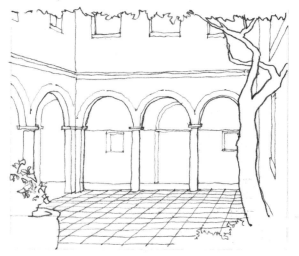

It is usually advantageous if we can see three sides of a space, i.e. those forms which define the space on three sides. If we only see two sides meeting at a corner, the view could look like a stage set and lack the feeling of enclosure which gives form to the space.

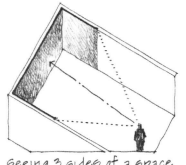

Seeing 3 sides of a space

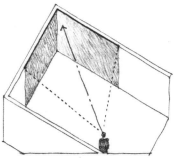

Seeing 2 sides of a space

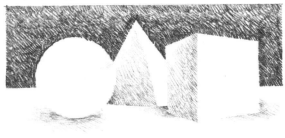

Contrasting tonal values define shapes and forms.

Cast shadows reveal forms in space and convey a sense of depth.

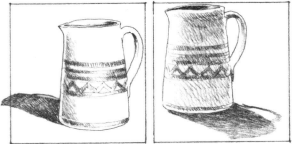

The orientation of shadows tells us where the light source is.

SEEING LIGHT

Light makes form visible by illuminating surfaces and textures. But without the contrast of shaded surfaces and cast shadows, it would be difficult to see the effects of light on forms in space. In drawing, therefore, the principal reasons for using light and dark values are to enhance our perception of form, differentiate one form from another, articulate spatial relationships, and to convey a sense of depth.

When drawing what we see, we have the actual conditions of light, shade, and shadow to guide our drawing and rendering of tonal values and textures. When drawing what we envision, we have no such guide since the images of the mind's eye are not always crystal clear. Therefore, we must rely on certain principles which can direct our use of shade and shadows.

- If our purpose is to define shape and form, the precise construction of cast shadows is not necessary.

- A discernible contrast in tonal value is essential for the perception of edges and corners.

- Shaded surfaces and cast shadows are usually not opaque, nor consistent in tonal value.

The visual qualities of cast shadows — their length, clarity, and tonal value — are clues to the quality of light, whether high or low, bright or diffuse.

The techique for rendering tonal values should reflect the texture of surfaces.

Forms may be hidden from view but the shadows they cast can reveal their shape......................................>

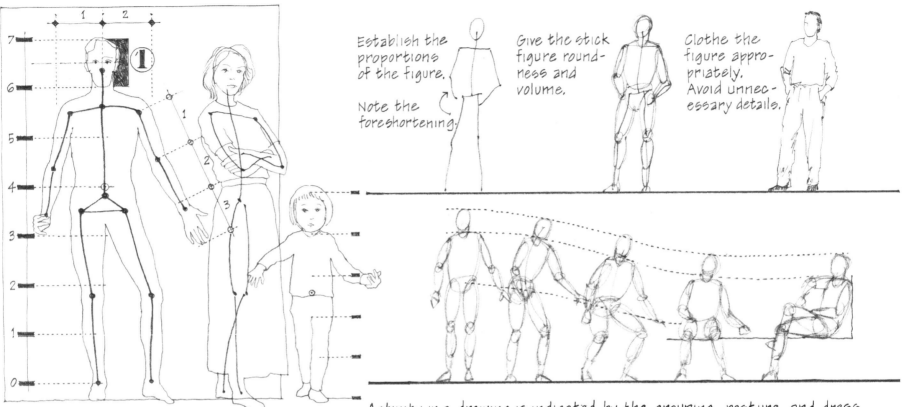

Establish the proportions of the figure.

Note the foreshortening.

Give the stick figure round-ness and volume.

Clothe the figure appro-priately.
Avoid unnec-essary details.

Activity in a drawing is indicated by the grouping, posture, and dress of human figures. Use the relative proportions of body parts as a guide when sketching different postures and gestures. Dress figures appropriately and remember that the amount of detail shown diminishes with distance and scale.

CONSIDERING USE

It is useful, particularly when drawing architectural and urban scenes, to include people to establish scale and use, and to describe our relationship to the environment. The figures we use to populate a drawing should be in scale with the environment and be arranged to indicate the nature of the activity appropriate to the place. The figures become important elements in a compo-sition and should not conceal or distract from a drawing's essential features.

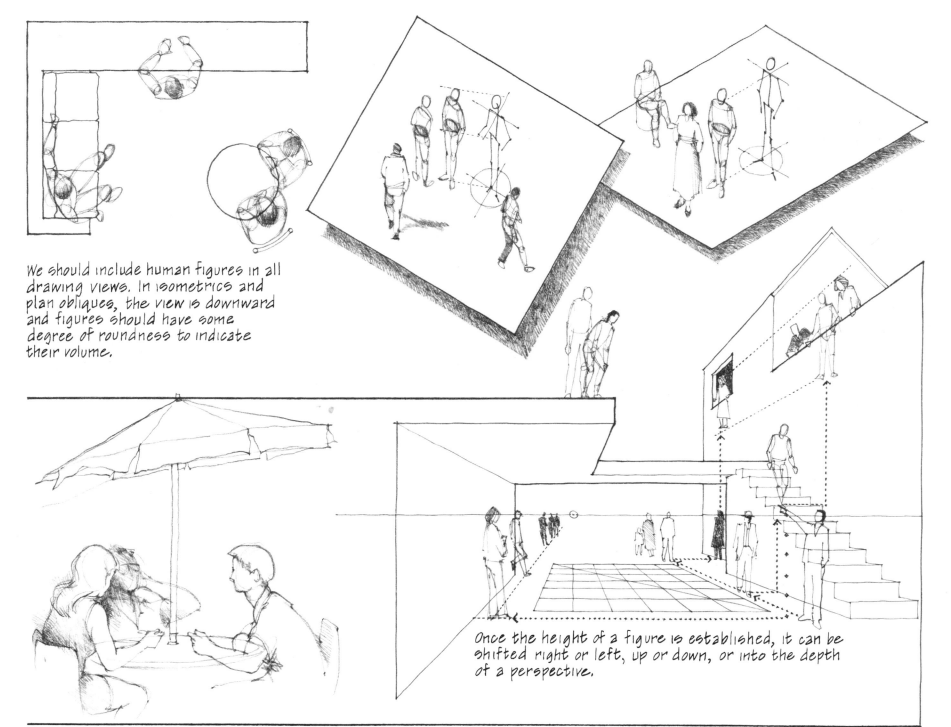

We should include human figures in all drawing views. In isometrics and plan obliques, the view is downward and figures should have some degree of roundness to indicate their volume.

Once the height of a figure is established, it can be shifted right or left, up or down, or into the depth of a perspective.

175

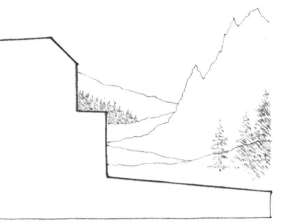

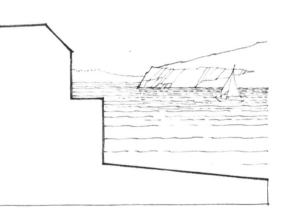

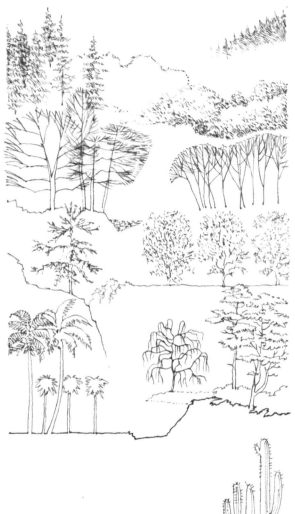

DRAWING CONTEXT

In addition to people, there are other elements which we can use to suggest the context for what we draw. These typically include typography, landscape, and plant materials. The ambience of a place may also be due to a quality of light, material colors and textures, the scale and proportion of spaces, or the cumulative effect of details.

The drawing of these elements must take into account their shape, scale, pattern, values, and texture. Keep in mind these are simply parts of a greater whole, and the amount of interest and attention we give them should be proportional to their importance to the overall composition.

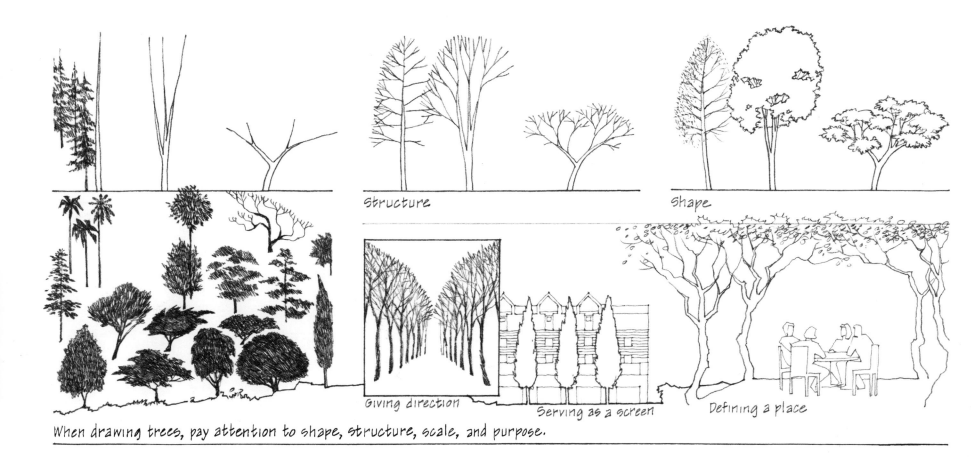

Structure

Shape

Giving direction

Serving as a screen

Defining a place

When drawing trees, pay attention to shape, structure, scale, and purpose.

Within any given context, details provide visual clues to the nature of what we are drawing. The combination of details we choose to use, therefore, should clarify rather than confuse the image.

DETAILS THAT COUNT

The mind can too often pass judgment without looking at the significant details of a situation. In trying to grasp the visual whole, we should be aware of the need for detail development and the interest and variety it brings to a drawing.

Details must be visually related to or placed within a structured pattern to make sense. This context serves as a visual reminder of the scale with which we are dealing. Ideally, this context should be drawn in lightly to provide a framework for a particular area to be worked on in greater detail and more elaborately.

The most significant details usually occur at transitions in shape and form. These details are directly related to the way materials turn corners or meet each other in a construction.

All materials have some degree of thickness. If the scale of a drawing permits, this thickness should be indicated along edges and contours, and where materials overlap at corners.

The closer we are to something, the more detail we can see. However, we can never include every detail in a drawing. Since some editing is necessary, we must decide what is important and essential to complete the image. Remember that a few details can suggest a lot. Including too many details, in fact, can deprive a drawing of the contrast it needs between complexity and areas of little or no details. By this contrast, detailed areas will naturally gain more emphasis.

180

SPECULATION
DRAWING AND CREATIVITY

6

With imagination, we can visualize what once was as well as speculate on what might be. In using drawing to enhance this power of visualization, we rely not only on our ability to draw fluently and convincingly, but also on certain attitudes toward the drawing process itself. We must see the image-making process as a creative endeavor which has at its heart the speculative nature of reflection and thought. Drawing is ambiguous — we draw out our thoughts without fully knowing where the process will lead. Drawing encourages reflection — while drawn images represent what we envision, they also present opportunities for exploration and discovery. Drawing stimulates creativity — it operates in the space between the real and the imaginary.

DRAWING AS SPECULATION

The process of drawing images on paper necessarily involves speculation. We can never determine beforehand precisely what the final outcome will be. The developing image on paper gradually takes on a life of its own. We must be open to the possibilities it presents as we reflect on and explore the thoughts and ideas it makes visible.

SPECULATE: TO PONDER. TO BE CURIOUS ABOUT. TO REVIEW SOMETHING IDLY.

After Paul Klee

WE MUST TRUST OUR INTUITION IF WE ARE TO MOVE FORWARD IN THE DRAWING PROCESS.

FLUENCY ENABLES US TO PUT THOUGHTS AND IDEAS DOWN ON PAPER INTUITIVELY.

FLEXIBILITY ALLOWS US TO TAKE A VARIETY OF APPROACHES, IF WE CAN TOLERATE AMBIGUITY WE OPEN UP TO MORE POSSIBILITES.

MAKING CONNECTIONS IS

A CREATIVE PROCESS

Drawing is a creative, interactive process wherein we continuously evaluate the image as we search for a congruence between the image we hold in the mind's eye and the one we are drawing. If we draw blindly, as if following a recipe, we limit ourselves only to a preconceived image and miss opportunities for discovery along the way.

Based on idea and developmental sketches by Henry Moore. RECLING FIGURE, 1935. Henry Moore▸

WITH SYNTHESIS AND SELECTIVITY, WE CAN DRAW WITH CLARITY.

ESSENTIAL TO SEEING THE PATTERNS AND RELATIONSHIPS THAT MAKE UP THE WHOLE.

A drawing can represent curiosity in the purest sense. Things come to mind as we view a drawing in progress, which can change our perception of the problem at hand and suggest possibilities not yet conceived. It allows us to explore avenues which could not be foreseen before the drawing was started, but which generate ideas along the way.

Despite the open-endedness of the drawing process, we must be in control so that the emerging image does not take over completely the way we draw. We must always be mindful of goal and purpose, and be selective in the direction we take in developing a drawing.

TRUST IN INTUITION

We must rely on intuition as a guide in the search for possibilities and to outline choices. Intuition, however, is based on informed experience. We cannot draw on intuition and draw out what is not already within each one of us. Still, drawing can lead the way in this intuitive search for ideas and provide a transition from present to future possibilities.

HUMAN FACTORS

ORGANIZATION OF THE DRAWING SURFACE

DESCRIPTIVE WORDS TO IMAGES

3·DIMENSIONAL FORMS IN SPACE

A COLLAGE OF IMAGES

A MULTITUDE OF POSSIBILITIES

A drawing does not arrive full-blown and complete. Drawings of first thoughts are necessarily tentative, speculative, and exploratory. We may start with specific aspects of a particular form or setting, or begin with a more generalized image of a concept or construct. In any case, where we start is not as important as where we end up. The most important, thing, therefore, is to get the first, intuitive images down on paper.

A COLLECTION OF DETAILS

"A hunch is creativity trying to tell you something."

Frank Capra

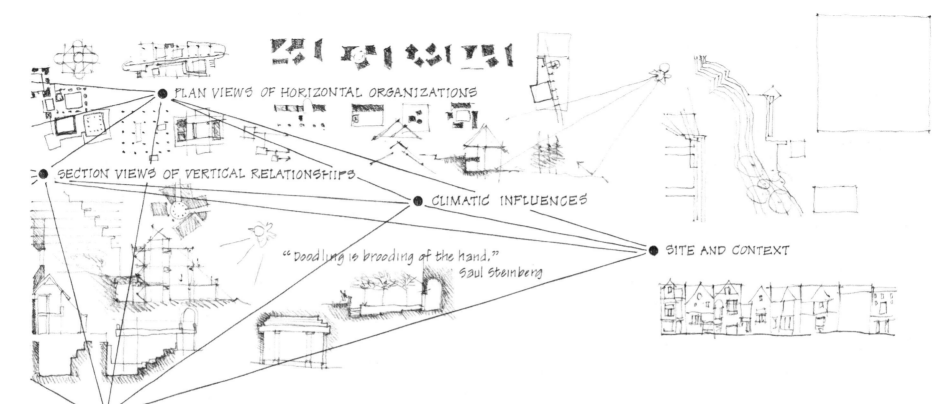

PLAN VIEWS OF HORIZONTAL ORGANIZATIONS

SECTION VIEWS OF VERTICAL RELATIONSHIPS

CLIMATIC INFLUENCES

SITE AND CONTEXT

"Doodling is brooding of the hand."
Saul Steinberg

STRUCTURAL PATTERNS

TAKE ADVANTAGE OF CHANCE

The first sketches we draw are similar to the outlines we use to organize the material for an essay. They help us distill subject matter down to essentials and decide what is important. As we draw, the subconscious works its way in and the mind's eye filters out what is of consequence. The more important aspects or features will tend to rise to the surface while lesser ones are discarded in the process.

The smaller the initial sketch, the broader the concept it can form. Small sketches are useful since they allow a gamut of possibilities to be explored. Sometimes a clear direction will emerge quickly. At other times, many drawings are required to reveal the proper course of action. In either case, drawing ideas out stimulates the development of alternative strategies in a fluent and flexible manner.

BE FLUENT

To be fluent in the creative process is to be able to generate a wide range of possibilities and ideas. To be fluent in the drawing process is to be intuitive when placing pencil to paper, responding with ease and grace to one's thoughts. We must be able to keep up with our thoughts, which can be fleeting.

We are able to put thoughts down on paper easily in writing. To develop this same fluency in drawing, we must practice on a regular basis. We learn to draw only by drawing. One way to facilitate continual practice is to keep a sketchbook and to draw in it whenever and wherever possible.

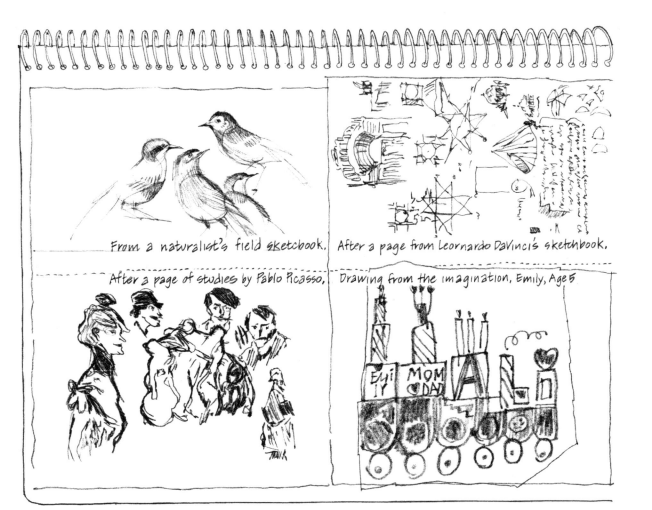

From a naturalist's field sketchbook.

After a page from Leonardo DaVinci's sketchbook.

After a page of studies by Pablo Picasso.

Drawing from the imagination, Emily, Age 5

Before drawing can become an intuitive part of our visual thinking, we must first be able to draw slowly, deliberately, and accurately. While speed may come with pushing oneself to draw faster, speed without the discipline of judgment is counterproductive.

Speed comes naturally only with practice and repetition over an extended period of time. Practice until the act of putting down a line is an automatic reflex, a natural response to what we are seeing, imagining, or drawing.

DRAWING ESSENTIALS

What would be necessary for these images to be complete?

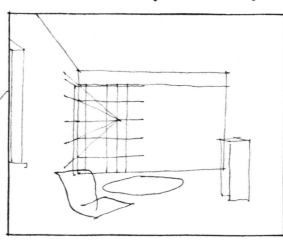

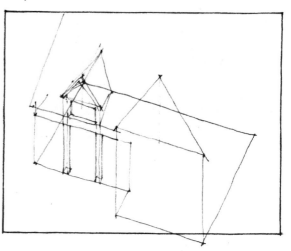

A quick mode of drawing is necessary to capture a brief moment in the flow of ideas, which cannot always be directed or controlled. Fluency in drawing therefore requires a freehand technique, with a minimum of tools. Using T-squares and triangles to draft one's thoughts diverts too much attention away from the visual thinking process.

Related to fluency is the idea of efficiency. Efficiency in drawing, and the resulting increase in drawing speed, comes with knowing what to draw and what to omit, what is necessary and what is incidental. This knowledge too can only come with experience and a seeing eye.

BE FLEXIBLE

To be flexible is to be open to exploring a variety of approaches as new ideas and possibilities arise. Flexibility is important because how we draw affects the unconscious direction of our thinking and how our visual thoughts are formed and articulated.

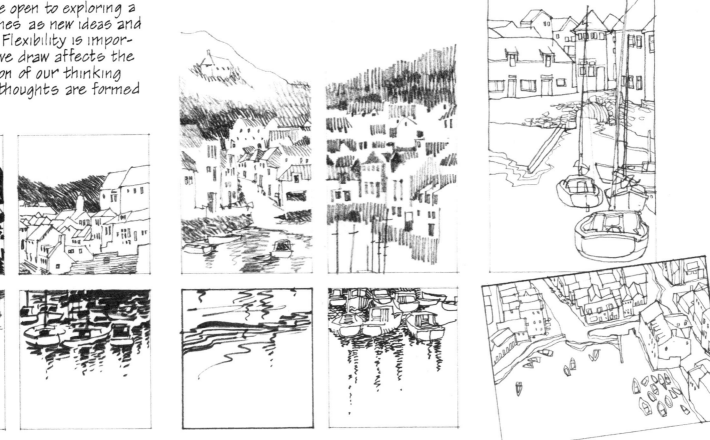

BECOME FAMILIAR WITH VARIOUS DRAWING MEDIA, TECHNIQUES, AND POINTS OF VIEW.

If we feel comfortable with knowing how to draw only one way, relying on habit and convention, we unnecessarily limit our thinking. To be able to look at a problem in different ways requires being able to draw these various views. We must become familiar and fluent with the various drawing media, techniques, and conventions, and view them simply as tools, to be selected according to their appropriateness to the task.

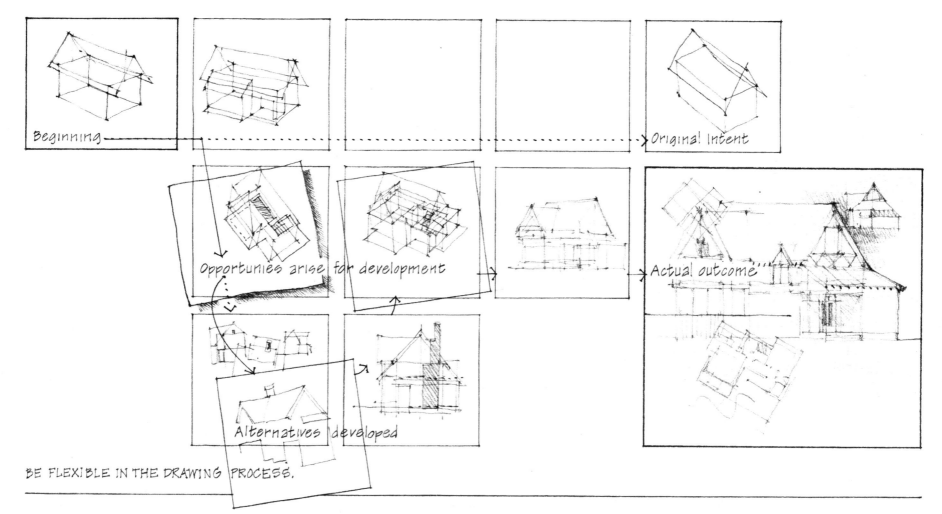

Beginning

Original Intent

Opportunities arise for development

Actual outcome

Alternatives developed

BE FLEXIBLE IN THE DRAWING PROCESS.

A flexible approach to drawing is the beginning of a search which often involves trial and error. The willingness to ask "what if...?" can lead, however, to alternatives worthy of development. A flexible attitude thus allows us to take advantage of opportunities as they arise in the drawing process.

While fluency and flexibility are important in the beginning phases of any creative endeavor, they must be coupled with judgment and selectivity. We must be able to generate and develop ideas without losing sight of the overall goal or purpose.

TOLERATE AMBIGUITY

The creative process occurs over uncharted territory. To pursue what we do not already know, it is necessary to have a sense of wonder, the patience to suspend judgment, and a tolerance for ambiguity.

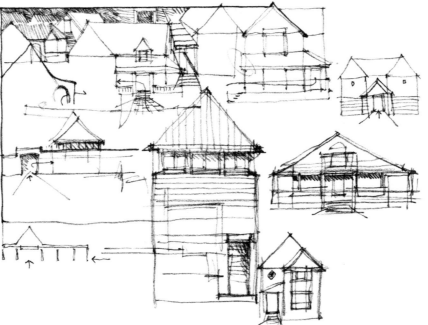

EXPLORATORY DRAWINGS ARE OPEN-ENDED, ABLE TO BE ADAPTED TO THE DEVELOPING NEEDS OF A SITUATION.

In accepting ambiguity, we unfortunately lose the comfort of familiarity. Dealing only with the clearly defined and the familiar, however, precludes the plasticity and adaptability of thought necessary in any creative endeavor. Tolerating ambiguity allows us to accept uncertainty, disorder, and the paradoxical in the process of ordering our thoughts.

The mystery and challenge of ambiguity applies as well to drawing. How can we draw if we do not know what the final image will look like? The answer lies in understanding the exploratory nature of drawing which is intended to stimulate and extend our thinking. These freehand and intuitive drawings differ from the more formal and explicit drawings used to communicate the results of one's thinking.

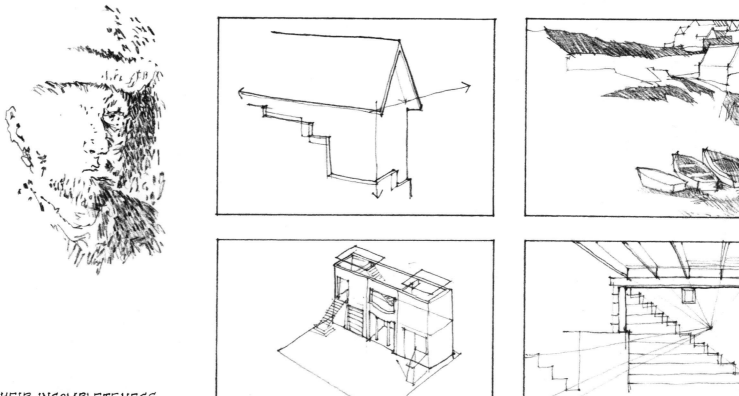

BECAUSE OF THEIR INCOMPLETENESS,
IN-PROCESS DRAWINGS CAN BE READ
AND DEVELOPED IN A NUMBER OF WAYS.

The first lines of a drawing are necessarily tentative, representing only the beginning of a creative search. There is an inherent ambiguity to the state of the drawing before it is fully formed. Only as the drawing is transformed and refined does it become clear enough to judge whether there is a satisfactory correspondence between the imagined image and the one we are drawing.

While a prior notion of an image is necessary, it can be a hindrance if we do not see it as something we can interact with as we draw. If we can accept this exploratory nature of drawings, we can benefit from what they reveal. When we can accept their ambiguity, we open up the creative process to chance and discovery.

SEE IN NEW WAYS

A creative imagination regards old questions from a new angle. To see in new ways thus requires a keen power of visualization and an understanding of the flexibility drawing offers in posing new questions and presenting new possibilities.

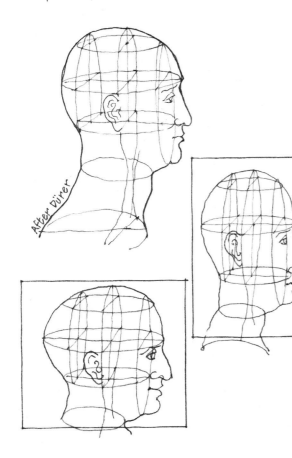

After Dürer

VARY THE POINT OF VIEW.

Relying on habit and convention when we draw can impede the flow of new ideas. Creativity feeds on a fresh eye. If we can see things outside of their primary context, we are better able to view the commonplace with a new perspective. We can transform the familiar to the strange and the strange to the familiar. We can see hidden opportunities in the unusual and the paradoxical.

Tangram puzzle

FRAGMENT, SORT, REARRANGE.

Drawing gives us the means to see things which are not possible in reality. As we draw, we can vary the arrangement of information. We can free the information from its normal context so that it can come together in a new way. We can fragment, sort, and group according to similarities and differences. We can alter existing relationships and study the effects of new groupings.

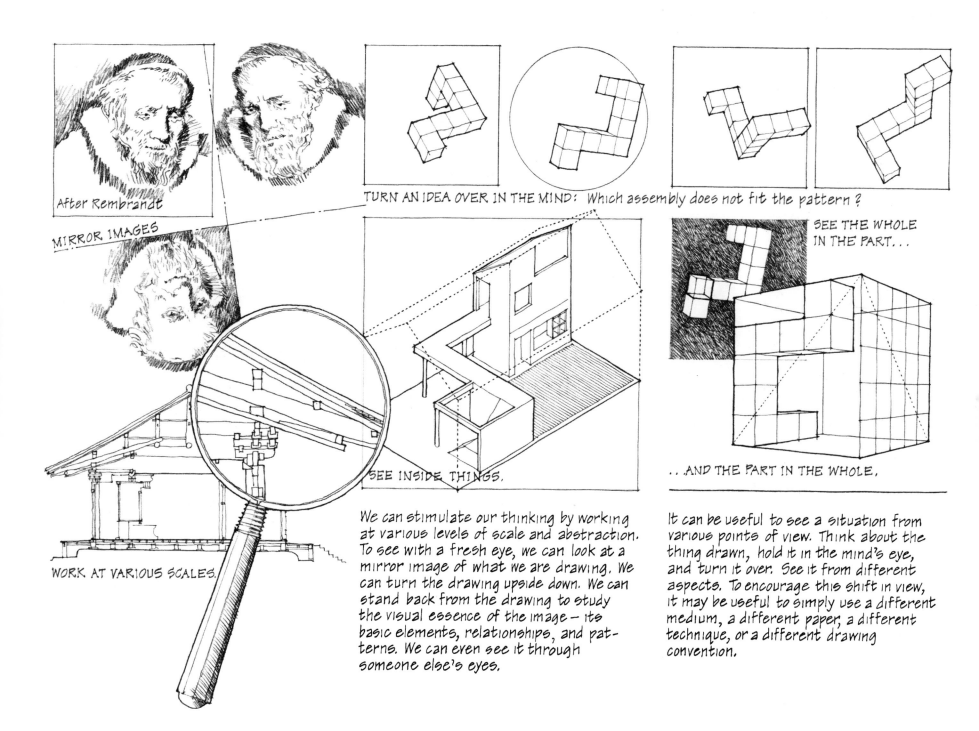

After Rembrandt

MIRROR IMAGES

TURN AN IDEA OVER IN THE MIND: Which assembly does not fit the pattern?

SEE THE WHOLE IN THE PART...

SEE INSIDE THINGS.

...AND THE PART IN THE WHOLE.

WORK AT VARIOUS SCALES.

We can stimulate our thinking by working at various levels of scale and abstraction. To see with a fresh eye, we can look at a mirror image of what we are drawing. We can turn the drawing upside down. We can stand back from the drawing to study the visual essence of the image — its basic elements, relationships, and patterns. We can even see it through someone else's eyes.

It can be useful to see a situation from various points of view. Think about the thing drawn, hold it in the mind's eye, and turn it over. See it from different aspects. To encourage this shift in view, it may be useful to simply use a different medium, a different paper, a different technique, or a different drawing convention.

MAKE CONNECTIONS

To make connections is to see similarities, incongruities, and unexpected relationships among a series of elements or groupings. Being able to make connections is crucial to the formation of new conceptions. Even as we draw, we can actively seek connections and recognize patterns. Drawing can thus serve as a catalyst for making these connections and seeing in a new way.

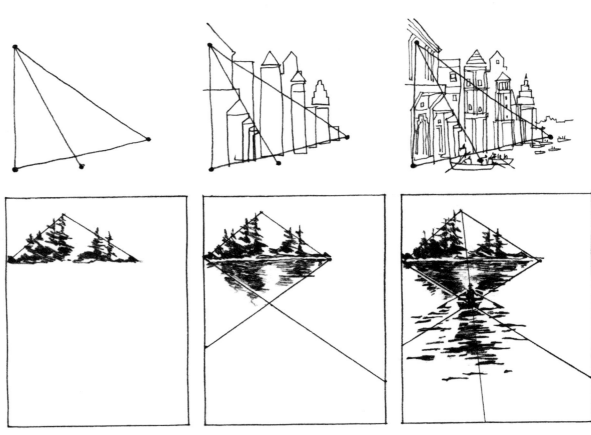

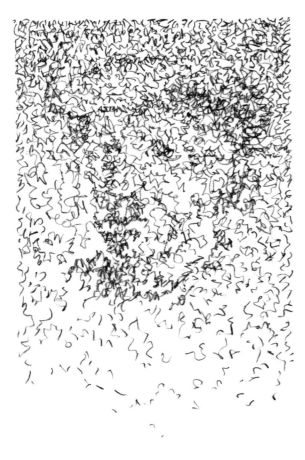

RECOGNIZE PATTERNS

To recognize patterns is to perceive the configuration of significant similarities or differences among elements. Since perception is based on the search for meaningful patterns, active pattern-seeking is a natural part of visual thinking. Even when confronted with an incomplete or amorphous pattern, we tend to fill in or project images to create order out of chaos.

In drawing, we invent and elaborate meaningful patterns with the basic elements of dot, line, shape, and tone. We try to establish coherent relationships and a visual unity in the composition of positive and negative shapes without sacrificing diversity nor shutting out the ambiguous and the paradoxical.

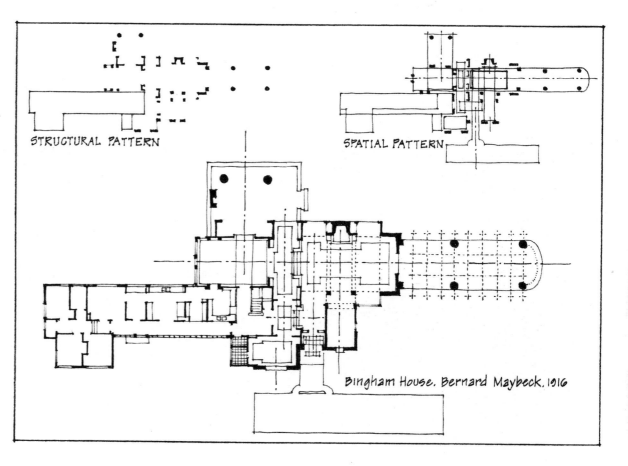

STRUCTURAL PATTERN

SPATIAL PATTERN

Bingham House. Bernard Maybeck. 1916

There often exist several layers of patterns in a drawing and therefore several layers of meaning. In addition to the fundamental composition of line, shape, and tone, there may also be meaningful compositions of detail, texture, and color. We should be open to recognizing these and not deal simply with the most obvious pattern.

We should first identify these organizing patterns of a drawing before delving into the analytical concern for details. If we can see these patterns in different ways — by grouping, closure, or projection — we create more possibilities and the potential for giving an image a greater depth of meaning.

ANALYZE AND SYNTHESIZE

Analysis and synthesis are complementary parts of a single, creative process. Analysis breaks something down into manageable parts; synthesis is the combining or rearranging of elements into a new whole. Drawing gives us the ability to work comfortably back and forth between analysis and synthesis. Analytical drawing looks at and abstracts constituent parts and their relationships within a larger context. Synthetic drawing orchestrates the individual graphic or design elements into a unified whole.

We develop and refine a drawing by building it up in layers. This layering can occur on a single sheet of paper if we develop a drawing in stages, beginning with the layout of foundation or structural lines. We draw these initial lines lightly in an exploratory manner. Within this framework, we can begin to analyze emerging patterns of elements and relationships.

Then, as we make visual judgments on quality of line, shape, tone, and composition, we draw over the developing image. In a number of related but discrete steps, we alternate between analyzing the parts of the drawing and synthesizing them into a single, unified composition.

USE TRACING PAPER OVERLAYS FOR:

STUDYING POSSIBLE COMPOSITIONS

DRAWING OBLIQUE VIEWS

TRYING OUT DIFFERENT FORMATS

COMBINING PARTS IN A NEW WAY

The transformation of a drawing can also occur through the physical layering of transparent sheets of tracing paper. In this process, we can draw over another drawing while analyzing its constituent elements. Through tracing paper, we can make connections, see patterns, and study relationships from one layer to the next.

Exercising judgment, we can retain certain elements and refine others. We can, in a physical manner, manipulate and rearrange the layered images as in a collage. We can form new associations and draw new patterns. We can discover and synthesize new images.

BE SELECTIVE

Fluency in drawing promotes the fluent generation of ideas. As drawing opens up our eyes to a range of possibilities, we must become selective and temper the divergent nature of fluency with convergent thinking. We must be able to discern and focus on what is significant. A creative search can add up to nothing if we lose this focus.

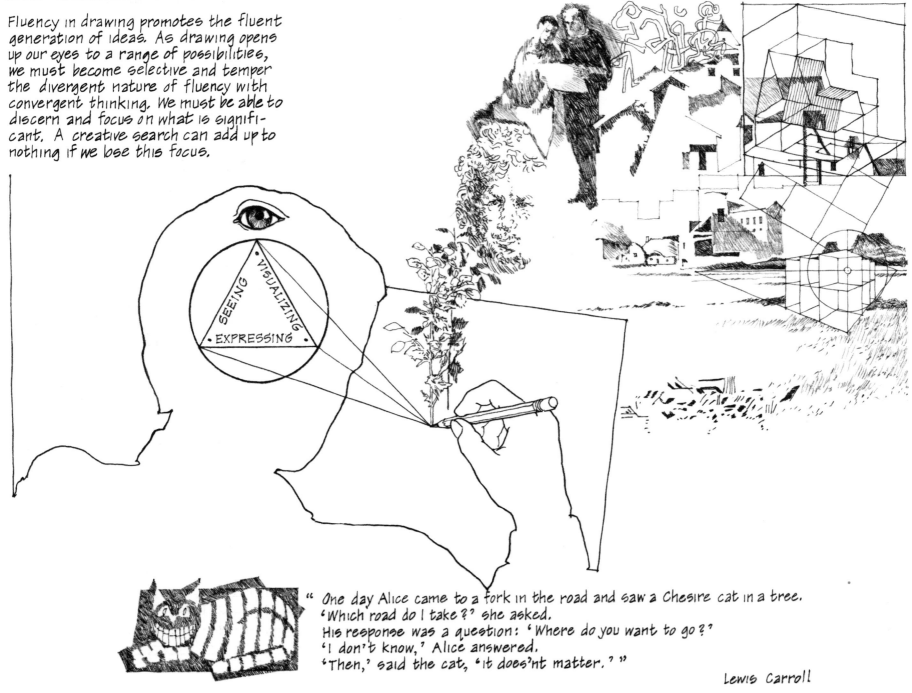

" One day Alice came to a fork in the road and saw a Chesire cat in a tree.
'Which road do I take?' she asked.
His response was a question: 'Where do you want to go?'
'I don't know,' Alice answered.
'Then,' said the cat, 'it does'nt matter.' "

Lewis Carroll

The Thinker

Auguste Rodin

"WE MAY TAKE FANCY FOR A COMPANION, BUT MUST FOLLOW **REASON** AS OUR GUIDE."

Samuel Johnson

Drawing without thinking is a dead end. We must reason as we perceive, envision, and draw. Drawing can help clarify thought only by combining the intuitive approach of visualization with the reasoning of the intellect. All the fluency we acquire in drawing will not substitute for an inquiring mind and a critical eye.

Drawing based on <u>The Thought Which Sees</u>. Rene Magritte. 1965.

In expressing the outer reality we experience and the inner reality of the mind's eye, we draw a dialogue between vision and thought. We create a separate world of images, in the space between the real and the imaginary.

BIBLIOGRAPHY

Arnheim, Rudolf. Visual Thinking. Berkeley, CA: University of California Press, 1969.

Crowe, Norman A. and Paul Laseau. Visual Notes. New York: Van Nostrand Reinhold Company, 1984.

DeBono, Edward. Lateral Thinking: Creativity Step by Step. New York: Harper and Row, Publishers, 1970.

Dodson, Bert. Keys to Drawing. Cincinnati, OH: North Light Press, 1985.

Edwards, Betty. Drawing on the Right Side of the Brain. Los Angeles: Houghton Mifflin Co., J.P. Tarcher, 1979.

Guptill, Arthur L. Freehand Drawing Self-taught. New York: Watson-Guptill Publications, 1980.

Hanks, Kurt and Larry Belliston. Draw! A Visual Approach to Thinking, Learning, and Communicating. Los Altos, CA: William Kaufmann, Inc., 1977.

Laseau, Paul. Graphic Thinking for Architects and Designers. New York: Van Nostrand Reinhold Company, 1980.

Laseau, Paul. Ink-line Sketching. New York: Van Nostrand Reinhold Company, 1987.

Lockard, William Kirby. Design Drawing. Revised Edition. Tucson, AZ: Pepper Publishing, 1982.

McKim, Robert H. Experiences in Visual Thinking. 2nd Edition. Boston: PWS Publishers, 1980.

Nelms, Henning. Thinking with a Pencil. Berkeley, CA: Ten Speed Press, 1981.

Pye, David. The Nature and Aesthetics of Design. New York: Van Nostrand Reinhold Company, 1978.

Röttger, Ernst and Dieter Klante. Creative Drawing: Point and Line. New York: Van Nostrand Reinhold Company, 1983.

Thiel, Phillip. Freehand Drawing: A Primer. New York: Prentice Hall Press, 1986.

" In order to apprehend
meaning in our experience,
it is essential for us to
see, and drawing is the
instrument of the
inquiring eye that teaches
us how to see. "

Edward Hill
The Language of Drawing
Englewood Cliffs, NJ:
Prentice - Hall, 1966

INDEX

This book has been designed, handlettered, and illustrated by Frank Ching